Yang Teng-Chi
Father's Videotapes

I. **Father's Videotapes**
II. **Avoid A Void**
III. **Diverse Identities**

登曼波
父親的錄影帶

童年無憂

登曼波

童年無憂無慮，滿愉快。

不像有些人在觀展後預想的那般沉重。

我出生於東勢，一個山裡小鎮。靠林場，得經過一條橋才能抵達。距離雪山極近的客家小鎮，彷彿結界，將許多事物封印。大埔腔。許多人訝異居然有年輕人能講瀕臨絕種的客家腔調。我阿嬤中文不好，總用客語溝通。我爸是家裡唯一離開這小鎮的：其他人不是務農、工廠作業，就是郵局公務員或廟公。以前景氣沒那麼差時，有人經營小賭場、KTV，多為八大行業系統。許多人被困在那裡。平輩中，我也是唯一離開、到城市念書的。

記憶是累積。漸進式拼湊才得以完整。我以前無法完整描述，可能現在的生活能讓我跳出來以利回憶。我一直整合作品，呼應記憶。很多老家的東西我留著，這些東西是回顧的觸發物。

它有時間感，某種順序。攝影給予記憶一個重新檢視、觀看的機會。整理作品時我深覺，自己有個內化的檔案夾，我知道每項作品不同的重量、分量，它們都被歸類在不同的感覺裡：有些屬於親情，有些很私密，有些具備訊息，理性，感性。我很清楚在不同時間該拿出什麼，好呈現在觀眾面前，好讓我的脈絡在不同時間點，甚至年代能重新被檢閱，回應當代提問。

小時候印象最深的是光，斜射。我們家獨棟，半磚半鐵皮，兩層。有窗簾，採光良好。記憶裡對光的印象滿深，還有阿嬤的聲音，她必須親自叫我起床我才會醒。親戚中我是唯一有單人房間的小孩。國中前跟阿嬤睡，之後有自己的房間。十五歲前的家屋裡充滿聲音，大家庭分棟相鄰隔音不好。習慣、共存後，會忽略談話內容。我從小知道這房子是多人共存的空間。

當時，三十多人彼此相連、綑綁。

我童年是孩子王，總是故意撩別人玩，召集所有小孩。我表演慾很強，堂哥拿 BB 槍射我，覺得我很三八。我會逼大家陪著唱歌，我用房裡的冷氣誘拐他們，開個人演唱會。長大後被說當年根本就是《哆啦A夢》的胖虎。玩捉迷藏時，遊戲重要關卡是我用立可白寫的「美」。無尺度捉迷藏，可以跑到鎮上任何地方。

像阿嬤一樣，我有個怪癖，可能與小時候

情節相關。我爸常不在家，我們想留住他給予的任何書信與物件。

申請替代役時，很多文件我爸不管，每次辦理時我都需要很多很多的解釋。阿嬤提醒我有些事她無法代勞，她閱讀能力有限。她的擔心是 overthinking，但緊張會傳染。我的不安全感顯示在保留東西的強迫症上。總沒把握可以完成事情，所以留存證明。像領養證，當年申請補充兵等等，我都留。其中也有很多是阿嬤幫我保留的。

會不會哪一天，這些事不成立？

因為生活使然，我不丟，把它們留在一個環境。剛開始不覺得這是素材，決定創作是因為出社會拍完電影、透過商業工作累積自信後，有 sense 去評估，我才回頭去歸納這些有重量的材料。

這本攝影集《父親的錄影帶》，便是自 2019 年首次同名個展以來，與其衍伸作《父親的錄影帶＿碧而不談》、《複寫：認同＿父親的錄影帶》三部曲的收納，與整理。

第一卷錄影帶：探索

國小二、三年級時就覺得自己是男同志，那時對同學有感覺，但不確定。國中有「異男忘」的《盛夏光年》般劇情，已確定自己的慾望。

真正的性經驗是在 1999 年九二一大地震後，小鎮災後封閉。大夥住帳篷、空曠地或打通鋪。那時我仍是孩子王，帶同伴探勘倒掉的百貨公司與民宅。

有遠親住深山，當時擔憂道路阻斷，移至市區。他是我堂哥的表哥。他們家做機車行，他跳八家將。其實就是流氓、小混混。

他大我兩歲，以前偶爾出現，搗亂。我們本來不熟，這群遠親通常滿崇拜我爸，因為他的角色：出外人、做黑的、賭場那掛。遠親知道我爸有名，respect。地震那年秋天，大人們瘋狂聚賭，像過農曆春節。我們小孩冒險，看電視，打通鋪睡覺。他睡我旁邊，喜歡弄來弄去，發現我有生理反應後很好奇，便持續在被子裡撫摸。

這段關係持續一段時日，直到結束避難，我們分別返家。在一個光線猛烈，太陽瘋狂的日子，我們往更深的階段探索。他知道我想要但不敢講，還很機車地慫恿我先去買菸。我猜他那時候有性經驗了，他叫我幫他吹，我拒絕。他的很大，我們沒戴

保險套，沒做完，痛，最後草草了事。當時覺得做了壞事，會得病，我馬上洗澡，在阿嬤的浴室待了很久。

那時父親常消失，總是隔天才知道他不在了。

探索他房間的過程是漸進式的。

我習慣去他房間拿錢，逐步探索。我爸房裡的設備挺好，他懂享受，用好床單，高掛天花板的音響，配有 DVD 與 VHS 錄影帶播放器。

我每次想看 A 片便翻父親的收藏。

先是異性戀色情片，後來發現他的同志色情片收藏。那時只覺得他什麼都看。後來往深處探，在很 horny 的狀態下，愈看愈不對勁，發現影片裡定點腳架拍攝的環境就是我爸房間。

確認後，發現是他本人。他也有跟女子的性愛片，但我第一次看到的，是他與男性發生關係。覺得一切很 sick，很震撼，不知如何消化。

沒有憤怒，很難形容。一方面覺得噁心，卻又無法屏蔽這線索，想知道更多。這經驗並未帶來創傷，因為知道自己也是同志，好像能理解父母為何不婚。雖然日後處理許多衍生出的事情時，會覺得為什麼我要負責？愈來愈不爽。會 angry。好像會怪罪父親，卻又合理化他的不平凡。他情非得已，就是這麼做自己，從事自覺壯觀、大器的事。他看外頭的世界，有中國夢。小鎮裡父親是異類，還曾開過一間名為「國王」的酒店。

國三時我看片頻率太高了，有天下午他敲我房門，跟我說，要看的話別看他拍的錄影帶。他遞給我一片男同志色情片 DVD。

「好玩就好，不要當真。」他說。

高中進入體制後，開始意識到自己私生子的身分，進而解構這角色。進入群體後我尋問，但像找到藉口發洩。大學後，我與母親六年沒聯絡。她會不定期匯錢給我，但有時我得打電話提醒，我對這身分很尷尬。高中以後，父親徹底崩壞，他可以養活自己就不錯了。

阿嬤 2018 年夏天過世。這件事至今我還無法消化。應該有部分是因為此事，促使我做個人作品，我爸那張黃夾克拿九重葛的肖像照片就是在喪禮時拍的。同婚抗爭時期，我與父親的相處密集。阿嬤過世後，年夜飯的氛圍也不太一樣。許多親戚開始改變說法，問我要不要帶伴侶回來，時代想法改變，我也不用再演戲了。

QUEER SENSE

我是順性別男同志。酷兒於我，是讓我們體會不同身分認同，進而產生想法，跟個別的人認識、相處的動機。有一個 sense，可以稱為「酷兒 sense」。

非性別認同，而是生活態度。

看待每一個人，不是先用對方的性別或形象去相處；而是從聊天與認識的深淺，從喜好去了解對方是怎樣的人。這態度很 queer，不想分類或簡化各種族群。我曾困惑於區別、名詞與邏輯，做《碧而不談》四處詢問，才發現有些事愈被分類、被標籤化，愈是缺少個別尊重。但有時為了權利與事件發聲，我們需要透過這些「簡化」，去跟不熟知此領域的人溝通。

酷兒是全面性的。我提醒自己用這理念跟大家相處。學習他們的說話方式，形容事情的方式，它某種程度有點政治正確。但我不會 push 大家去盲從。個人層面，我多了一種角度去欣賞事物，找到樂趣。在路上看到中性打扮的人，你不會覺得刻意，那是超我的自然，有美感的狀態，那就是酷兒氛圍。

《碧而不談》與接下來的作品多了種較穩定的情緒，去探索喜好事物的內裡。以前可能會顧慮我不是這族群的，這樣講會不會

有所冒犯？但我今天是個有 queer sense 的人，該用各種角度去理解、感受。五年、八年前，我可能不太知道如何跟跨性別者聊天。有些話不知道該不該問，他們在一個比較 sensitive 的狀態。我也經歷過，但你「跨過」後會覺得其實那正常無比。但要體驗正常前，必須有所歷練。

酷兒邏輯是在捍衛 LGBT、Q、QIA 與之後的族群。

男女同志如今達到 Pinkwashing 階段。酷兒是門檻與窗口。安全感極重要，在這環境的人都必須擁有該思維，其他族群才能發聲，避免再受傷。《碧而不談》我刻意把 queer sense 正常化，把它變得多彩。我喜歡這種生活感，尋找一般日常環境哪裡有這種思維。

我以攝影維生。近年在主流媒體做性別專題，於同志大遊行期間刊登。突然間，累積了一些和公眾有連結、和我個人作品脈絡有關，同時跟環境有實質連結的作品。

從 Free The Nipple、變裝皇后，到跨性別，尺度愈來愈開放。我合作的雜誌編輯愈來愈期待每年的自我突破，所以產生了《碧兒不談》。這成為我生活圈的一部分——認識皇后薔薇、Popcorn、妮非雅、菲利冰大家們，也接觸更多跨性別族群，之後會認識家族其他成員。未必常見面，但平時看他們限時動態社群 po 文，已變日常。

但這日常如果整合得好，可以變成 sign，一個可跟群眾溝通的 sign。原本我不知道到底會怎樣，但漸漸有所效應，這是累積，不是曇花一現。我用攝影這工具或媒材工作外，還可以跟非藝文圈的一般群眾

溝通。這象徵我們時代在演變，主流環境的演變是見證。

喜愛紀錄片《安迪·沃荷：時代日記》（Andy Warhol Diaries），討論介於流行與藝術的「之間」。如果藝術無法影響社會，它的對話者永遠只針對部分對象。對我來說，好的藝術能產生影響，它 fit in 當代，甚至存在於比我年輕一輩正感受的、好奇的事物裡。

我希望於兩者間取得平衡。只是剛好我跟父親的身分，是打破一般邏輯框架的鑰匙，這鑰匙觸發我開啟更多的對話群眾。若沒有父親，我可能沒那麼大的自信去完成這件事，是他的角色，以及如此對性坦然的態度，讓我的自信得以完整。

豔舞與無關禁忌

現實環境的物件，我滿喜歡它們在展場上被用另一角度呈現。

最近我把一些機車坐墊變板凳，把腳踏車弄成高腳椅，這很情色的。它們的設計原本就與人體有所接觸。

三部曲展覽中，父親的物件接近檔案學。那些東西所擺放的位置是不能被觸摸的，必須拉出一個距離，保護式的，讓觀眾用對待史料的方式觀看。

眾多舊物中，我對父親的陽具燈感覺特別強烈。首展當時用壓克力箱子裝著，外邊有層我的攝影透明片，檳榔樹叢。我刻意把母親的屏東記憶加入，有些浪漫地把爸媽放一起。雖然他們屬於完全不同邏輯時空，但很合，兩個狂人。

《複寫：認同__父親的錄影帶》我再將陽具燈放置在透明壓克力箱裡，只是這次它下面墊了 1994 年製造的中國地圖，那是父親從中國帶回來的，代表他那幾年的遠行。到第三部曲，除了父親外，有張黑白照，是我穿阿嬤的碎花洋裝與她同框。我身上局部的日文刺青，則是童年時她常哼的民謠〈桃太郎〉。拉開地緣、國界，擴大家族成員，讓原本內容根據國立臺灣美術館特定的空間做形變與再對話。

在臺北市立美術館的首展《父親的錄影帶》裡，藏有一個很隱晦的符號，那是父親寄來的家書。上面有一個藍色戳記。來自勒戒所的官印。

他總共進出勒戒所兩次，是國中吧？這時間點常跟他的中國行錯亂。所造成的直接影響是我開始讀書，為了證明自己。別人總預想我這種小孩一定完蛋。

父親的確成癮，他曾出現幻想，我在場時被嚇到。他講些非真實的狀況，可能有關過去。他現在的思緒很斷片，雖然已有失智症狀，但多少有些原因對我而言，很曲折。

2014 年我去柏林，看見當地的音樂、創作和藥物相連，開始理解藥物的文化與生態。

紅中白板強力膠，我爸那年代藥物是無法被制約的，那氛圍迷亂，卻又自由。

藥物在我的作品裡面較隱晦，較偏中性。像《碧而不談》裡，那些被放置在敞開腋下，那散發棉花糖鮮豔色澤，若不細看，會以為是小貼紙小飾品的迷幻藥。每個人應該都有權利決定自己是否使用。我希望更多人了解藥物的真實面。很多極好的作品，對我而言，都是藥物盛行的 90 年代出產的。那時電子音樂品味太好，很有能量，我當 DJ 時經常播放。那年代有很純粹、正宗的叛逆。現在的叛逆我覺得好假。

喜歡 90 年代可能在認同自己的青春期。父親的不羈，那些本來怨恨的東西，反而變成魅力。

第二卷錄影帶：隱私

這次（2022 年夏天）去德國發現性的另一面，以前沒察覺的 fetish，我對手特別有感覺。我嘗試過拳交但沒特別熱愛。3P、4P 太忙有種表演感。嘗試暗房，但缺乏安全我會焦慮。我在性裡面會提醒自己不要想很多。性是能量，好的性能忘我，完全感受，解放當下。

我對不同膚色的人種有很敏銳與特定的喜好。亞洲人我喜歡年紀大的，白人喜歡年紀中間的，諸如此類。我曾為了理解不同年紀的人，透過約炮認識年長族群。我曾跟一對情侶同住。我從約炮創作，我有這個意圖。

今年生日，我從二手拍賣買到 Hi8 的播放攝影機，獨自主動且抽離地觀看父親的錄影帶。

上次看是國中。後來包括做第一次個展時，我其實都沒再回顧影帶內容，只單看影帶殼外觀與父親收藏的雜誌。

我的作品回應記憶，回應那個還在震驚的我。

看錄影的當下壓力非常大，一方面不想再有那股噁心感，我調適自己，更提醒自己得跳脫出來觀看。我思考，這些影片到底

能不能給別人看？我有沒有這權利？照理說是侵犯隱私。我甚至自拍性愛影片當素材，想說兩者並置，想過各種方式，但依然沒有答案。

最近父親身體較差，我問他當時到底為何要把這些收藏轉交給我。所有過程我都有紀錄，以此回應：這隱私是真的，還是我自己設定受體制影響的？我爸只說：「你不是有拍東西？這些本來就要給你，你不要的話就丟掉。」

我們的年代好像刻意在歸類。

對我爸可能這就是一個開心的紀錄，或作品。父親的影片裡，我發現他有構圖、打光，甚至用很粗糙的迴路方式剪接。我想如果他當時有 OnlyFans 或 Twitter，可能早就上傳。所有疑慮只是個人框架，而這框架是成長環境塑造出來的，其中當然有我的性格。我拉扯這些，透過作品開啟不同對話。

我出國後拍攝不同對象，表達個人隱私，但我依然沒有直接展演我爸的作品，可能是社會氛圍使我覺得沒辦法這麼做？但其實那些作品非常 arty，不只是情色。那 vintage 的畫質、構圖，他堅持做的初衷，儼然成為歷史紀錄，而非單純的性愛影片。

這也回應青春期時媒體對性愛影片的新聞評價，讓我判定那是父親的「性愛影片」。但那是媒體亂象，將隱私變成武器與工具。媒體教化我們性是骯髒的，是把柄。我回應這件事。身邊女生朋友也經歷過分手後，前男友將先前偷拍的性愛影片上傳。這些影像流出去後，我們「應該」羞恥。但為

什麼？我好朋友當時雖然受傷，但只輕輕地說：「我在裡面性感就好了。」

但社會氛圍還沒到這地步。

其他訪問中我談到戀父情結，指的不是真實父親，而是形象。父親那時的朋友們現在想起來都滿邊緣，但那是對於我，一個成長中，男同性戀的男性形象建立。某程度我探索對這族群的慾望。很不想說我的作品裡有挑戰階級意識，但有。我激賞他們的生活，不只尊重，甚至想美化。邊緣即是高貴。

我對父親沒有慾望，不會性幻想他。

我們太像，或許是性角色上的重疊，但不全然。有些壓抑的東西相似；但生活體驗不同。我啟蒙於網路，他的生活圈令我匪夷所思：做黑的、開酒店、在中國的「事業」……我不確定。但我想那已是他的循環。我爸很聰明，但沒有 fit in 這個體制，他在 underground 的循環裡生活。居家娛樂。

我想透過現代的東西去呼應，甚至表達他們的靈魂其實更自在。

決定性瞬間

大學第一堂課被告知攝影可以愛人，可以殺人。我一直回應著，是個人作品裡的脈絡。

認識自己多少，就是認識這世界多少。白先勇的《孽子》、蔡明亮的《河流》，以及求學時李淑貞老師的提點，給我很大的啟發。因為成長經驗，我對挖掘自己極有熱忱，並著迷於這種折磨。

我對決定拿起相機拍攝的動機相當迷戀。

看到什麼，決定記錄的那契機。喜歡拍攝的事物或當時狀態是令人興奮的，商業工作我製造契機，營造氛圍，建立關係。拍個人作品時，裡頭的人我至少都要有三分熟。我可以拍不熟的，但會覺得那沒靈魂，或我盡量不拍他們的臉。我對主動幫陌生人拍照不是很自在。對我而言，攝影需要關係與連結。

不太會形容自己的風格。目前為止，我的敘述針對事件或動機，不太描述風格，對我而言那是其次。動機對我而言格外重要，所以我在意大家只注重一般形式。攝影表達訊息，可能我剛好風格很明顯。但這討論不完。我欣賞的各種東西變成我，但促使我攝影的動力是回應環境與族群。

我不太懂創作帶來的和解與救贖。與父親間沒有任何誤會。像我強調的「展演性」。我與父親對話，可以很私下，但為何要記錄下來？是因為我覺得這對社會有所回應。為何我爸那年代的人沒辦法跟我正常講話？展演性是創作，也是個人的整合，更是與環境的對話。

近期的我，攝影有點跟慾望脫節。

戰戰兢兢地拍，嚴肅對待。回家看照片時覺得很有魅力。那不是性不性感，而是自信，奔放。我想用自己的方式去收藏，讓這些作品在不同時間點有被重新檢視的機會。

攝影是另種角度與層次的放置，與當代事物開放性的討論。我不提出一個完整觀點，但給大家一個重新回顧的方式。

去他的沙文悲劇，Let's 羞恥運動。

採訪整理　白樵

THOSE CAREFREE DAYS OF CHILDHOOD

Yang Teng-Chi

Care-free and pretty pleasant—
that was how my childhood was.

It's not like some of you might imagine after
watching my exhibition. It's not that gloomy.

I was born in a small mountain town called
Dongshi in Taichung in central Taiwan. It's
close to an experimental forest and very
close to Snow Mountain. You have to walk
through a bridge to get there. The Hakka
community where I grew up was isolated.
Many things existed there and only there.
The Dapu accent of the Hakka language is
the accent I speak with. Many are surprised
that I am young but speak this branch of
Hakka, which has nearly become extinct. My
grandma didn't speak Mandarin well. So, we
talked in Hakka. My dad was the only one
in my family that left the town. Others were
farmers, factory workers, public servants
working for the Post Office, or Miaogong,
which means a temple manager. When the
economy wasn't that bad, some of them ran
small casinos, Karaoke bars, or nightclubs.
Many people were stuck there. I was also the
only child leaving the town to study in a city.

Memories accumulate over time. Bits
and pieces are put together to make my
memory whole. I was unable to describe
my memories without missing some ele-
ments. Probably it's the life that I am living
that reminds me of those lost elements.
I have been putting together my works to
resonate with my memories. I keep things
from my family house, and these things are
triggers of my recollection of memories.

Memories come in chronological order.
Photography creates opportunities to review
these memories. When sorting through my
works, I categorize them in my mental files
according to their respective weights and
significance. Some of them are kept in the
family file while some of them go into the
private file. Some are informative. Some
are rational. Still others are emotional.
I know perfectly when to present what to
the audience so that the contexts can be
reviewed in different points of time or eras
to respond to the questions of the time.

Light is the most memorable from my child-
hood. Sun shone through the window from
an angle. Our family house stood alone. It's a
two-story building with good lighting. Half of
it was made of bricks, and the other half was
made of metal sheets. There were curtains
and my grandma's voices. She had to wake me
up in person. I was the only child who didn't
have to share a bedroom with others. I slept
with my grandma before studying in junior
high. Before I was 15 years old, the house

was filled with voices because I had a big family living in a thin-walled house. After getting used to it, I would ignore others' conversations. I knew when I was a child that this house was shared by many people.

Back then, more than 30 people were connected—tied together.

I was a leader among my friends in my childhood. I made fun of others and gathered my friends to have fun. I loved performing. My cousins shot me with airsoft guns because they thought I was too perky and showy. I used to force people to sing with me. I lured them to my personal concert in my room with air-conditioning. I was told that I was just like Gōda Takeshi in *Doraemon*, a classic Japanese Manga/Animation. When playing hide-and-seek, I would write the word "BEAUTY" using liquid paper at important passes. We would hide at any place in the town without being restricted.

Like my grandma, I have a silly habit. Maybe the cause was the way my childhood was. My dad was seldom home, so grandma and I tended to keep things and letters he left us.

When I was applying for substitute military service, my dad neglected loads of paperwork. I had to go through lengthy explanations whenever I tried to get relevant things done. Grandma reminded me that she was unable to help me with many things because of her limited literacy. She was an overthinker. Anxiety is contagious. My sense of insecurity manifested in the form of compulsorily keeping things. I was not confident in getting things done, so I kept certificates, such as certificates of adoption or replacement soldier service. I kept many things—many of which were kept by grandma on my behalf.

Will there be a day where these things no longer hold true?

Because of my life experiences, I don't throw them away. Instead, I keep them in a space. At the beginning, I didn't consider them as meaningful materials. After I accumulated confidence through cases of commercial photography and filming, I decided to step on the road of art creation. That was when I started to feel that I have the ability to review and evaluate these materials. So I started to categorize these materials that carry weight.

This photo portfolio is called *Father's Videotapes*—a convergence and compilation of the 2019 *Father's Videotapes* and the sequels—*Father's Video Tapes__Avoid A Void* and *Diverse Identities __Father's Videotapes*.

THE FIRST VIDEOTAPE: EXPLORATION

I became aware of my homosexuality as early as in my second or third year of elementary school. I felt attracted to one of my classmates but uncertain about that feeling. Back in junior high, I had straight crushes just like the story in *Eternal Summer*, a Taiwanese gay movie.

I had sex for the first time after the catastrophic Jiji earthquake in 1999. Outbound access was blocked. People camped and slept together in temporary shelters. I was still the leader among friends, leading my friends to explore collapsed department stores or private residences.

Some of my extended family lived deep in the mountain but relocated to the town for fear of disrupted transportation. He is my cousin. His family ran a motorcycle service station. He played Ba Jia Jiang (bodyguards for gods) in temple fairs—in fact he was a gangster, a thug.

He is two years older than me. Occasionally he showed up and messed around. We didn't know each other well. My extended family admired my dad because he left the town to run gambling and sort of mafia businesses. They respected my dad for that. In the autumn following the huge earthquake, adults gathered and gambled crazily like they did when celebrating Spring Festival. Children, on the other hand, went on adventures, watched TV, and slept together. He slept next to

me and touched me because he thought it was fun to see me getting aroused.

This relationship continued for a while. It didn't end until we resumed normal lives and went back to our own houses. One day, the sun glared, and the light was intense. We explored deeper. He knew I wanted it but dared not ask. He egged me on to buy cigarettes—very annoying. I believed that he had had sex before. He told me to blow him, but I refused. His was huge. We didn't use condoms and didn't finish it. It hurt. We did it hastily. I felt I was doing something wrong, and I would get sick. I took a shower immediately and stayed in grandma's bathroom for quite some time.

Back then, my father disappeared quite often. Usually, it's on the next day that I would know he'd left.

Exploration in his room was progressive.

I used to take money from his room and explore slowly. My dad kept good things in his room. He knew how to enjoy his life. He used bed sheets of good quality. There were speakers hanging on the ceiling, DVD and VHS players, etc.

I wanted to watch porns, so I sorted through his collection.

I started with heterosexual porns, and then I found his gay porn collection. I thought he just wanted to watch different kinds of porns. I explored deeper when I felt horny. Gradually, I sensed something weird. I finally became aware that the space in the porns WAS my dad's bedroom.

After further scrutinization, it was him. There were videos in which he had sex with women. But in the first video I watched, he was doing it with a man. I felt sick,

shocked; I didn't know how to process it.

I wasn't angry. It's difficult to describe the feeling. I felt disgusted but unable to overlook this clue. I wanted to know more. The experience wasn't traumatic. I knew I was gay, so I probably understood why my parents hadn't had a marriage. When later dealing with the subsequent problems, I didn't feel like bearing the undue responsibilities. I felt angry and blamed my father. However, I rationalized his particularity. He had no other choices; he was being himself, doing things that he deemed significant and magnificent. He dreamt of worlds outside of the town; he had a Chinese dream. He was a weirdo in the town. He even ran a bar called "KING".

I spent too much time watching porns in my third year of junior high. He knocked on my door one day and told me not to watch the porns he made. He handed me a gay porn DVD.

He said, "Just have fun; don't take it seriously."

After I entered senior high, I became aware that I was an illegitimate child. I started to decompose this identity. I looked into my internal conflicts. But it's just like an excuse to give vent to my feelings. In college, I resumed contact with my mother, whom I'd lost contact with for six years. She wired money to me but not always on time. Sometimes I had to call her to remind her. Because of this, I felt awkward. Dad had been unfunctional since I entered senior high. He could barely provide for himself.

Grandma passed away in the summer of 2018. I am still processing it. Partly because of this incident, I started to create my own works. One of my dad's portraits, the one in which he was wearing a yellow jacket and grabbing Paper Flower in his hand, was taken during the funeral. During Taiwan's same-sex marriage legalization, my father and I spent a lot of time together. After the passing of my grandma, the atmosphere during New Year's Eve dinner changed. Many relatives started to ask whether I'd like to bring my partner to dinner. Time and mindset have changed. I no longer need to put on a show.

QUEER SENSE

I am a cis gay man. Queer is a motivation driving me to know and hang out with people with the recognition of identity differences. It's Queer Sense.

It's not about recognizing gender identities but about attitudes towards lives.

When you try to know someone, you chat and get to know him/her based on his/her preferences instead of his/her images or gender. This attitude is queer. I don't want to put labels on or simplify different communities. I used to be confused about distinctions, nouns, and logic. I asked many people when I was curating *Avoid A Void*. And then I realized that categorization and labeling would diminish respect for individuals. But sometimes we have to resort to simplification when we need to communicate with people unfamiliar with this area to safeguard human rights or handle incidents.

Being queer is wholistic. I always remind myself to uphold this spirit to get along with others. I try to learn their languages and ways they describe things. To some extent, it's politically correct. But I don't urge you to follow suit without understanding why. With this attitude, I have an extra angle to admire things, to have fun. When you see someone in neutral clothes, you wouldn't think it's intentional— it's natural; it's sublime. This is queer.

Avoid A Void and the following works contain more stable emotions. They explore deeper into things that I like. I would have worried about being offensive because I hadn't belonged to certain communities. But now I understand the meaning of queer. So I know I need to see things from different angles. Five or eight years ago, I might not know how to chat with transgender people. I didn't know what shouldn't be asked. They are in a more sensitive state. I've been there, too. Once you "cross over", everything is just normal to you. But to feel normal, you have to finish your quest.

The queer logic ensures the rights for LGBT, Q, QIA, and other following communities.

Pinkwashing is now the mainstream. Queer is a portal. A sense of security is very important. People in the environment need to adopt this mindset for other communities to express themselves to prevent being traumatized again. In *Avoid A Void*, I tried to normalize the "queer sense" and enrich it. I like such an attitude towards life. I often try to discover such a mindset and attitude in daily lives.

I make a living by taking photos. In recent years, I work on gender columns in the mainstream media during LGBT pride. Over the course, I've made quite some works substantially connected to the public, my personal context, and the environment.

I created more works pushing the boundary over time, from Free The Nipple, to drag queens and transgender. My editors and I start to anticipate my breakthrough each year. So I created *Avoid A Void*. This has become part of my life. Then I met Chiang Wei, Popcorn, Nymphia Wind, and Feilibing IceQueen and became involved in more transgender groups. I met others in the same community. We don't necessarily hang out often. But watching their social media stories and posts now is part of my life.

If these works and activities can be integrated properly, they can give rise to a "sign", which can be communicated to the general public. I didn't expect anything. But I've now seen some effects over time. It's accumulating. It's not short-lived. In addition to photography and media, I can also communicate with people outside of the art and culture circle. This is the evidence showing that time is changing. The change in the mainstream is a testament.

The documentary: *Andy Warhol Diaries* is enjoyable. It discusses the area "between" popular culture and arts. If arts are not influential, then the scope of the target is limited. Good arts are influential; they fit in the contemporary world. They even exist in things that younger generations enjoy or are curious about.

I hope to strike a balance between the two. It's just coincidental that my father's and my gender identity is key to breaking the framework that follows the normal mindset. With this, I am able to communicate with more communities. Without my father, I might not have such confidence to get these things done. It's his role and openness to sex that makes my confidence full.

STRIP DANCE, IRRELEVANCE, AND TABOOS

I like presenting common objects in a different way in exhibitions.

I recently transformed some motorcycle seats into benches and bikes into bar stools. This is erotic because these objects are designed to be in contact with bodies.

In the trilogy exhibitions, my father's objects were presented nearly as archives. They were placed in inaccessible locations from a distance to the visitors. It's protected. Visitors had to watch the objects as if these objects had been historical items.

Among these old objects, I have a particular attachment to the penis lamp owned by my father. It was contained in an acrylic box when it was presented in the first exhibition. On the outside were the transparencies of my photographs showing betel nut trees. I intentionally blended in my mother's memory for Pingtung, the southernmost county of Taiwan, and somehow romantically put dad and mom together. Although they follow completely different logic, they matched. They were both bold and defiant.

In *Diverse Identities__Father's Videotapes*, I once again placed the penis lamp in an acrylic box. But this time, it sat on a map of China made in 1994 to symbolize my dad's trips over those few years. In the third exhibition, in addition to my father's belongings, there was a photo in black

and white. In the photo, I stood next to grandma in her floral dress. I have tattoos in Japanese, and that's the folk song called *Momotaro*. She hummed the tune often when I was a child. This extends beyond geography, transcends national boundaries, and includes more people into the family. So, the specific space in the National Taiwan Museum of Fine Arts transformed and conversed with the visitors again.

When *Father's Videotapes* was firstly on display in the Taipei Fine Arts Museum, there was a subtle sign. That was a letter sent by my father to his family. There was a blue seal on the letter— the seal was from the rehab center.

He stayed in rehab twice. I think I was studying junior high. Back then, he traveled to China often. I started to study then to prove myself. People usually presumed that children of my sort would end up badly.

My father used to be a drug addict. He hallucinated, and that scared me. He talked about non-existent things— maybe incidents occurring in the past. His thoughts are incoherent to me now. Maybe it's a symptom of dementia. Or they're just incongruous to me for some reason.

I went to Berlin in 2014. Seeing the connections among music, artworks, and drugs, I started to understand the culture of drugs.

Barbiturates, toluene, etc. Drugs in my father's prime time were not strictly restricted. It was a messy but free era.

Drugs in my works are subtle and neutral. Take *Avoid A Void* for instance, the psychedelics placed in the armpits were as colorful as marshmallows. If you don't take a closer look, you would mistake them for tiny stickers or accessories. People should have the rights to decide whether or not to use them. I hope more people would better understand the facts about those drugs. Many outstanding works were created in the 90s when drugs were rampant. Electronic music back then was great and energetic. I play them a lot when I am a DJ. Back then, rebellion was pure and authentic. Rebellion nowadays is pretentious.

I like my adolescence in the 90s when I was trying to recognize my identity.

My father's unruly discretion was something I resent. But now it's charming to me.

THE SECOND VIDEOTAPE: PRIVACY

I discovered a side of sex in Germany in the summer of 2022. It's fetish. It's something I wasn't aware of. I am particularly interested in hands. I tried fisting but found myself not particularly into that. Threesome or foursome are too much like putting on a show. I tried dark rooms. But the lack of sense of security made me anxious. I remind myself not to overthink when having sex. Sex is a source of energy. Good sex is immersive. You lose your self-awareness in it. You simply enjoy it.

I am sensitive to skin colors, and I have specific preferences. For instance, I like elder Asians, mid-aged Caucasians, etc. I used to hook up just to know more about elder people. I used to live with a couple, and I have my own intentions—I am inspired by casual sex.

I got myself a secondhand Hi8 camcorder for my birthday this year. I watched my father's videos alone from a mental distance.

The previous time was when I was studying in junior high. I didn't watch it again when I was curating the first exhibition. I only looked at the tapes themselves and my father's magazine collection.

My works respond to memories and the me that is still in shock.

It's stressful to watch the tape again. I didn't want to feel disgusted again, so I adapted myself and reminded myself to keep a mental distance. I was wondering if I could play these tapes for others. Do I have the right to do so? Maybe it's privacy violation. I even made my own porns and thought of playing them with those of my father's in the exhibition. I've thought of many ways. Still, I haven't got the answer.

Father is not in good condition in recent years. I asked him why he gave his collection to me. I recorded the whole process to respond to this question: "Is privacy real? Or am I just restricted by morality? He asked, "Don't you take photos? These are meant for you. Just throw them away if you don't want them."

In our era, categorization seems intentional.

To my dad, it's just records of happiness or works. In his videos, I see composition, lightning, and rough editing. If he had had access to OnlyFans or Twitter, he would've uploaded them. All the concerns are personal shackles shaped by the environment where I grew up and, of course, my characters. I thought this through carefully and initiate conversations through works.

After I went abroad, I took photos of different people to demonstrate the concept of privacy. Still, I haven't put my dad's work on display. Maybe it's because of the atmosphere that made me feel it's improper to do so. Those works are arty, not just erotic. Due to vintage resolution and composition and his unwavering intention, the works seem like historical records instead of just sex videos.

This also responds to the news comments on sex videos in my adolescence. Because of these comments, I decided that these were father's "sex videos". But that's

inappropriate for the media outlets to turn privacy into weapons and tools. It's the mass media that tell us that sex is obscene, is something we can blackmail others with. I respond to such phenomena with my works. I have a female friend. She broke up with her ex. Her ex uploaded their sex videos that he secretly recorded, believing that people should be ashamed after such videos are brought to the light. My friend was hurt. But she only responded with: "It doesn't matter. I was sexy in it."

But society isn't as progressive.

In some interviews, I talked about the Electra Complex. I wasn't talking about my father but the image of a father. Father's friends, in retrospect, were loners. Such image built up my imagination of male homosexuality when I grew up. So, I want to explore the community. I really don't want to say my works contain some elements challenging hierarchy. But, indeed, there are. I admire their lifestyles. I not only respect it but even want to embellish it. Keeping my distance is noble.

I don't have feelings for my dad. I don't fantasize about him.

We are too much alike possibly because of our sex role. But that's not all of it. Some of the things that we hide from others are similar. But our life experiences are different. My revelation occurred on the Internet. His social circle baffled me: he engaged in illegal activities, ran clubs, did "business" in China... I am not sure. I suppose that's his circle. My dad is clever. But he doesn't fit in the contemporary institution.

I want to use things that we can see today to respond to or even highlight the fact that their souls lived more at ease.

THE DECISIVE MOMENT

I was told in the first session of the photography class in college that photography could love someone, could kill someone. This laid the context of my works, to which I have been responding.

How much you understand yourself is how much you would understand the world. Thanks to Bai Xianyong's novel *Crystal Boys*, Tsai Ming-Liang's film *The River* and Prof. Shu-Jane Lee. I learned a lot. Because of my childhood and adolescence, I was passionate about self-exploration. I was fascinated with such excruciating undertaking.

I am fascinated by the motivation to decide to take out the camera and take photos.

The moment I decide to take photos of something, the object, or the state are exciting. For commercial commissions, I create opportunities and make rapport. When taking photos for my own artistic creation, I take photos of people that I know. I can take photos that I barely know, but the work would be soulless. Alternatively, I try not to shoot their faces. I am not comfortable taking photos of strangers. To me, photography requires relationships and connections.

I don't know how to describe my style well. As of now, descriptions center around events or motivations instead of the style, which is secondary. Motivation is very important to me. People usually only pay

attention to the style. This is one of my concerns. Photos are expressive. Probably my style is rather noticeable. But the discussion would be too lengthy. Things that I admire have become part of me. But it's my desire to respond to the environment and communities that motivate me to shoot.

I don't quite understand the reconciliation and redemption brought about by creation. There aren't any misunderstandings between my father and me. I focus on performativity. My conversations with my father can be very private. Why did I record them? Because I believe these also respond to society. Why can't I have normal conversations with people around my dad's age? Performativity is creation and personal integration. Moreover, it's a conversation with the environment.

Recently, my photography is a bit too detached from desires.

I shoot carefully, and face the photos seriously. When I see the photos back at home, I see charming works. It's not about sexiness but confidence and boldness. I like to keep them the way I like so that these works can be reviewed at different points of time.

Photography offers an alternative angle and layers of complexity. It's an open discussion on things and incidents of the present. I don't offer the wholistic view but a method for revisits.

Fuck chauvinistic tragedies.
Let's join the shame movement.

Interviewed & composed by Pai Chiao
English translated by Andrew Lai

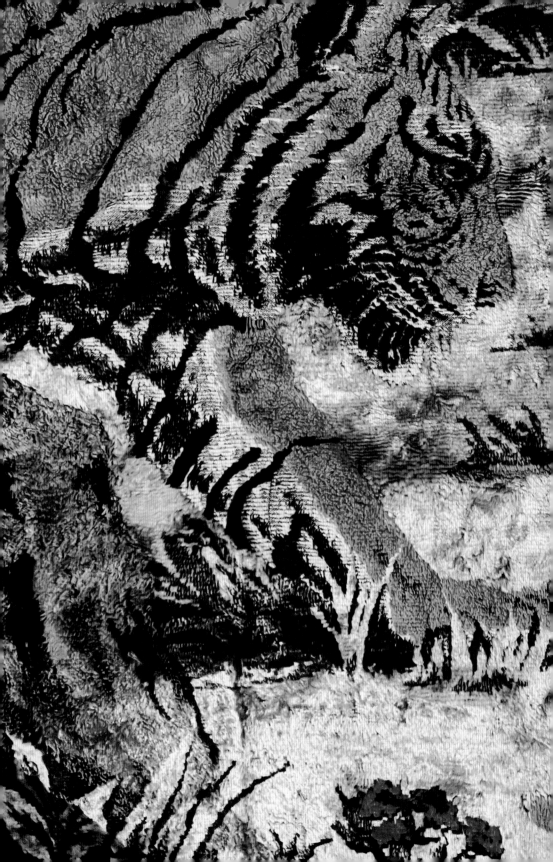

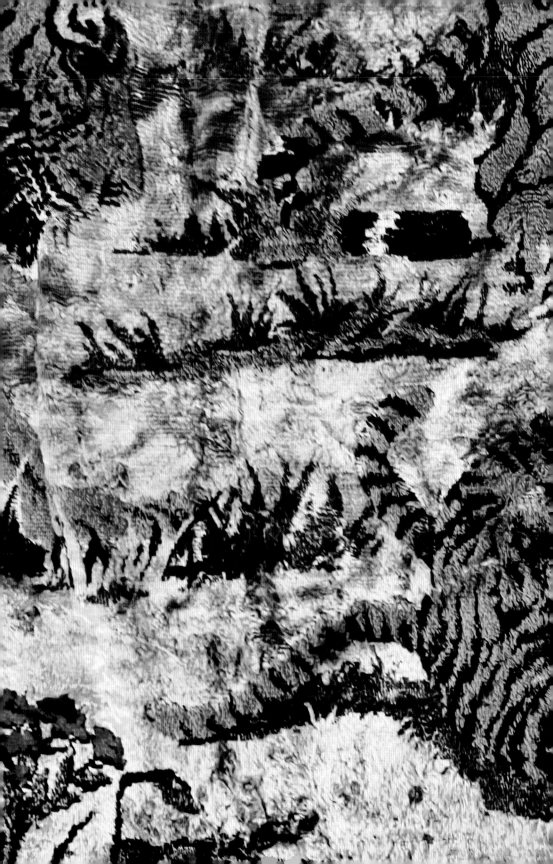

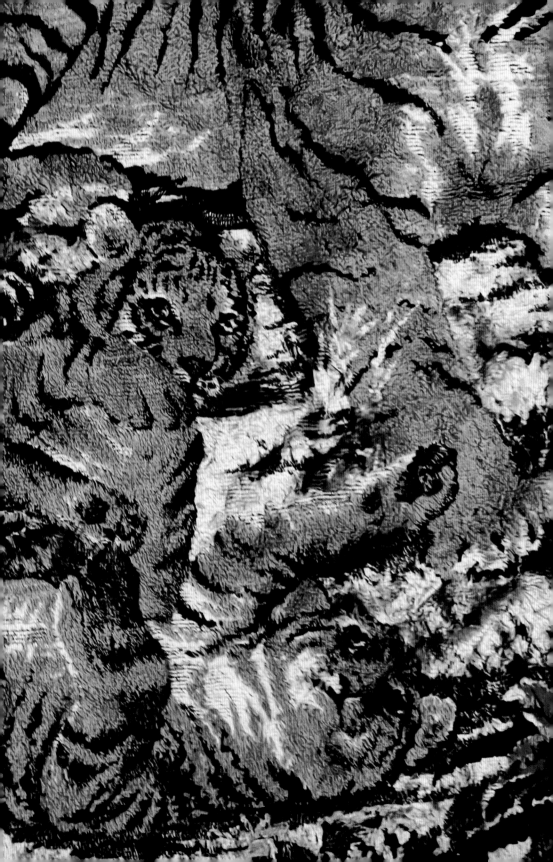

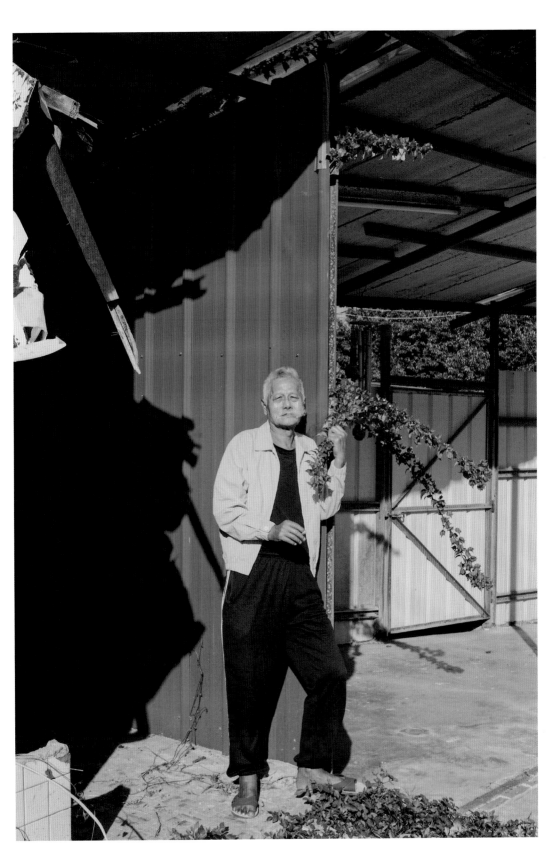

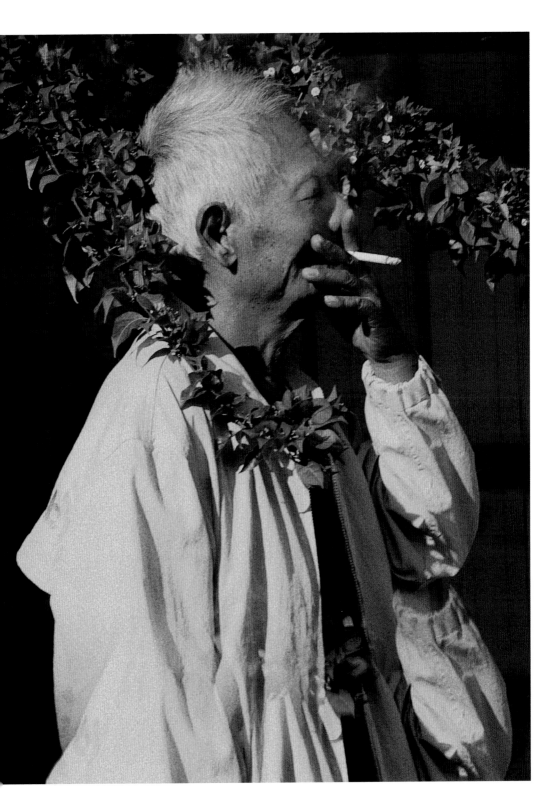

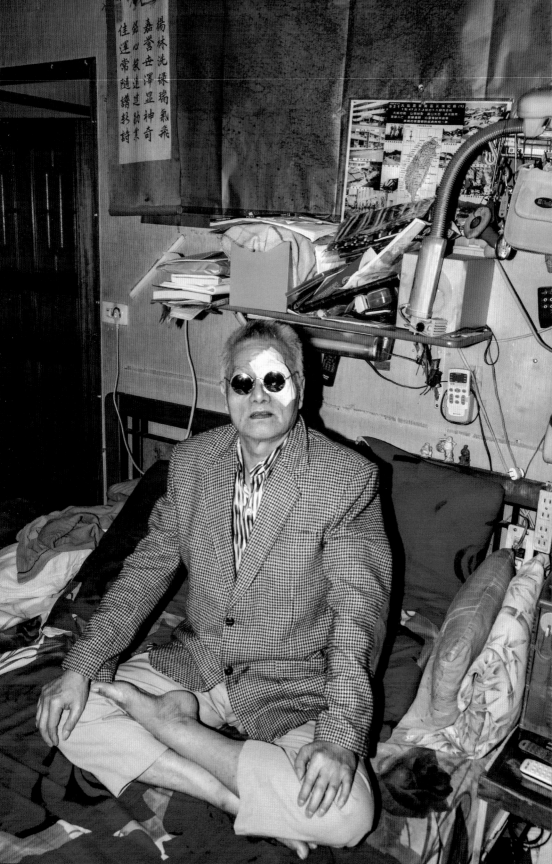

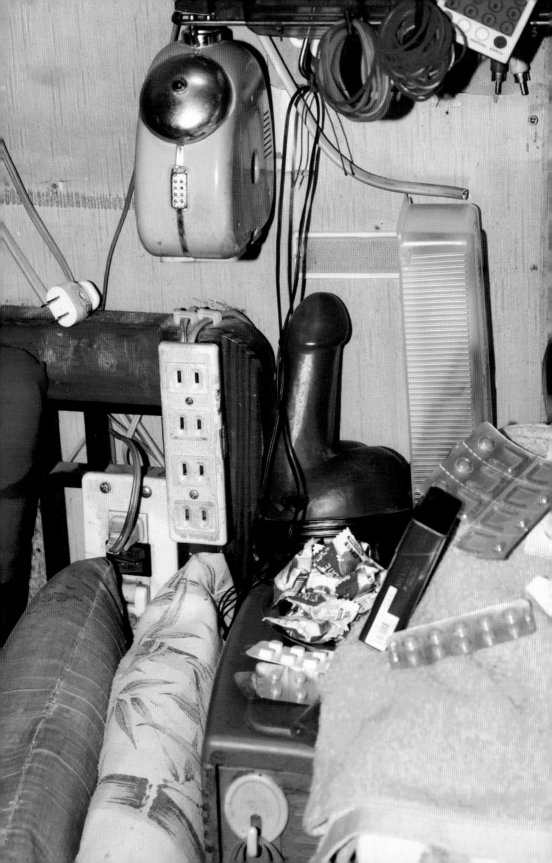

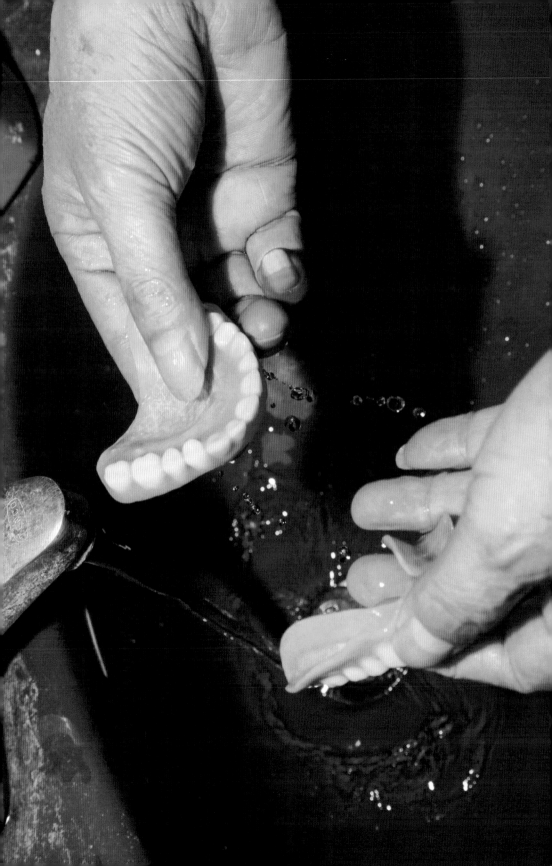

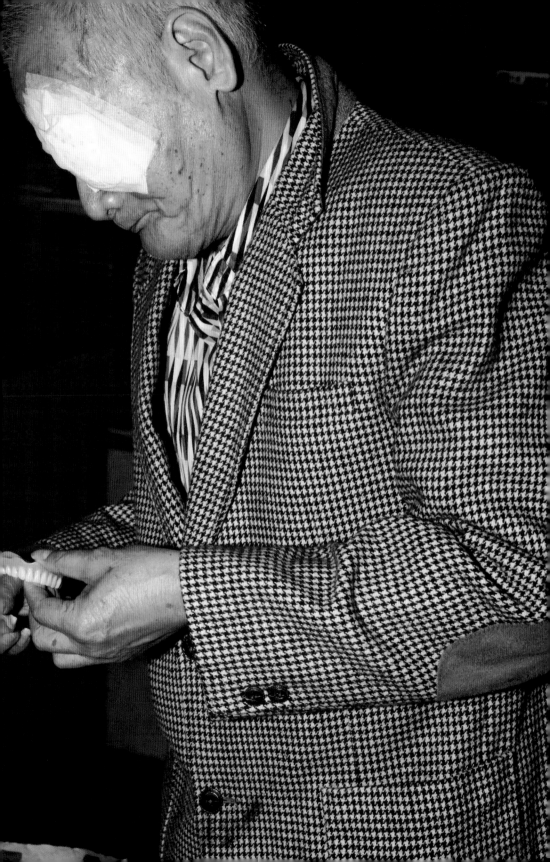

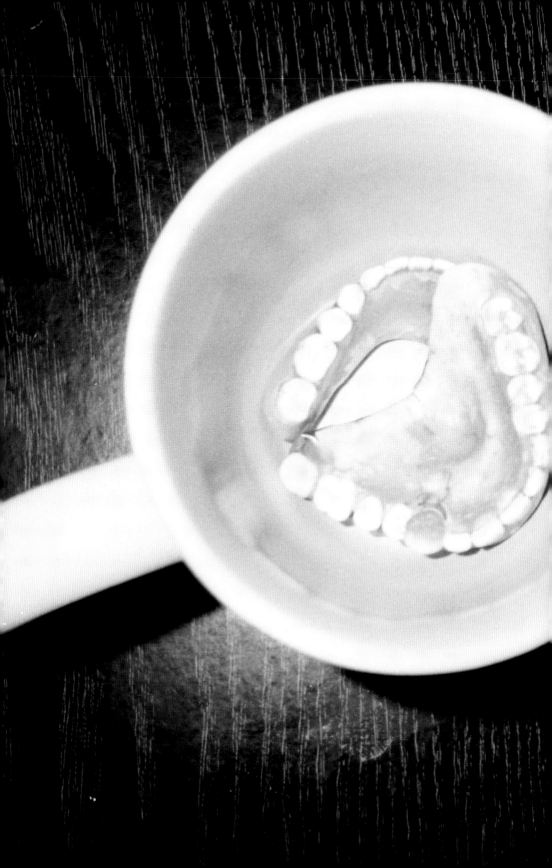

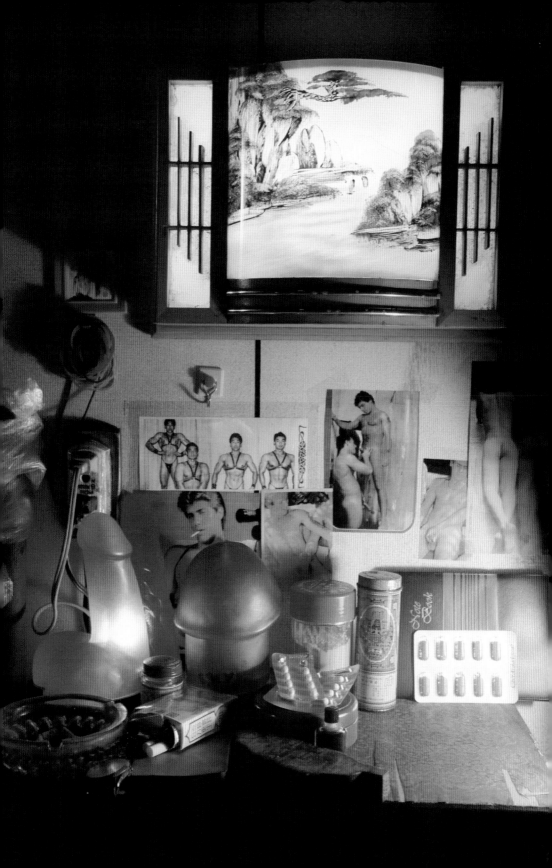

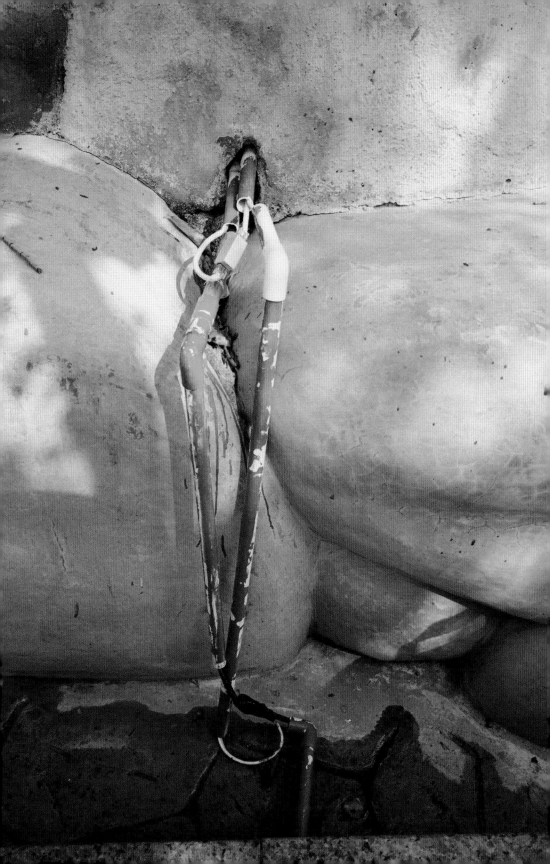

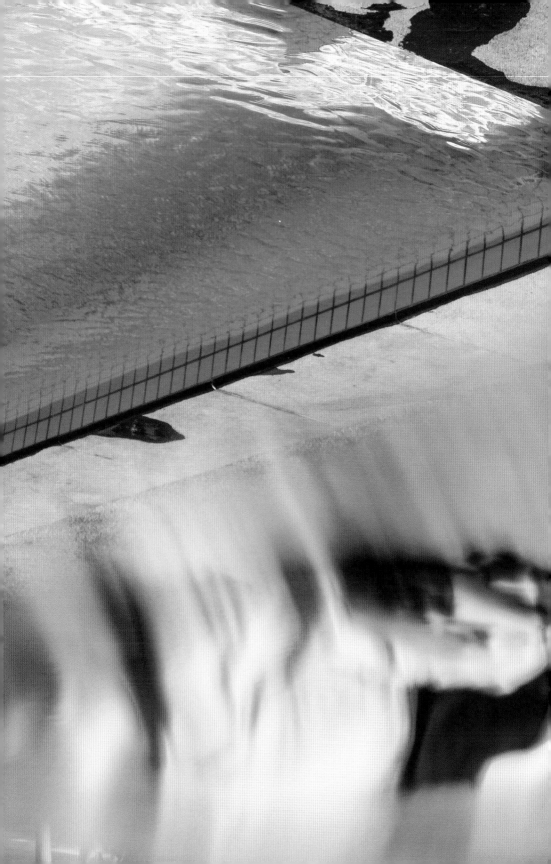

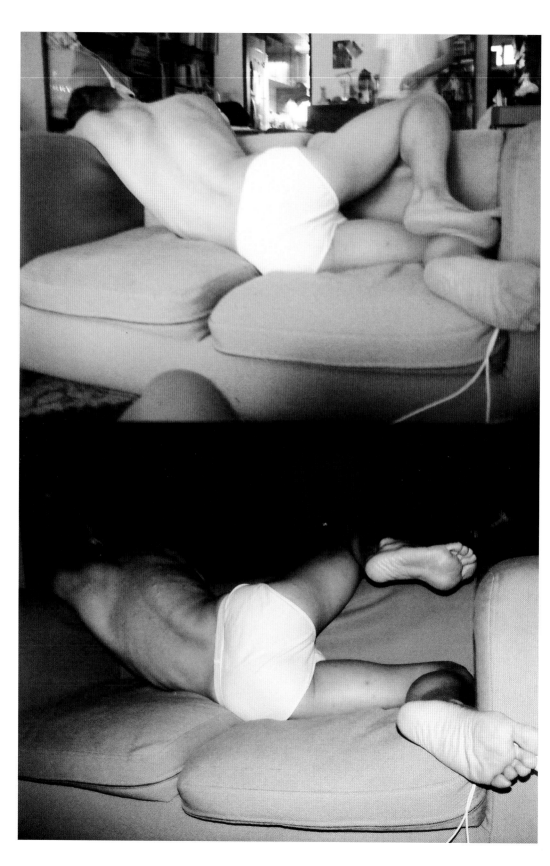

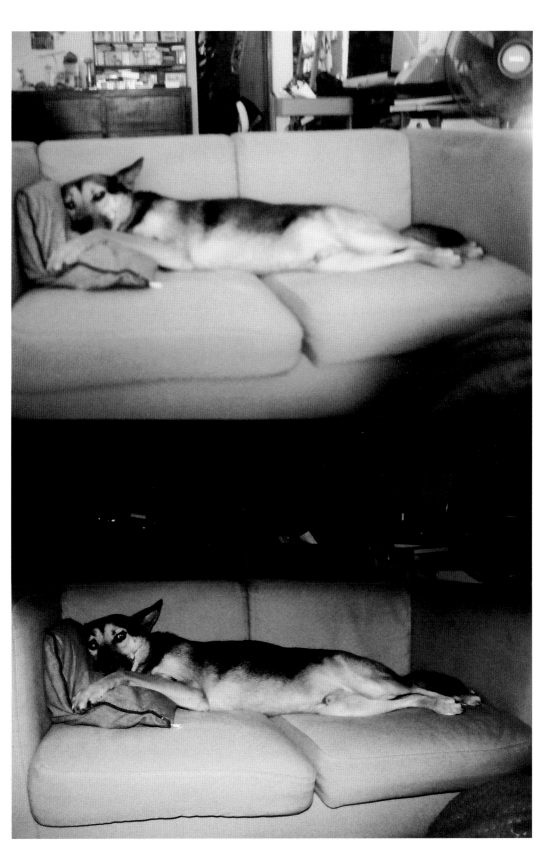

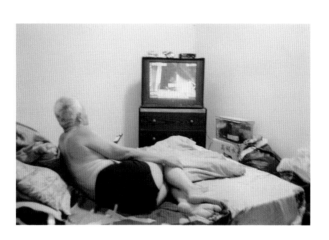

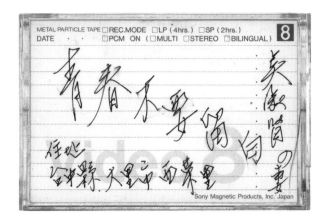

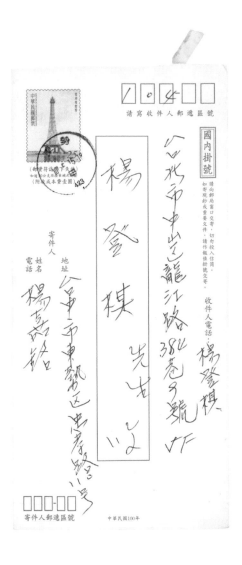

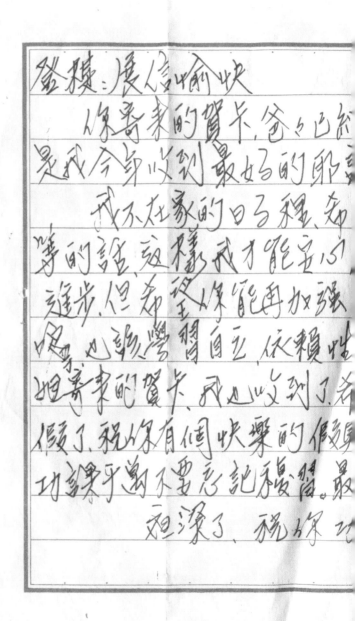

發獏:展信愉快

　　你寄來的賀卡,爸爸已經
是我今年收到最好的那張

　　我不在家的日子裡,如
等的誰,這樣我才能安心

進步,但爸爸望你能再加強
呢,也該學習自立,依賴性

姐寄來的賀卡,我也收到了,放
假了,祝你有個快樂的假期

功課要平均不要忘記複習。最

　　　祝溪了,祝你功

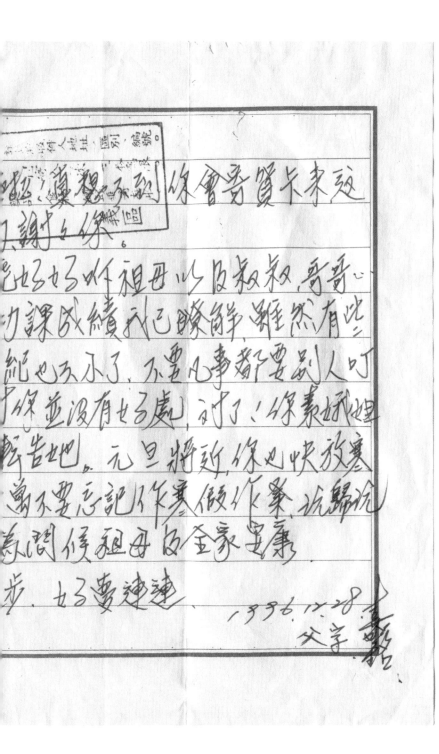

……萬想不到你會寄賀卡來．太謝謝你。

已好好叮祖母以及叔叔，哥哥，功課成績我已瞭解，雖然有些缺點也不小了，凡事都要別人叮，你並沒有好處，對了！你要娩姐報告她。元旦將近，你也快放寒，萬不要忘記作寒假作業，坑歸……義問候祖母及全家健康。

步，好要連連。

1996.12.28.
父字

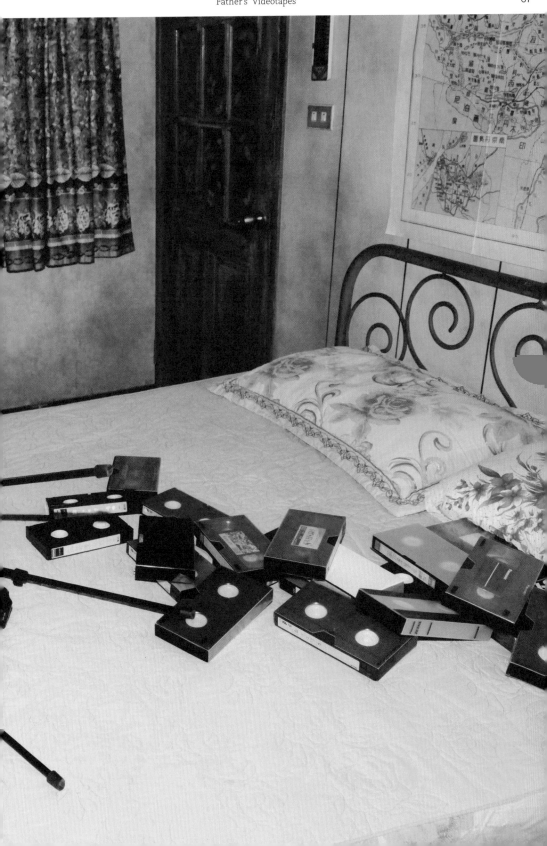

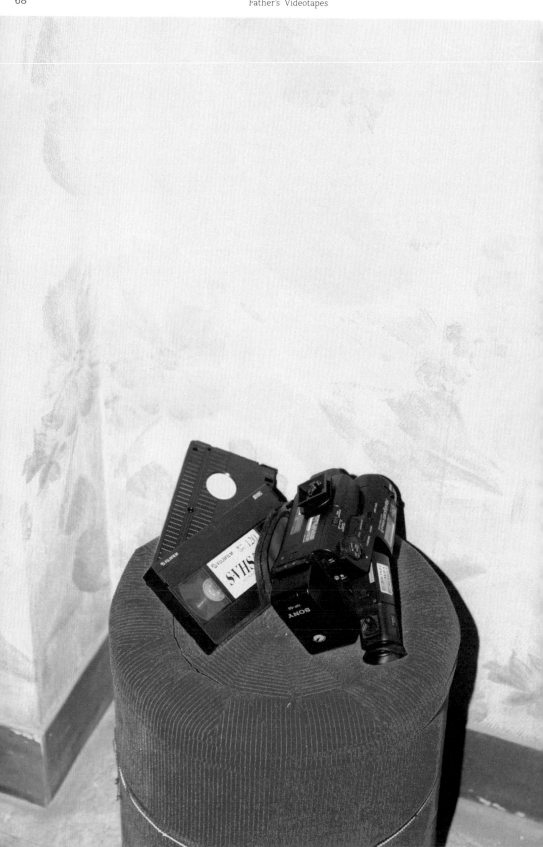

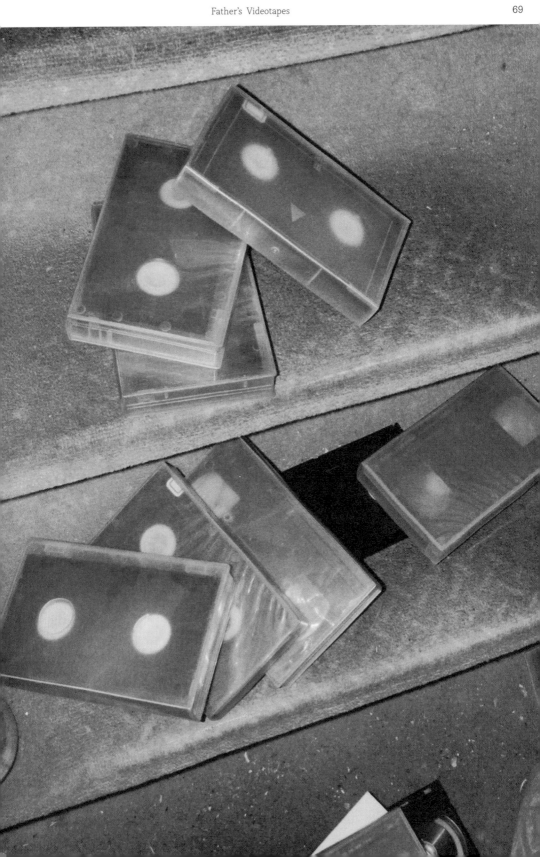

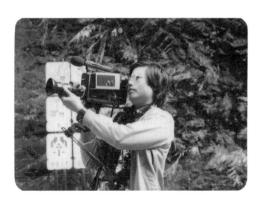

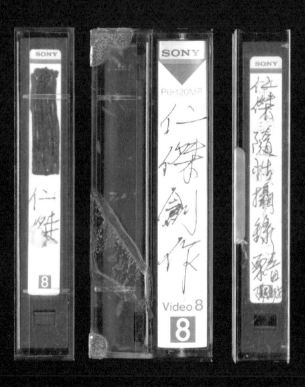

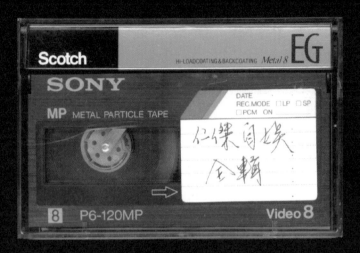

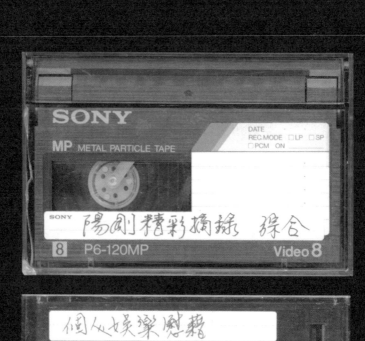

SONY

MP METAL PARTICLE TAPE

DATE
REC.MODE ☐LP ☐SP
☐PCM ON

SONY 陽剛精彩摘錄　綜合

8 P6-120MP Video 8

個人娛樂慰藉

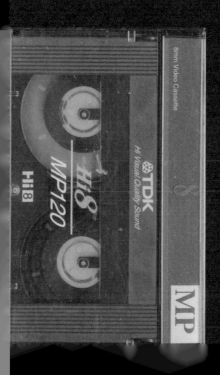

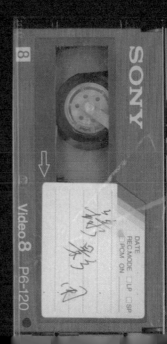

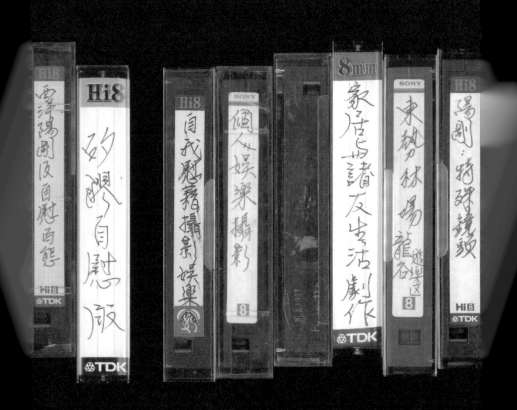

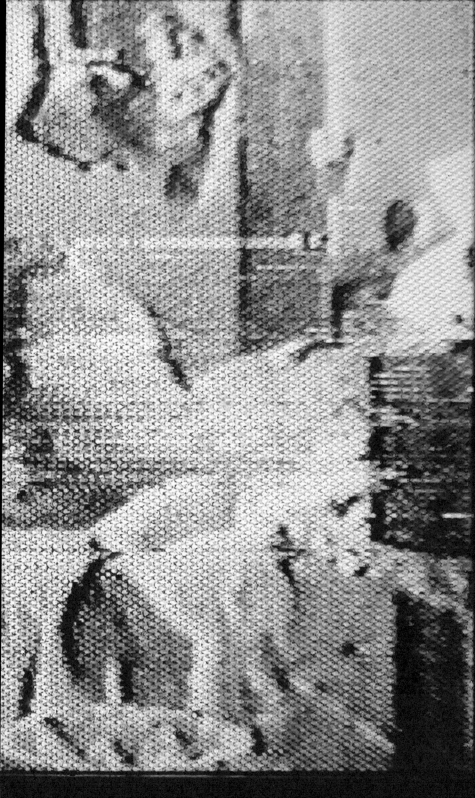

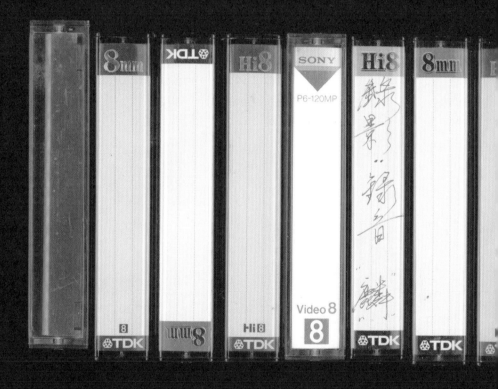

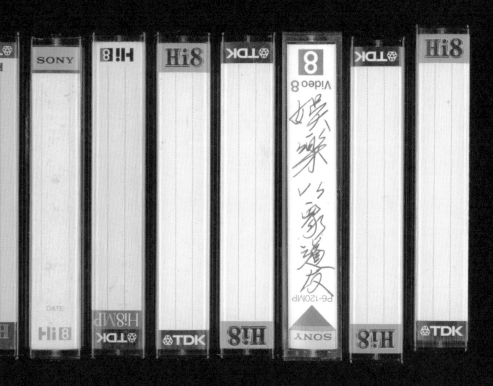

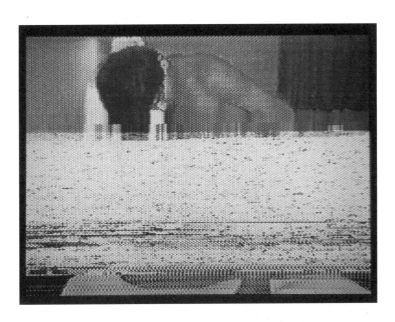

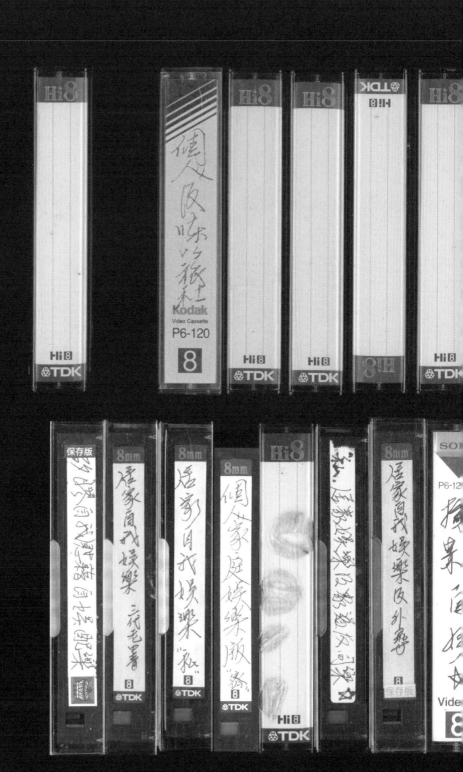

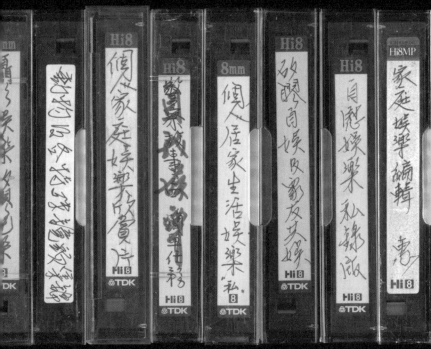

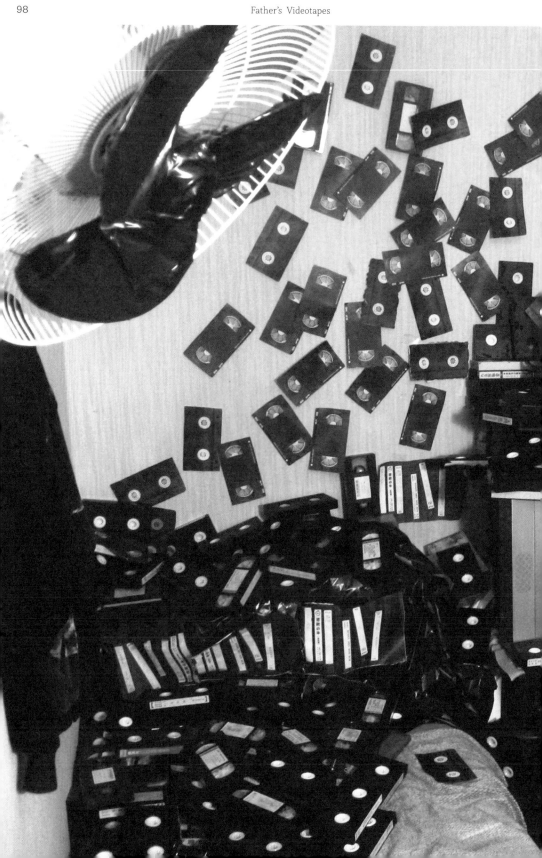

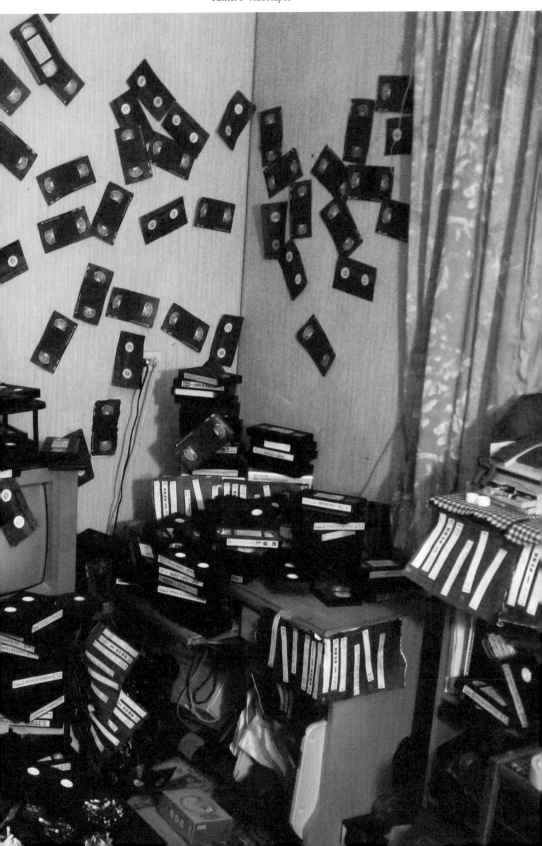

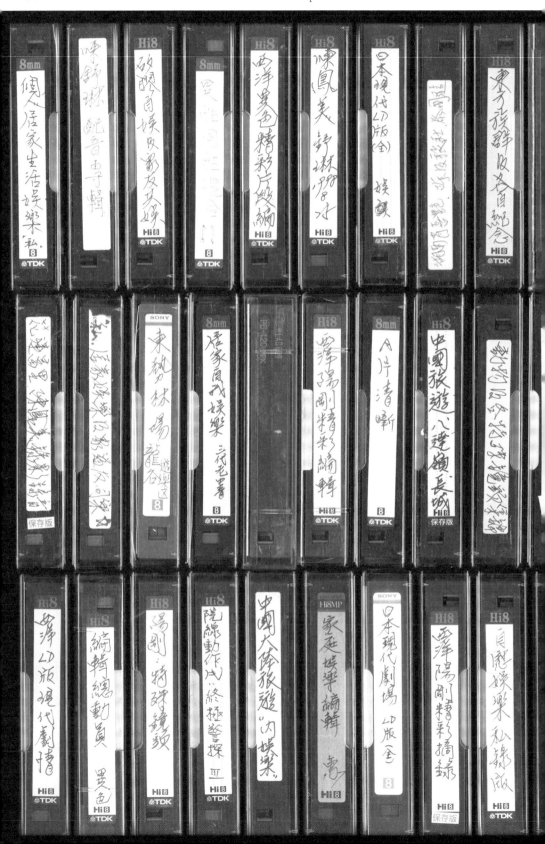

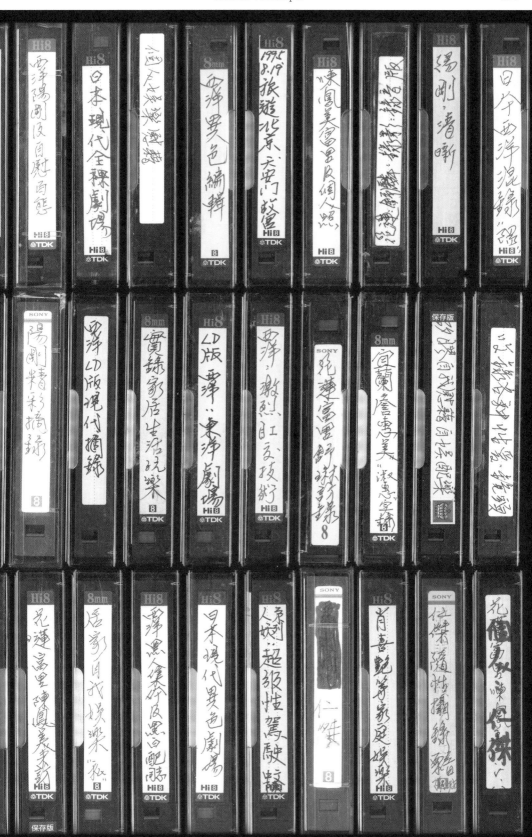

YANG, Chia-min

關於這本專輯的誕生……

從去年四月底，我們的錄影帶上市之後，就不斷的有許
友希望我們能出版攝影專輯，以便能有更多的欣賞選擇。
而之所以延遲至今才推出的原因，我想有告訴您的必要
十個月來，除去一些製作水準無法達到我們要求的小工
談，我們抱著這些資料，前後和將近十家的中大型印刷
談過，其中不是一亮東西便吃了閉門羹，便是吃定了你
殊產品」而大開其口，所幸經一位熱心朋友的極力幫忙
順利地與此次承印的公司談攏，這其中的過程，真可謂
苦辣」俱全！

還有一點，就是關於售價的問題，或許您會覺得價格似
高！但小馬只能很抱歉的告訴您，我們已經在可能血本
的邊緣上盡量調低定價了，因為同樣的製版成本，分攤
少的印製量上（只有1000本），價格偏高是可以理解的。
而我們最最的希望是，當您在欣賞過這冊專輯的同時，
覺得還差強人意的話，請別吝惜您的鼓勵，那將是我們
前走的最大原動力，相反的，若是您覺得有任何的不周
是有更好的建議，也請告訴我們，以俾能做得更加完善
嗎？

謝謝您！

2、男人圈生活雜誌

LIFE OF GAYMA — GAG MAGAZINE

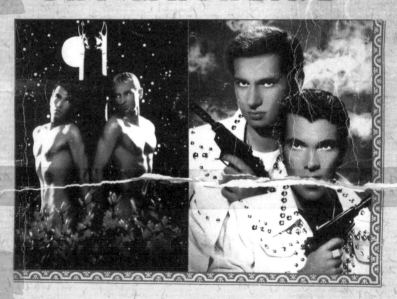

精裝本　　　　　　　　　[不經一事，不長一智]

WISDOM COMES FROM ZXPERIENCE

1. 男人圈生活雜誌

LIFE OF GAY MA-GAG MAGAZINE

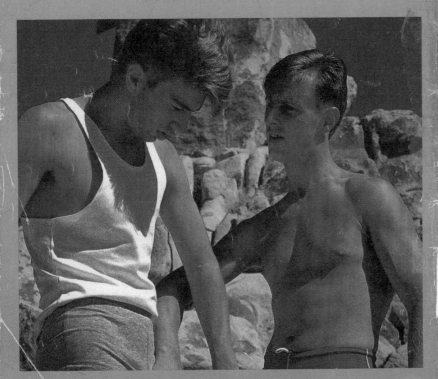

人同此心，心同此理
**EVERYBODY FEEIS THE SAME
SAME ABOUT THIS.**

高級精裝本

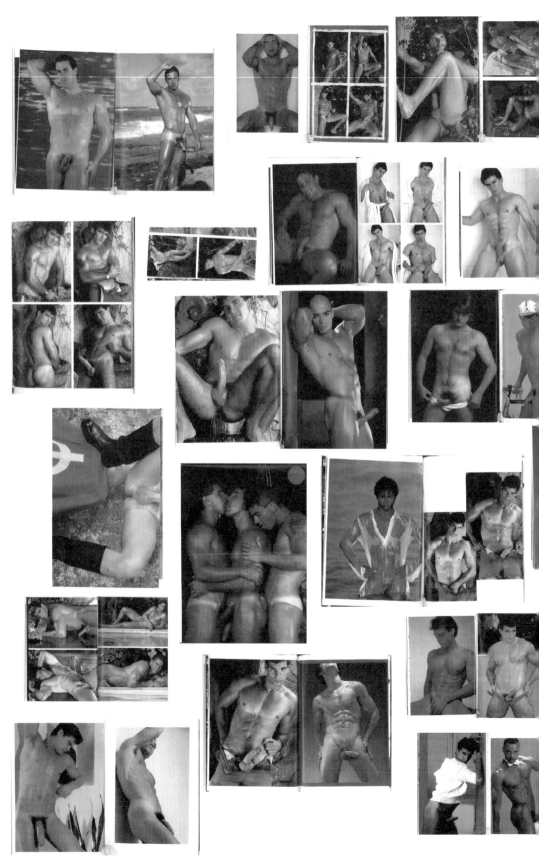

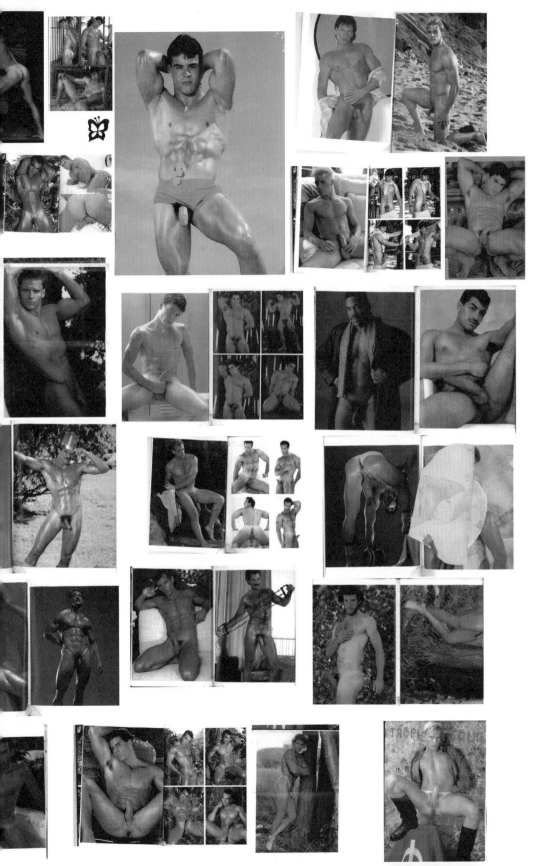

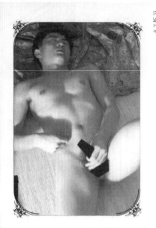

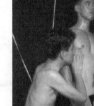

STEAM HEAT
SH

我、的"本應"自剖"
不多話。就此開始

（快樂三人行）
我的園生活
撰稿者：天宁

三溫暖求愛記

盛夏奇遇——
我的第一次（一）

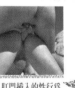

肛門插入的性行為
「以愛為中心的插入」

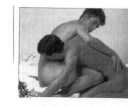

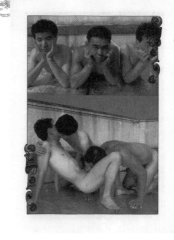

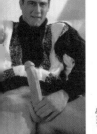

◎媽的故事

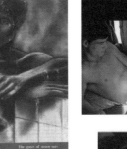

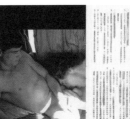

The gusts of steam surrounded me. In a thick, milky cloud. The hot boards of the steam room warmed my ass, and I squinted to see beyond the impenetrable cloud. It was no use. Dark figures came in and out of the doorway, each new entrance hollowing the steam around my sturdy perch. I relaxed and leaned back.

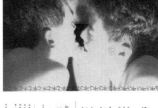

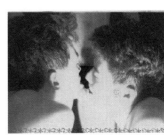

殘夢餘是很空！

一、流精歲月

文・小類三郎

流精歲月系列
海水浴場篇

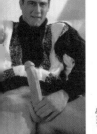

18歲的思索

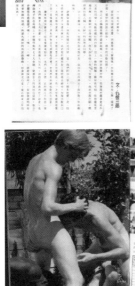

LEO & JAMIE

台北男妓花樣多

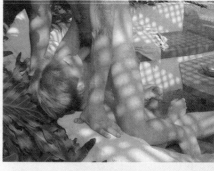

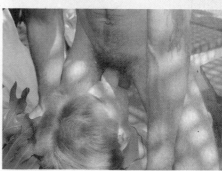

投稿者：小高

三月初由於業務關係，出差台北數日，約了方便辦事我住進西門開區內的一家旅館，由於該家旅館房間播音甚差，往往在午夜傳來陣陣的戀愛呼求。

一眼望去，走進房內的他，確是一塊好材料，不胖不瘦不高不低，皮膚細白，客氣英俊儀美習慣了，我迫不及待的愛他去掉衣掛，他那有如老手般的，在找身體一算，一件件的除去我身上衣物，一陣陣的愛撫，終於愛上了快液激射出來，快感是無比的舒服，真是要了我的命。

繼之下卻發現，原來是對我的愛撫，坐立時的激了起來，但此時的我有如熱鍋上的螞蟻，既典奮又好嗎了。他見高潮已到，立即轉身，那個身邊需要撫，他見高潮已到，立即轉身，我頭了一跳，搜起話筒，建抄說後，再出抄愁，怱然響起，我嚇了一跳，而我卻不由自主的問說，可有男妓來隔房傳來兩男做愛聲。男服務生間找是否想召召女幼晚夜，可有男妓，而我卻不由自主的問說。

一小時的鏖戰後，兩人都疲憊萬分了。結束出差返回台中，興奮之餘，總在午夜幻想又與他做愛了，想念著時再認我出差呢？雖是短暫的相識，卻縈給我日後暇思，浮幻影裡，可謂是難於言語能及。

一會兒一陣男服務生界了，我因工作關係經常出差台北，慣住中部，首要道宿是F⋯。我想既然已表白答道您是F⋯。乾脆說法，果真不負所望的召來同之友。

影舞戀的台北夜

歧視 也許 並不 得適

◎何謂愛滋病

關於此種病痛的可怕，從種種的報導中已瞭解了，相信您從世界各國的急診病中尋找愛滋病的資料，以往努力的研開愛治療愛滋病的對策，而發現了不少愛滋病患者，因此，每國國民均有研讀瞭解愛滋病的必要。

愛滋病的AIDS，是Acquired Immune Deficiency Syndrome 的略稱，中譯為「後天免疫力缺乏症候群」。又稱為「後天性全身免疫力缺乏症候群」，即身免疫機能不全的疾病。簡單的說，即是身體機能抵抗力失去，而死亡的疾病。

一旦進入血液中的病毒，病毒管身體若有細菌之外的侵入，守住身之抵抗力的淋巴球，淋巴球會制之痳痺之，攻滅之。此種病毒侵入時，淋巴球，破壞身之重要的白血球之時，毒會侵蝕，破壞這重要的白血球，身體之抵抗力喪失。病人若如最後終於因身之健康人身之球，已無法抵抗通常的健康人。

◎透過血液體液感染

愛滋病起於病毒的感染，在完全無預備的狀態，一有外敵侵入時，立即就衝擊出了。因此，收刺傷染病者的針器，亦容死亡。愛滋病的病毒，以往說治癒上極其困難。治分之一，大死亡，其最後約三分之一，大死亡，其確是目前最可怕的疾病。

在一九六五年發現了第一位愛滋病患者；一九七一年第一例美國。一九八一年美國的同性戀者，為愛滋病的第一位，一九八五年發現了第二位愛滋病者。一九七〇年代末期，在非洲發現的同性戀者，以同性戀者，在日本，朝一位美國的同性戀者，為愛滋病。

◎愛滋病的檢查法與預防法

愛滋病的性行為以外的，注射針筒的針頭入口侵入射器，用過的針器，亦為危險性，由於激烈的性行為，而易使肛門成為愛滋病的感染途徑。進行激烈尤其是同性戀者的愛滋病，因此肛門或口部，尤其是以血友病的患者易，而輸血血漿製劑易進入血液或體液中。愛滋病，可能性很高。同性戀者易滋病，同性戀者易感染此病，因此一則對於血液，注射用之血漿製劑的小道具，亦有而注射。

例如：從此侵入的危險性。另外，亦有因輸血而易其受感染。射器，有可能成為愛滋病的性行為，普通性接觸，而在此侵入。當然，血液、體液接觸到的入口侵入。當然，液、體液若通過皮膚粘膜的傷口，附著了愛滋病的性行為，因陰莖口、或肛門口，即小心地對付。例如：小傷口，或黏膜等的激烈行為。

◎發燒、淋巴腫大、下痢現象不斷

據說一旦感染了愛滋病毒，潛伏期間從數個月到八年之久。潛伏期間，即使帶有愛滋病病毒，亦無症狀可見。此外，一帶病原者，最容易的事是傳染給他人。是以一旦帶有愛滋病毒，此即是較低的，此外，一帶病原者，最容易的病毒傳染給他人。是以此一帶病原者最容易的傳染給他人性行為的感染率增加。目前，隨著潛伏期的感染者的增加，目前，隨著普通的感染者，今後應可預見升高的可能性亦將升高。

◎愛滋病的症狀與診斷

建議輕者，此一階段的症狀，通常被稱為愛滋病關連症候群。上述症狀消失時，即第二階段，普通進入育骨的抵抗力逐漸衰失時，到了病進青骨的，抵抗力逆失。此階段，被細菌、細菌，不易致命的疾病來致命性食道炎、肺炎、守住陰部細菌等的臨床病例上，亦會發現因陰部病例上，亦會發現因陰部守住細菌等的臨床病狀而引起精神異常的症狀。一發病的案例中，愛滋病，一發病者的一生三成，三年內約有八成的患者。

假設一發病，三年內約八成的患者，因而死亡。以前的衛生所各都市政府的有關單位詢問，就必須接受愛滋病的檢查。以前，事實上，被確認愛滋病患者的有關單位可實際檢查的可靠一家醫院接受檢查，其可信度極高。目前，日本實施的檢查法，乃稱為「粒子凝集法」的血液抗體檢查，其可信度極高。是否受到了感

染，可在確認是有感染之虞的二至三個月內檢查出來。因為在感染後三個月或六至八週後可出現陽性反應。因此，三個月後的檢查，若出現陰性反應的結果，即可安心了？

只要生活正常，有何預防方法呢？只要生活正常，不容易感染愛滋病的臨床病例。主要的為手、足、口部的接觸，握手、吊帶、浴室、游泳池、噴嚏、食物、飲料等的感染，即小心地對付愛滋病的感染之虞的三至因此，最重要的為，必須對最易感染的性行為加以注意。首先，僅對有感染之虞的對象，

而有效的預防方法是使用保險套。因為愛滋病的感染源是皮膚、黏膜的傷口，附上精液等的愛滋病毒。侵入體內造成感染，以保險套將皮膚與性器的接觸，加以保護，為愛滋病的預防方法的一種。現今美國報導，已研究成功專門預防AIDS有效的殺滑劑，實為創制類防AIDS有效的一大福音。

玻璃圈立足於社會

文：化文

現今時下男子，不少於青少年期間，為了追求女友卻屢屢遭挫，而後信心大失，當發現同為男性的朋友易於相交時，即轉變追求方向，投入所謂的男同性戀行列中。

實例：暗戀及表白過程

有兩個男子，一位是文質彬彬的大學生，一位是粗壯的外務員，兩人由於租屋的關係，相處了近三年之久，起初就讀某大學的小倫（假名），並不知道自己有同性戀的傾向，當有一天在無意間看見，同樓的阿雄（假名），正在浴室內進行自慰，然小倫心中，不知何故的燃起一股激盪烈火，此時小倫不時的回想著阿雄健壯的胴體，有時更利用種種機會去接近阿雄，而忠厚的他卻不知我的故意碰撞，是為了尋求刺激，但由於長久的暗戀，壓抑之情無法解脫，使我動起對阿雄表白的念頭，首先計劃分段進行，覺得良機即予求愛，我觀察阿雄的自慰時間，大約三天一次，結構等。

如一個小男孩因家庭中，所以更決定利用此時示愛，果然機會來了，我故意借機要求共用浴室，一眼望去阿雄的七寸金剛挺立，我便提議相互口交會很興奮，阿雄木呆了一會兒，終於點頭答應了，這一次的相交，構成了日後更加親密關係。

懇請社會公衆平等視之

根據心理衛生專家指出，男同性戀者一般在少年階段即已形成，其因素包括甚廣，有家庭影響、職業環境、交友對象、性機能及器官

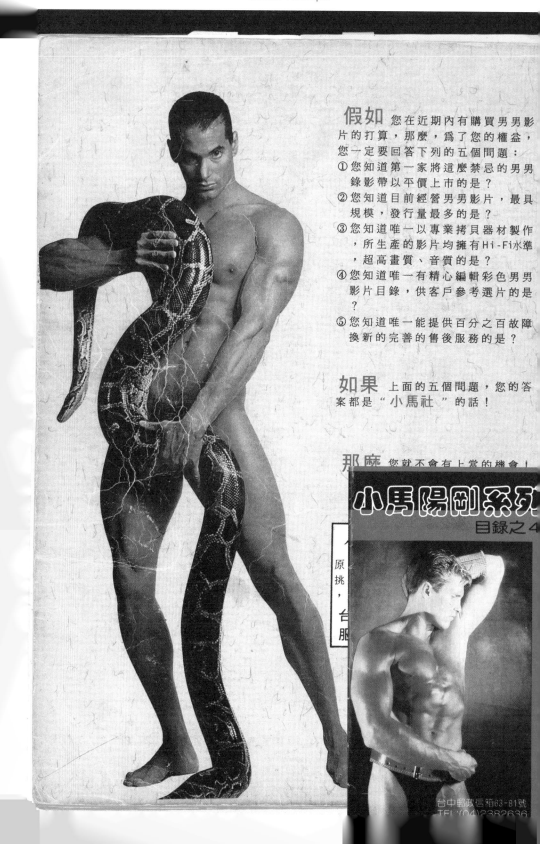

♥ 6月份　生活雜誌 ⇒ 徵友資料 ♡

☎ : (04)3335851

♡1 姓名：柯育帆。年齡：27 身高：166cm　54Kg　NO.皆可 地址：本刊代轉（台北區）	♡11 姓名：李民 TEL:(055)870756 [晚上10點後洽]
♡2 姓名：趙慕文。年齡：48 身高：168cm　65Kg　別號：I 職業：商　TEL:(02)939-4827	♡12
♡3 姓名：陳志明。年齡：20 身高：170cm 60Kg 別號:皆可 地址：本刊代轉	♡13
♡4 姓名：林世煌　年齡：28不登 學歷：商專 職業：工 性趣：交友、音樂 地址：TEL:(07)3463528	♡14
♡5 姓名：林家年　年齡：30 學歷：專科、中等身裁、 　　　正當職業、性木納 來信：台南郵政1049號BOX	♡15
♡6 姓名：小高。年齡：30 身高：170cm　59Kg　別號:I 　　學歷：大學 台北郵政112-766號 BOX: 自認條件佳者	♡16
♡7 姓名：ANDY　年齡：27 身高：175cm59Kg 別號:I 學:大學 台北郵政112-766號 BOX・（自認條件佳者）	♡17
♡8 姓名：陳啓眞・年齡：30 身高：180cm79Kg.商專畢來者不拘 call(060)435039.（中部地區）	♡18
♡9 姓名：陳鎮國：年齡：22・大學生 177cm 68Kg No.I 喜戶外活動 地址：台中縣龍井鄉中港路東園巷 　　　一弄53號	♡19
♡10	♡20

hallic Phantasies, Part 1 Phallic Phantasies, Part 1 Phallic Phantasies, Part 1 Phallic P

愛友之門一徵友

姓名・林○文

純金打造・24K的陽剛之美

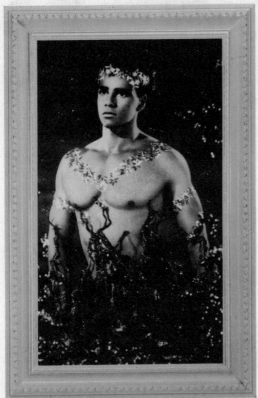

THE ART OF THE MALE NUDE II

小馬發行刊物系列之(二) $1200

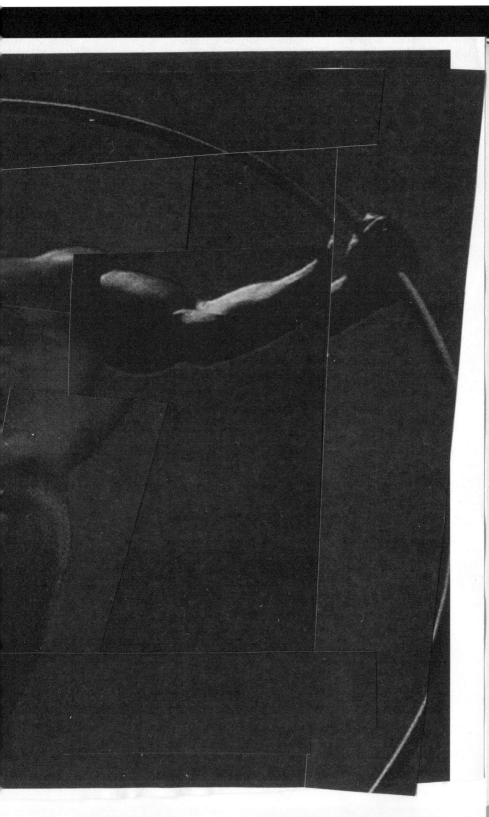

潤滑

插入股心

黑狗

狠

我很GAY的性生活

久旱不雨，竟然在毫無預警下

壓在床邊，一陣狂吻及愛撫下

以他優勢的身才，把我雙

的龜頭，瞬間已插入股心，快

一送一抽一來——一往，把我搞得

香、……快感，使……送一……龜頭……

吐出後即張開兩腿

肛門附近有很多的括約肌，經插入時會感到異常疼痛，可以很強的性感地帶，本來是為了要男性對於肛門的性行為很喜歡

一抽一來一往，把我搞得噯直哼，

採用背後位法時，對方的臀部會往上翹起，所以莖插入前後，可以用舌頭和指甲撫摸。而如果對方被大量流出時，可以用指和和刺激，這樣

莖插入前後，可以用舌頭和指甲撫摸。而如果對方的臀部會往上翹起，所以用手指甲撫摸，這樣會使太危險了。所以在使用手指時，這樣很強的性感地帶男性雙方都一樣。只要輕敏一觸摸，就會有很敏銳的反應是很有效果。只要輕敏

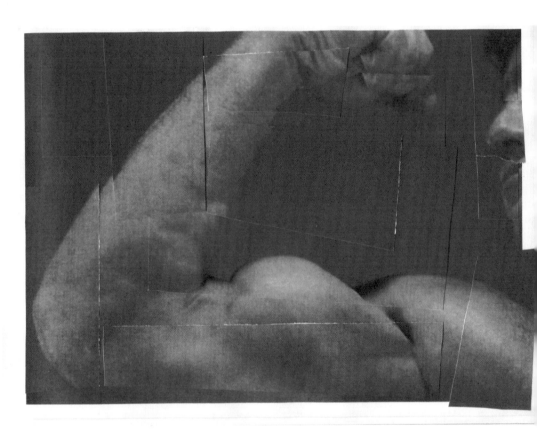

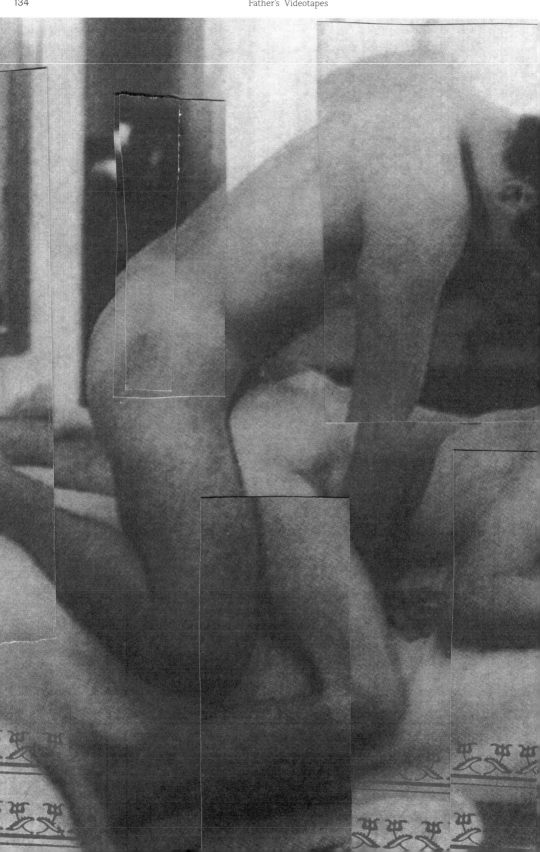

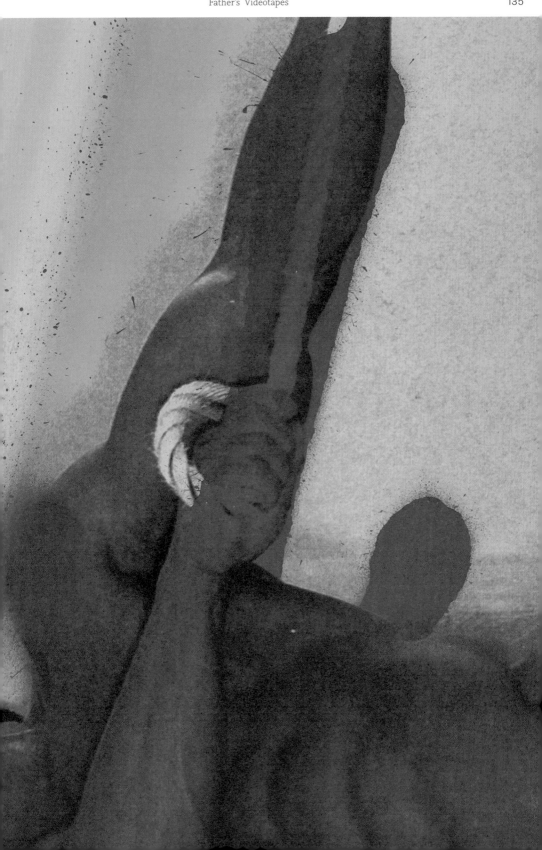

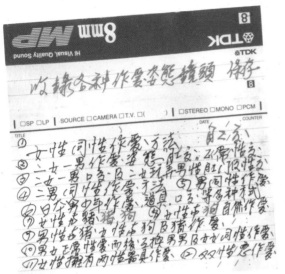

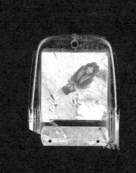

問
如果去
的夢，那
到 最遠的
想起 只因
痛，不再追尋
是我一生中

"無結果

爸，你知道現在同性婚姻合法只

我不知道啦！ 同性婚姻以

合法、 本來就不合法啊！

現在合法了、 不是啦！本來合

那怎麼辦、 我說現在合法

現在合法了？ 現在合法了？

大家都有個人各人的生活

那沒辦法啦. 現在合法以

現在!? 啊！沒辦法合法

已經合法了啦. ! 沒辦

已經合法了啦. 同性婚姻

你不知道嗎？

你都不知道嗎？

我不知道，什麼事情我都
不知道 你想知道嗎..?

那你想知道嗎..?
我想知道啊！

我幫你換一台收音機好不好.
好啊！這樣你就比較知道
不知道這樣很軌話啦！
會活好些！
知道！
一個月的事
一個月過了
是嗎！

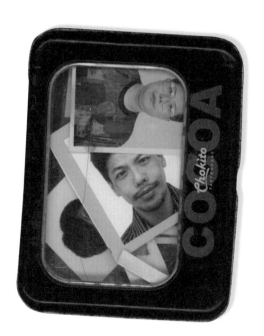

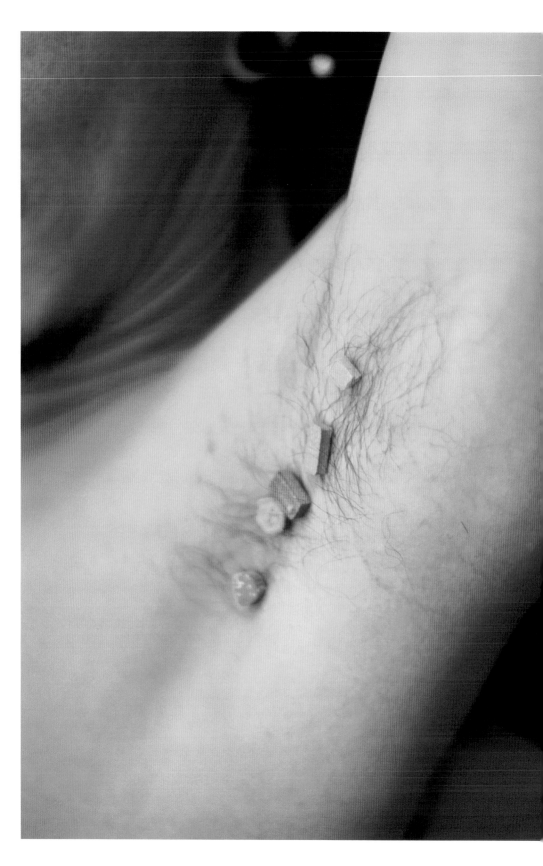

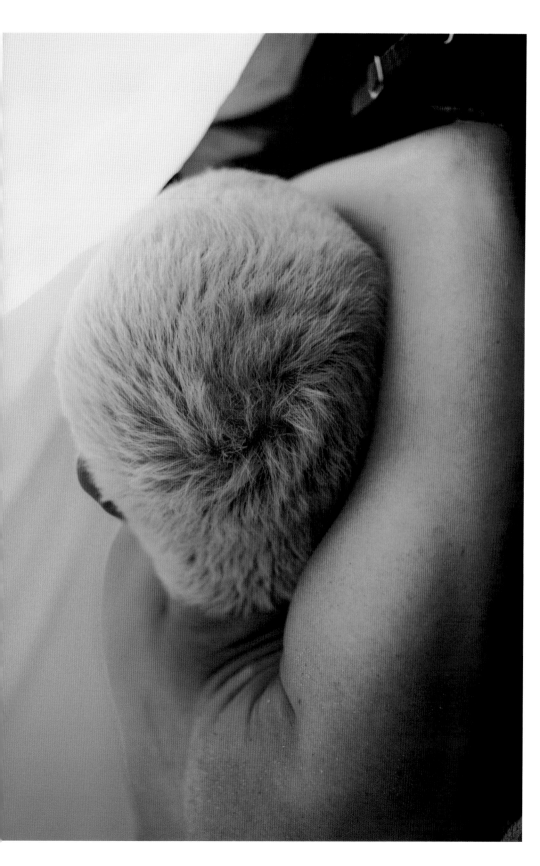

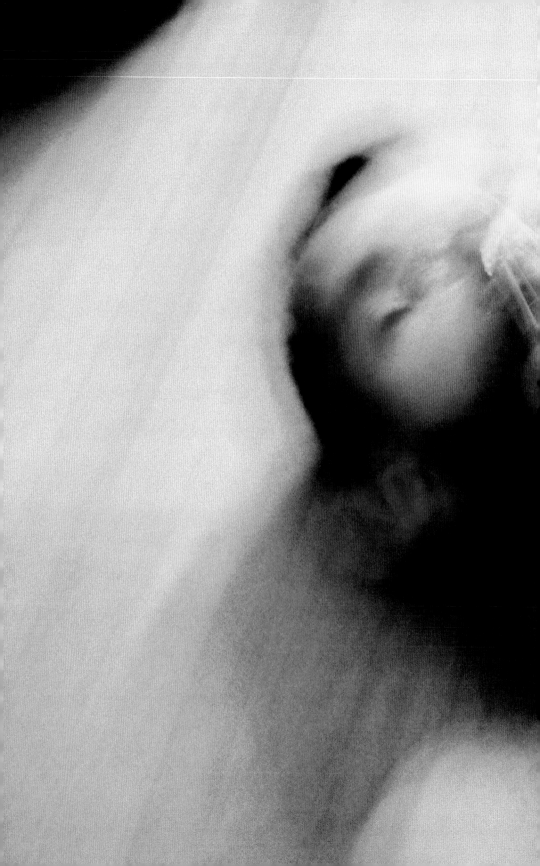

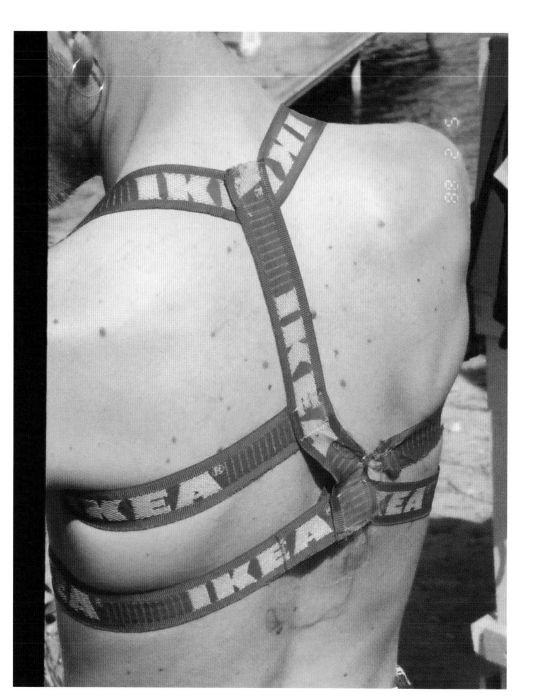

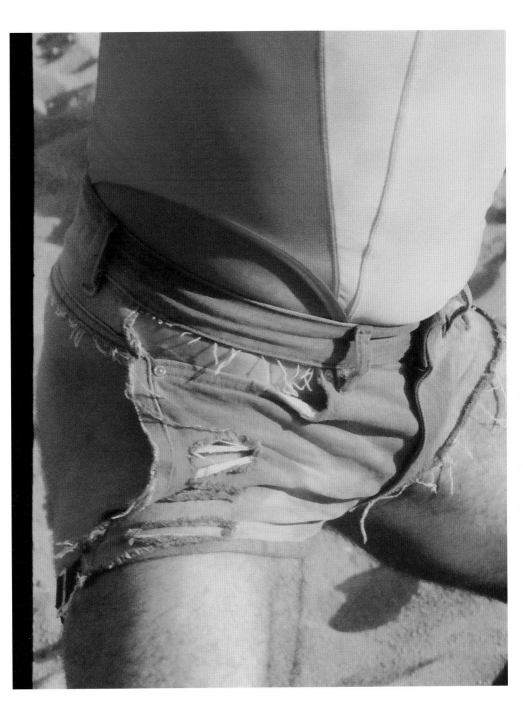

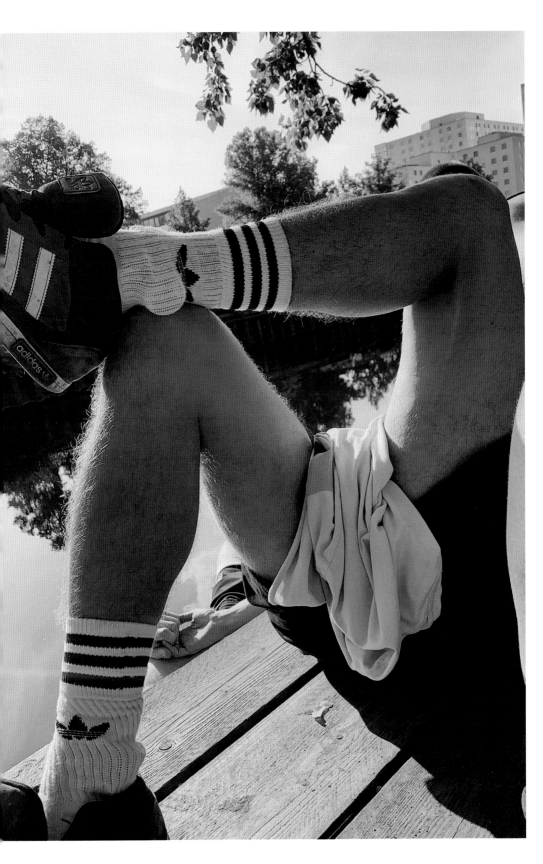

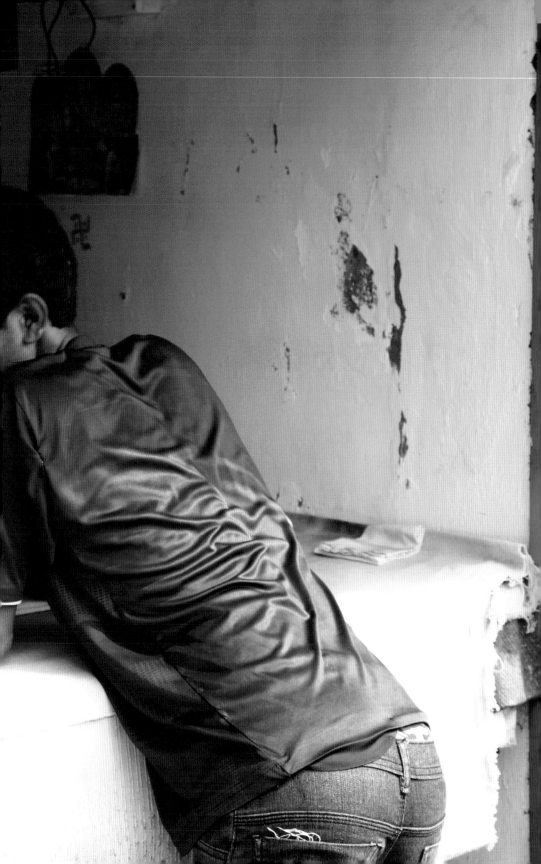

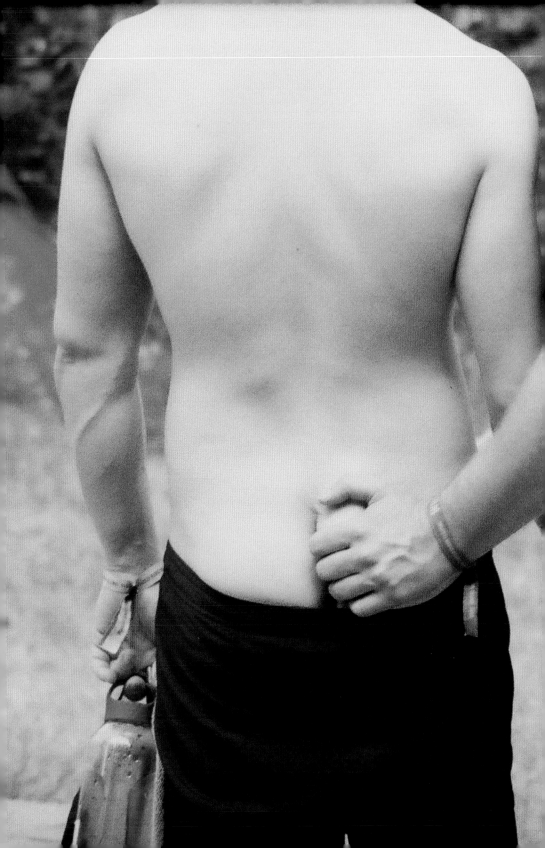

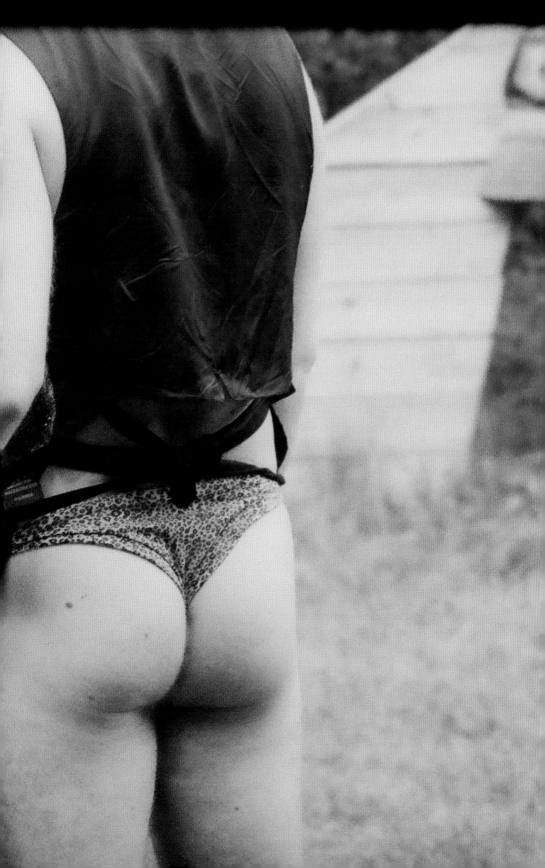

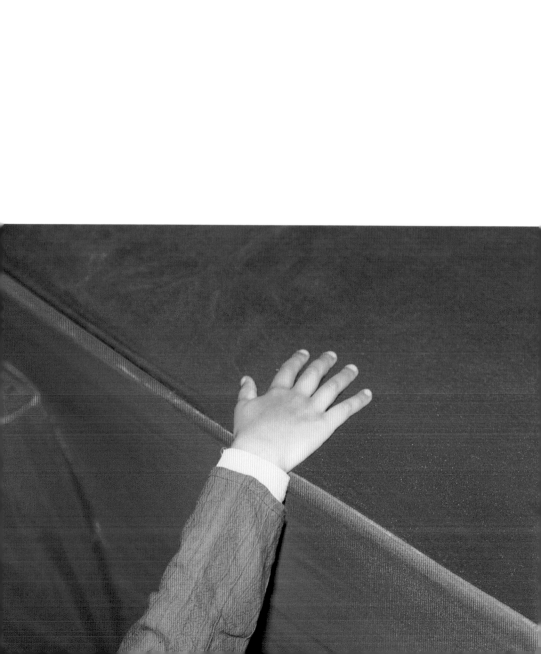

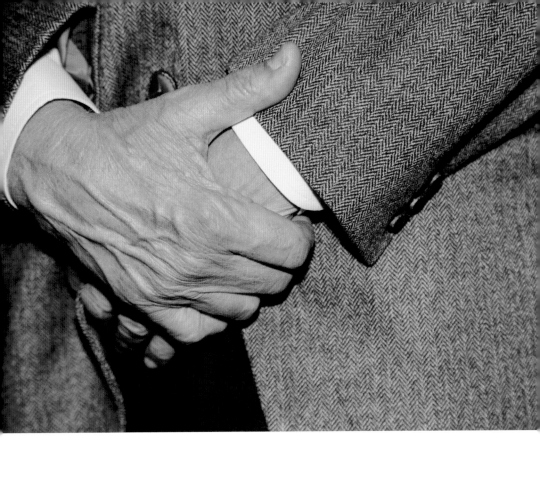

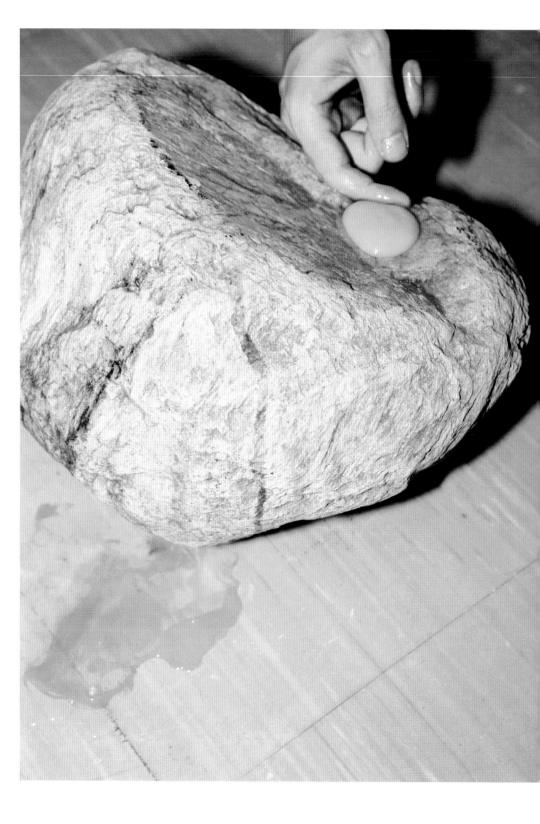

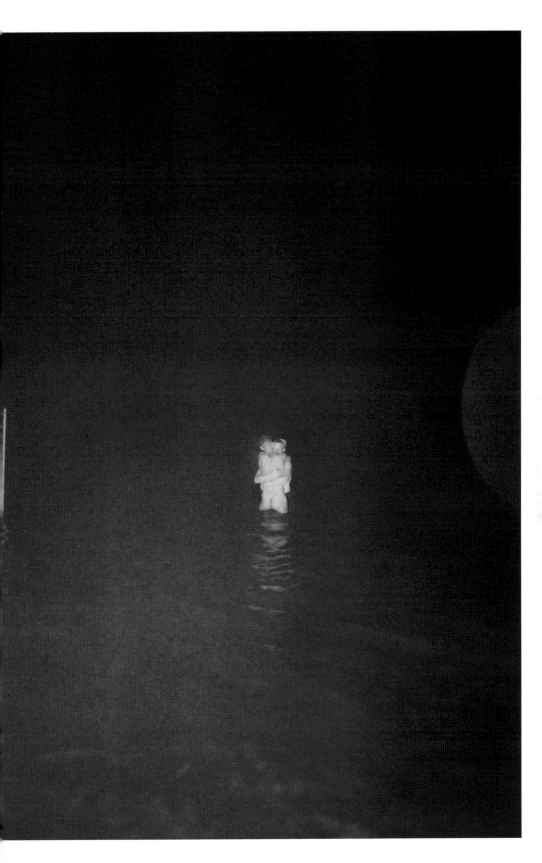

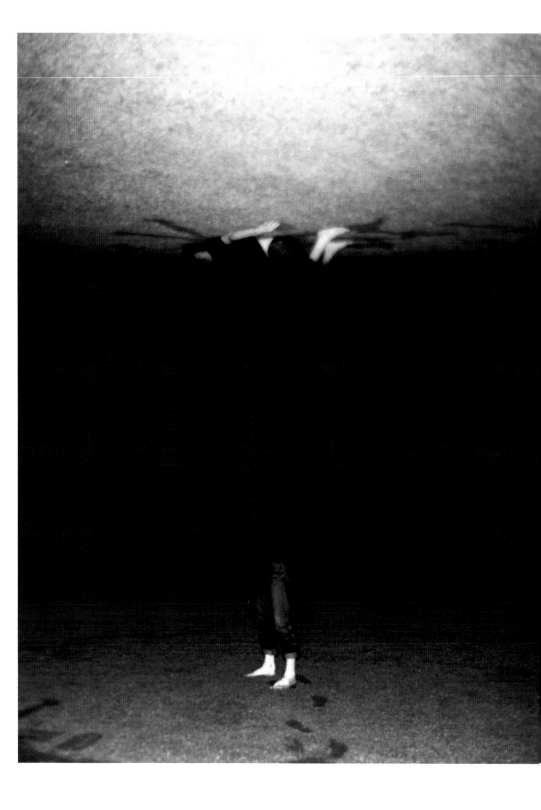

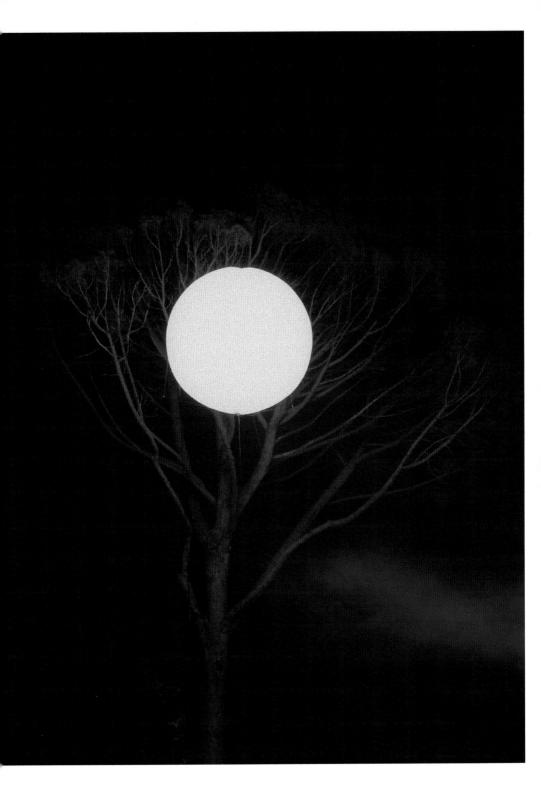

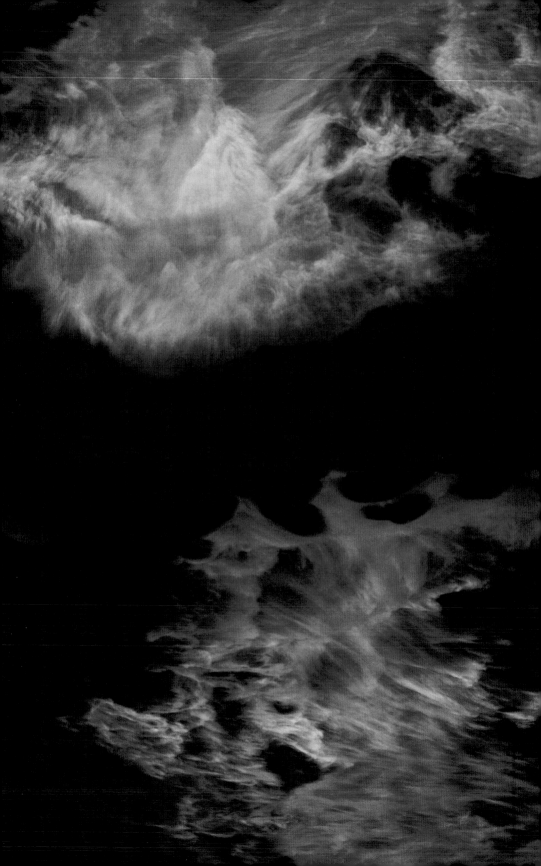

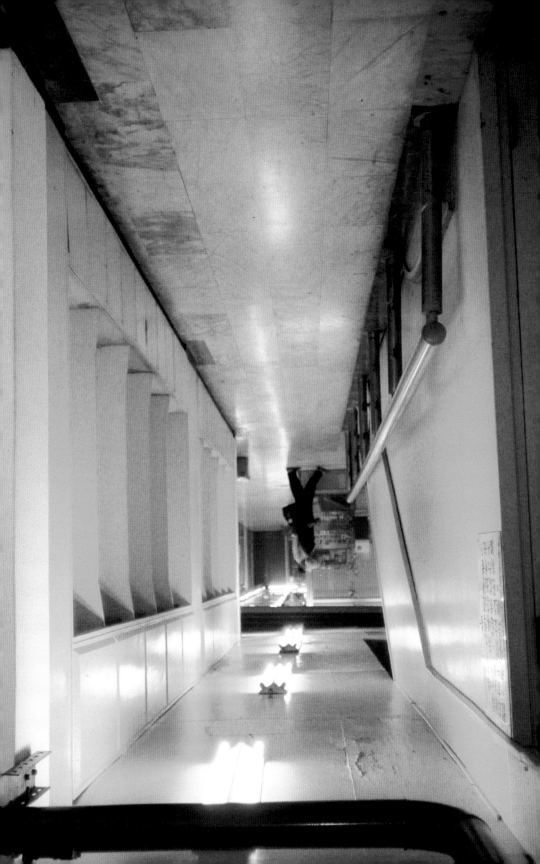

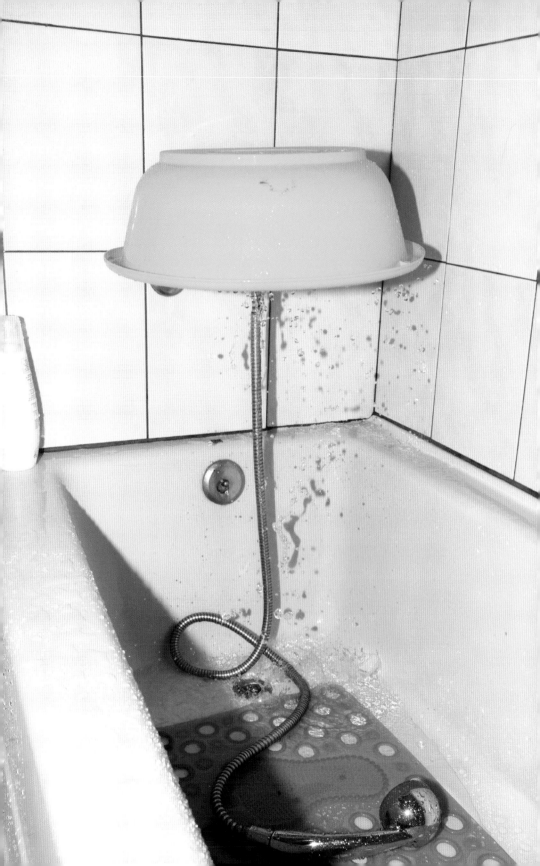

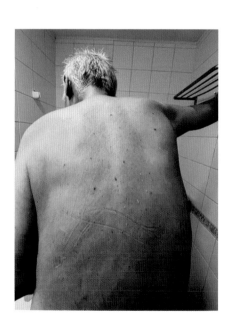

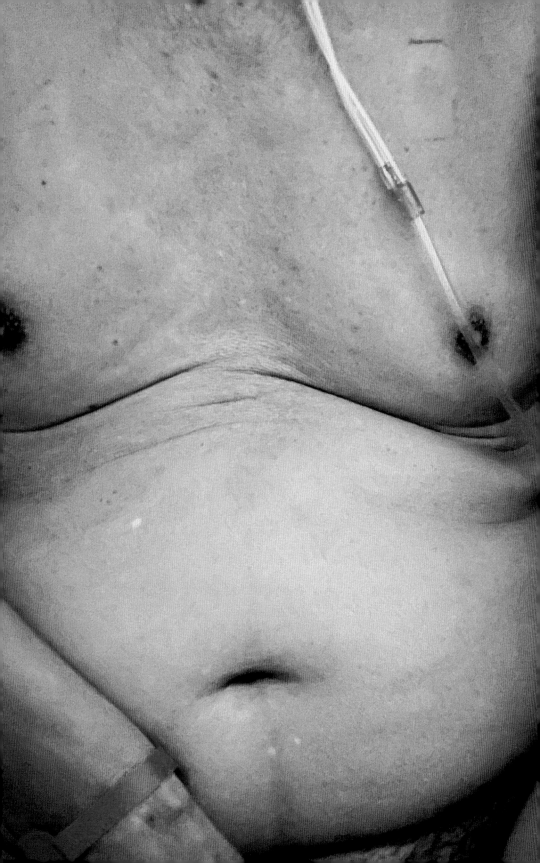

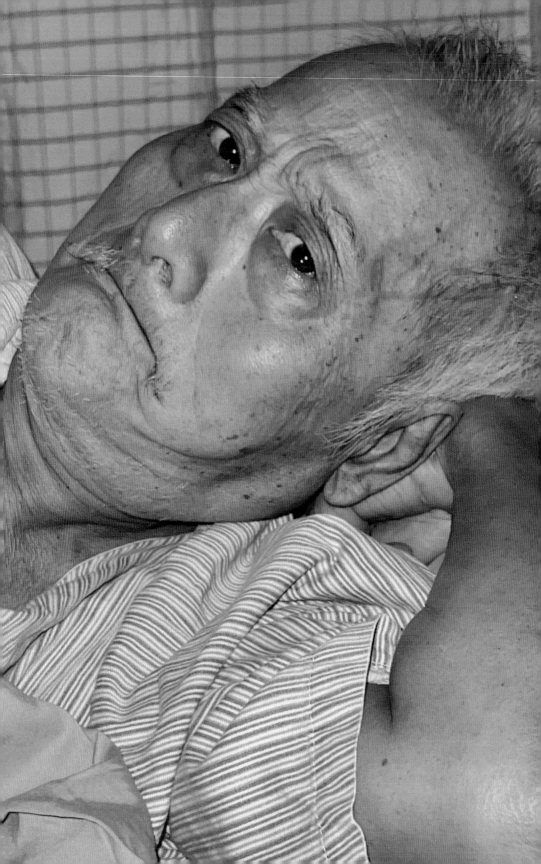

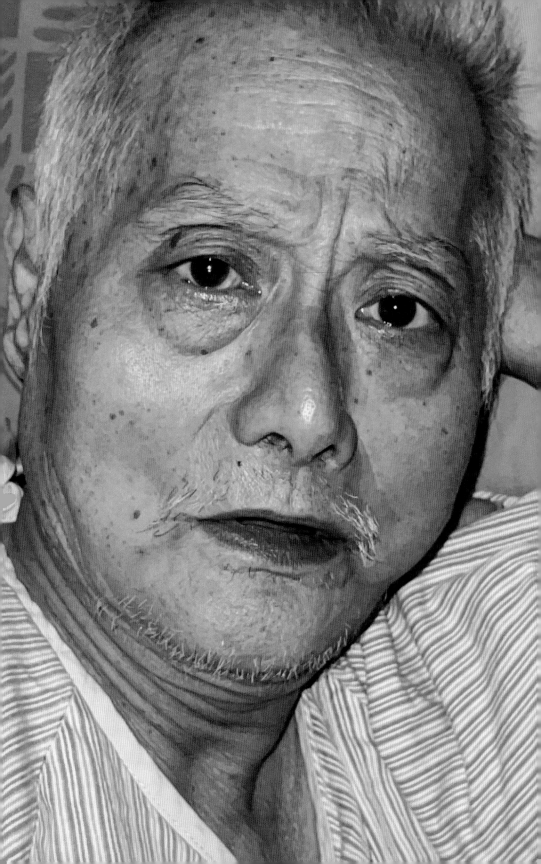

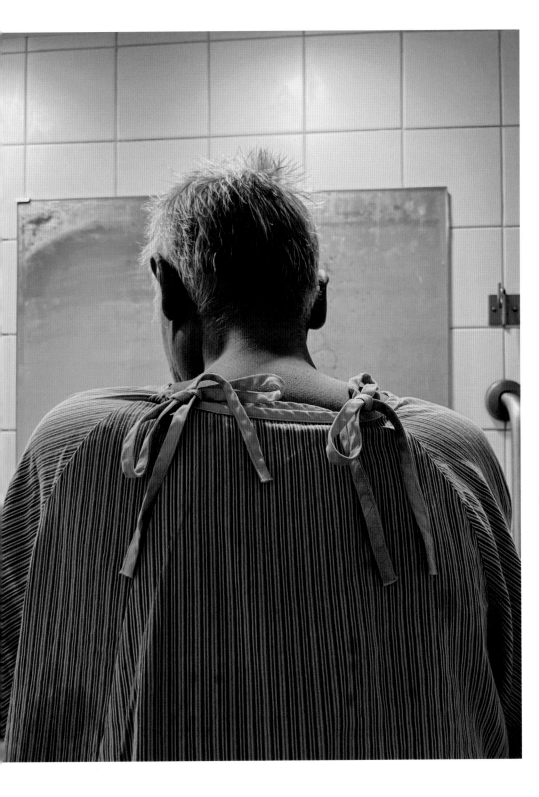

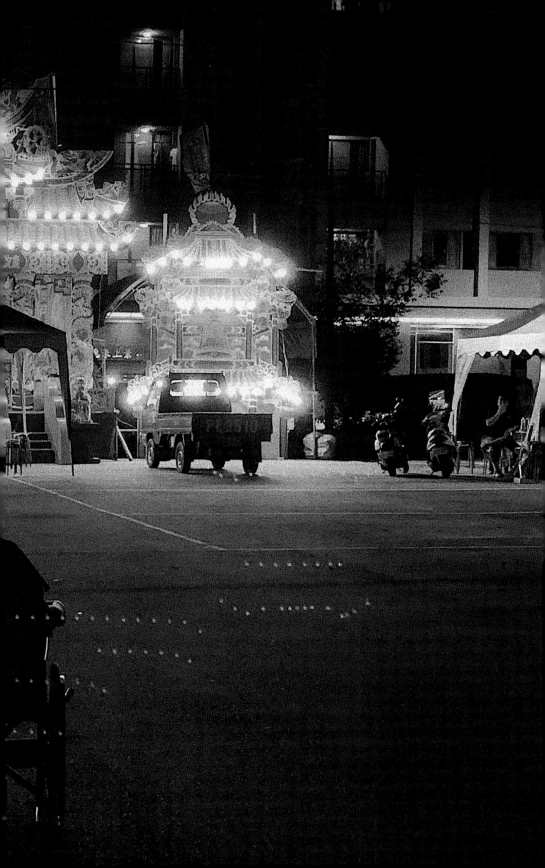

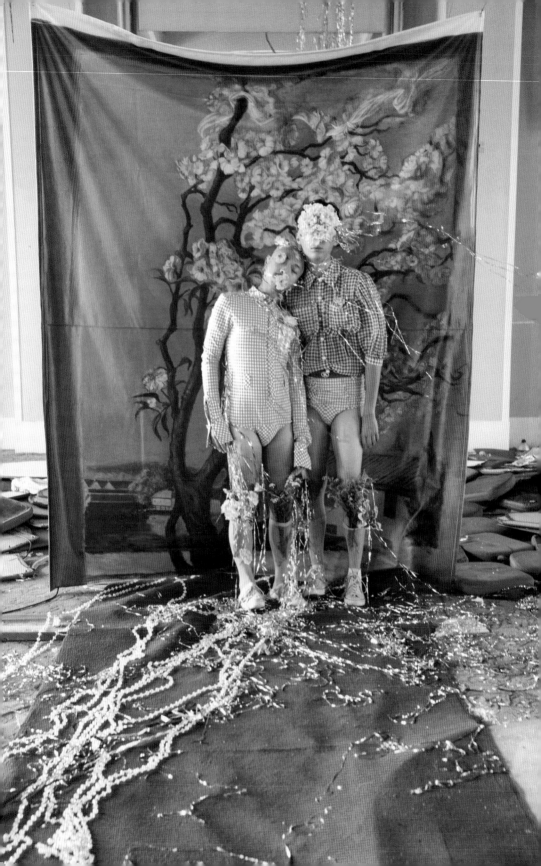

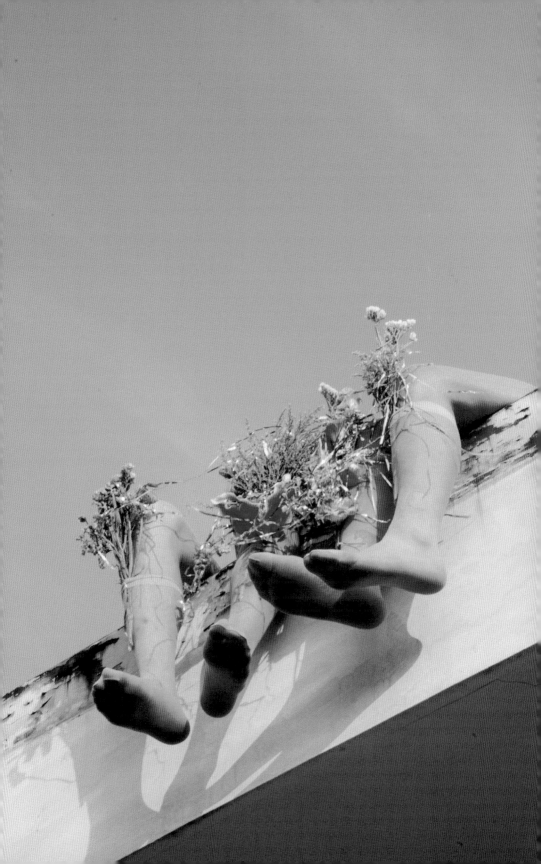

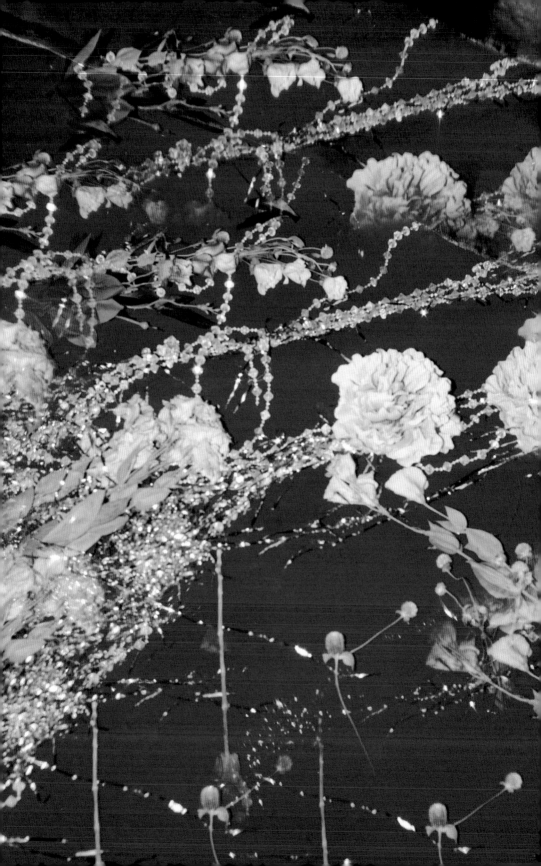

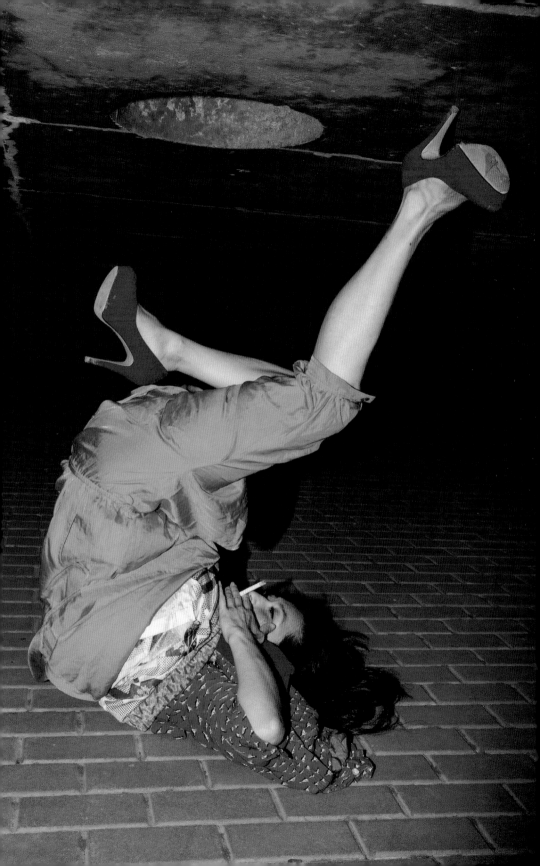

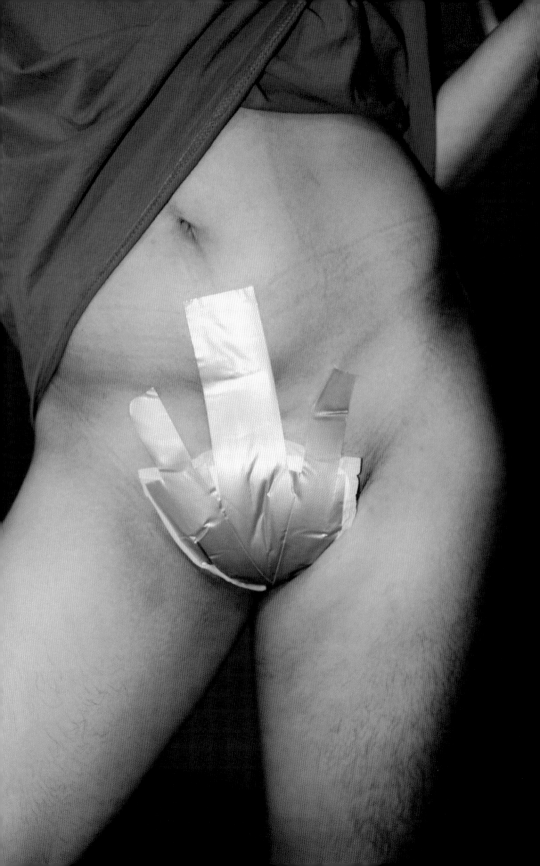

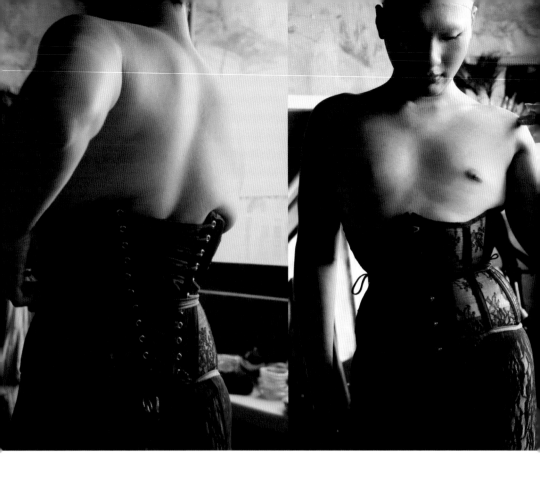

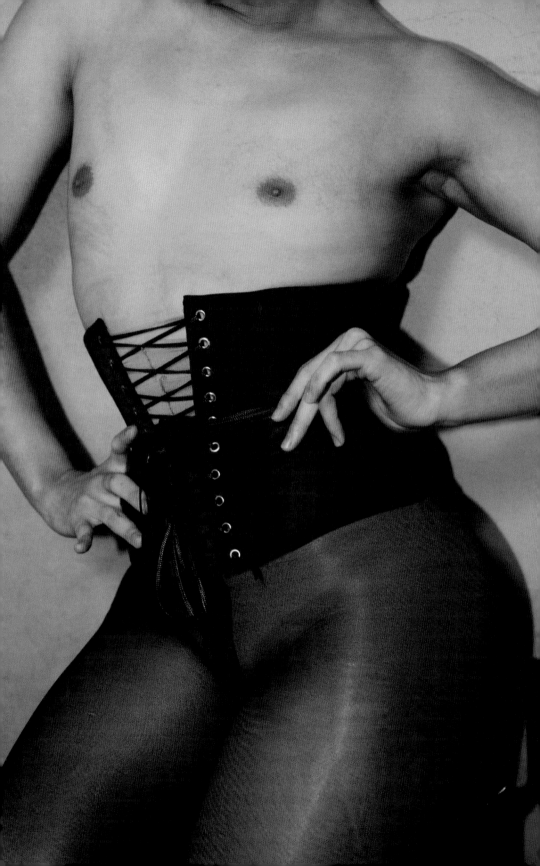

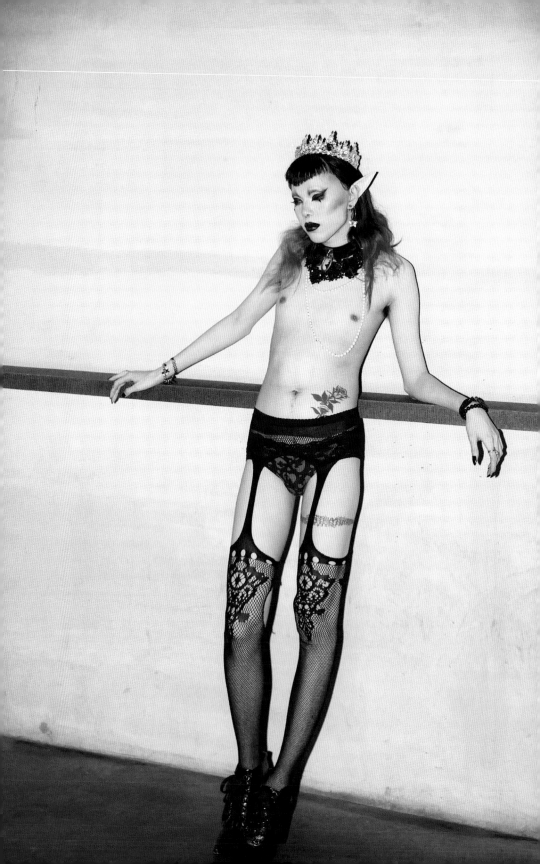

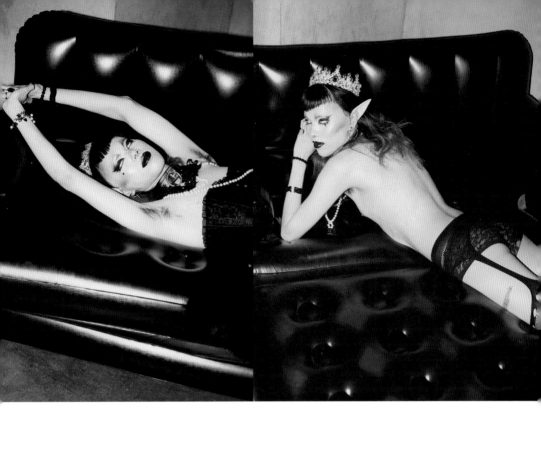

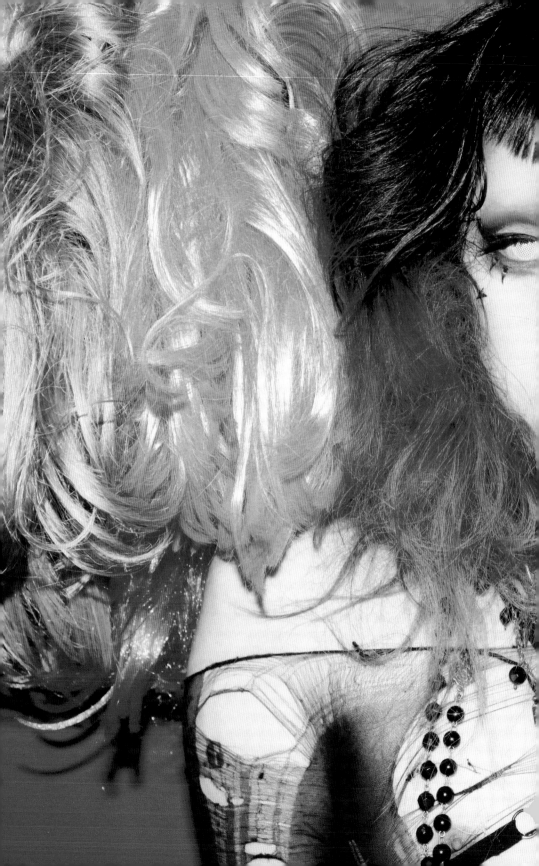

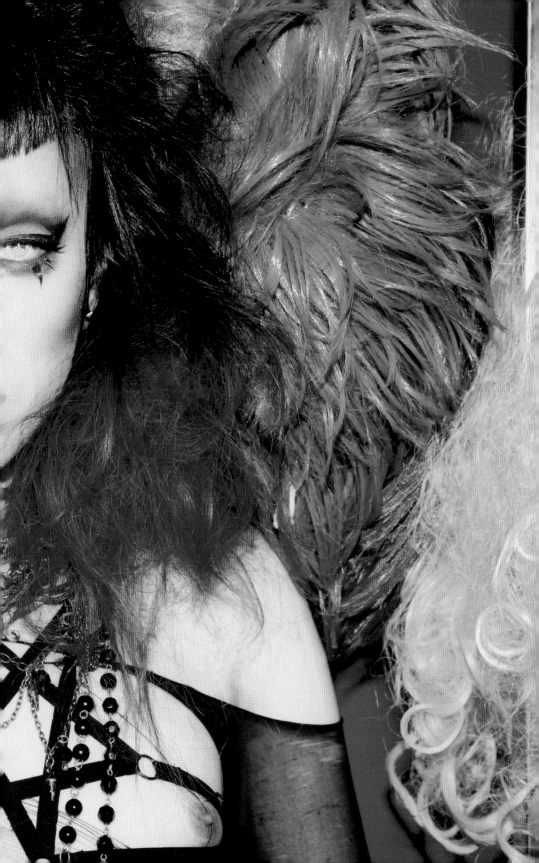

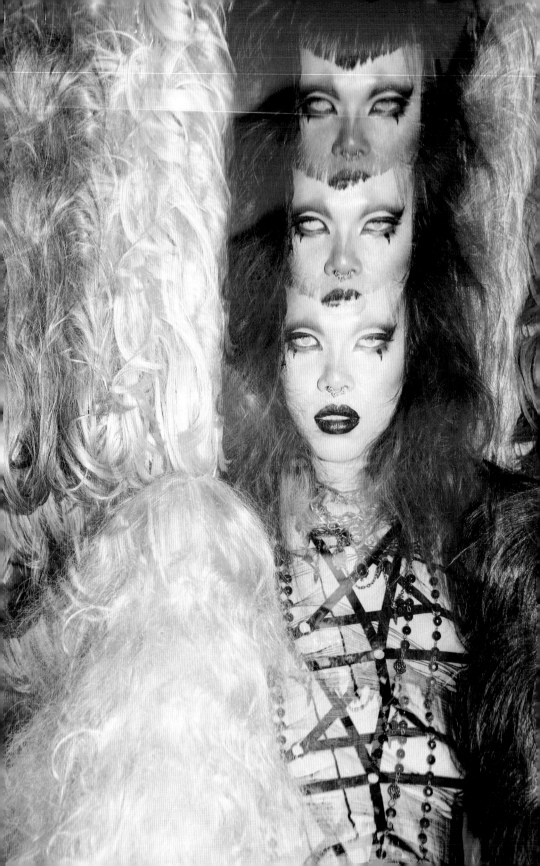

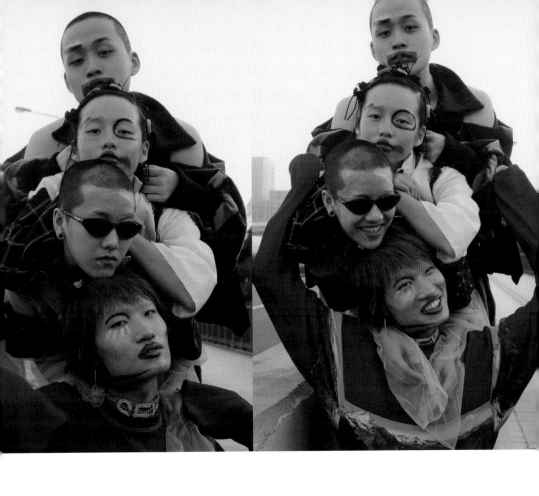

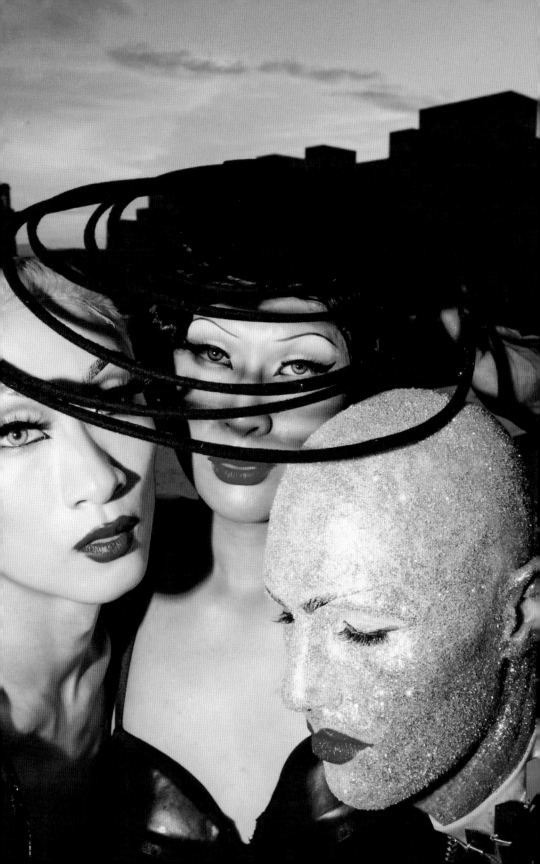

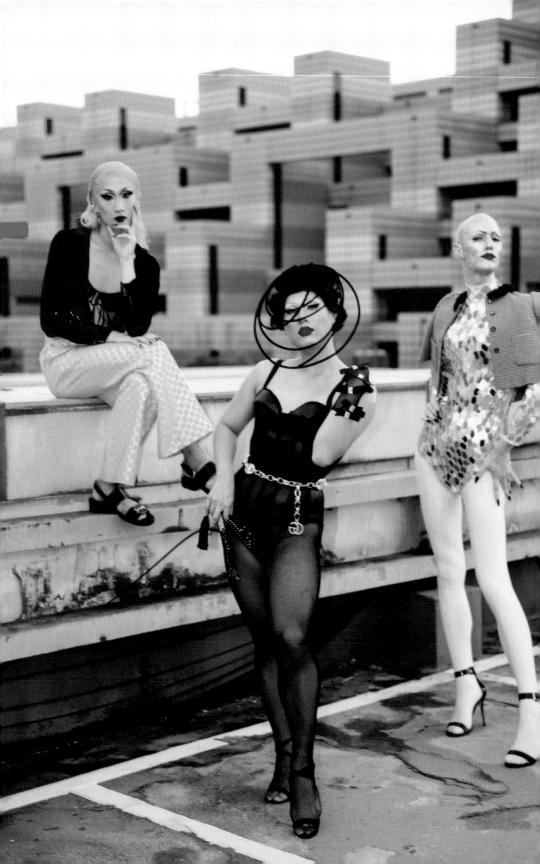

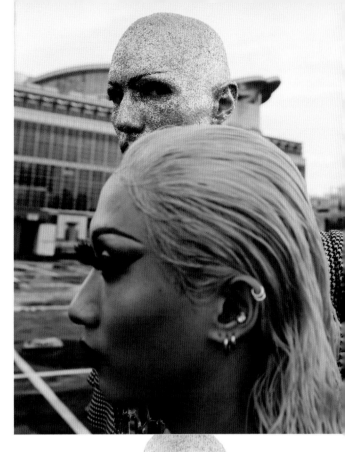

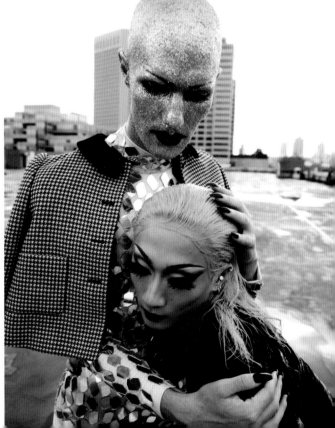

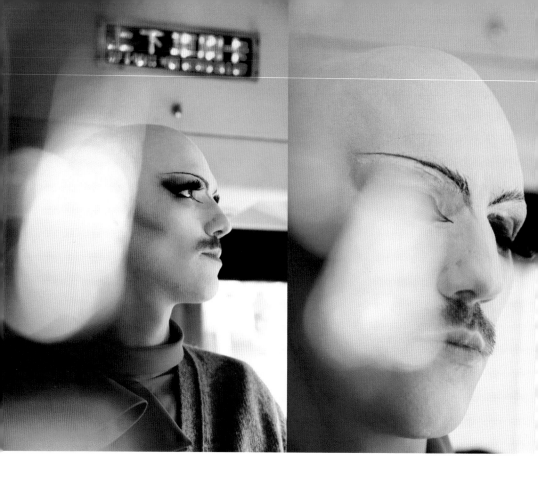

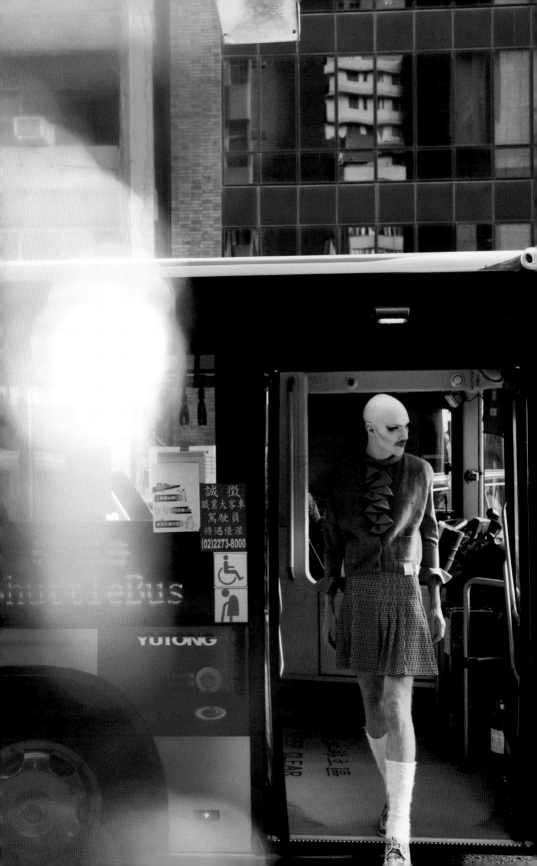

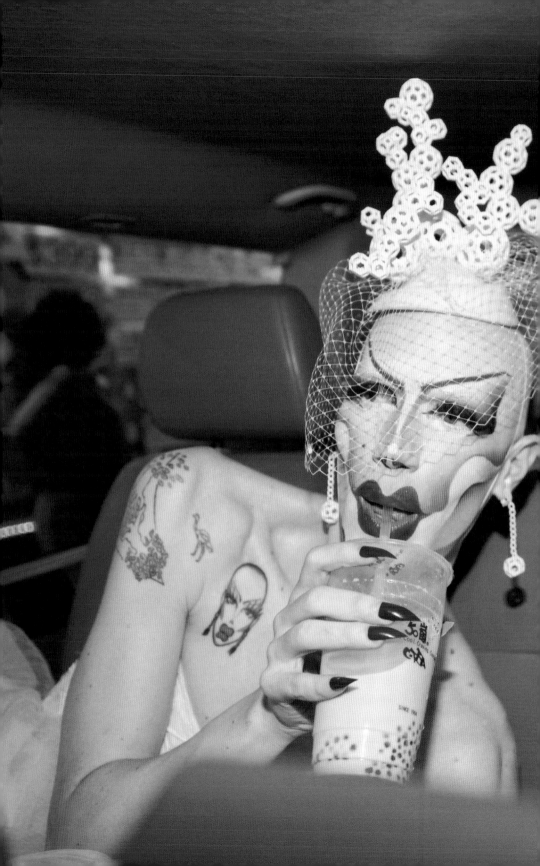

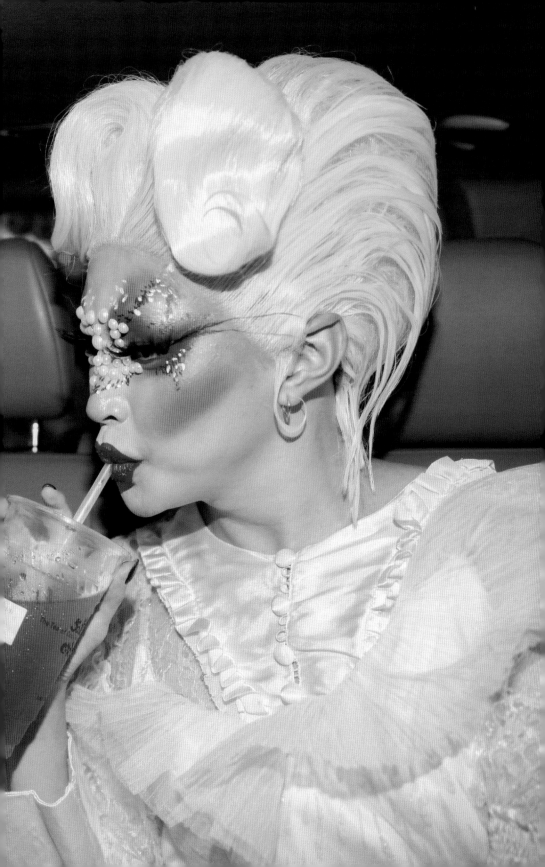

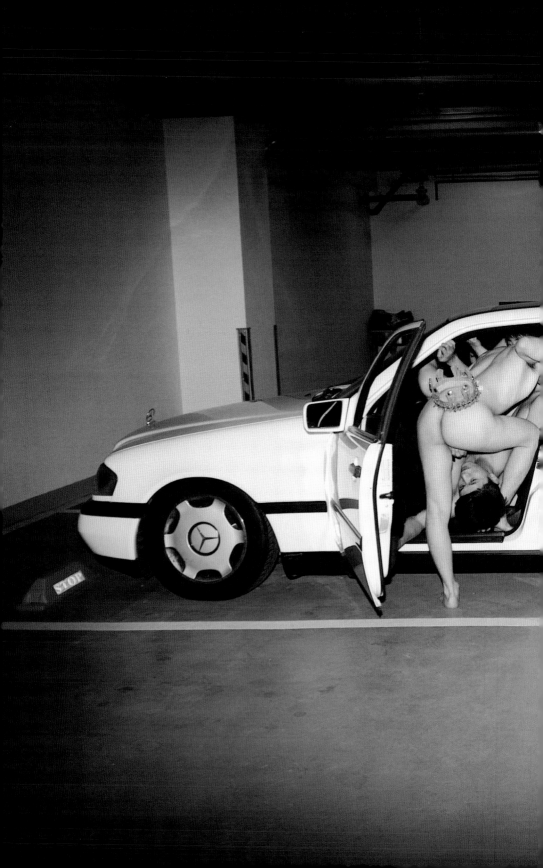

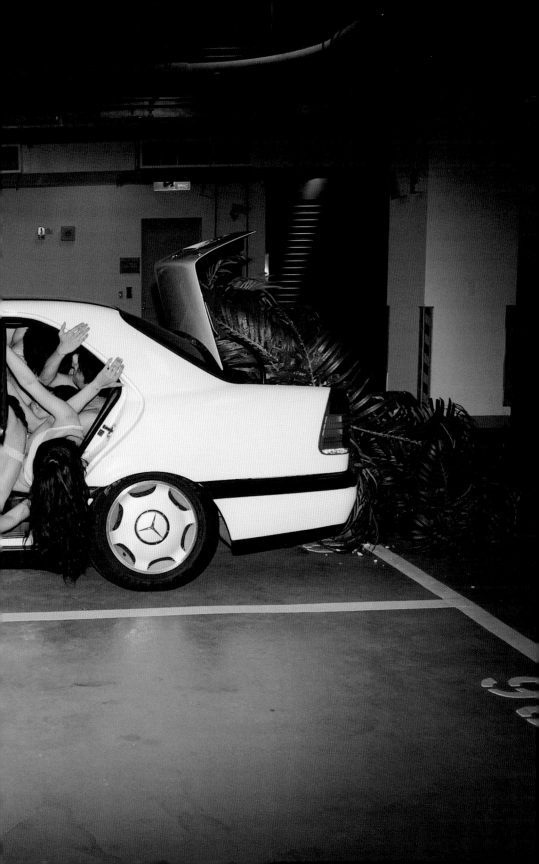

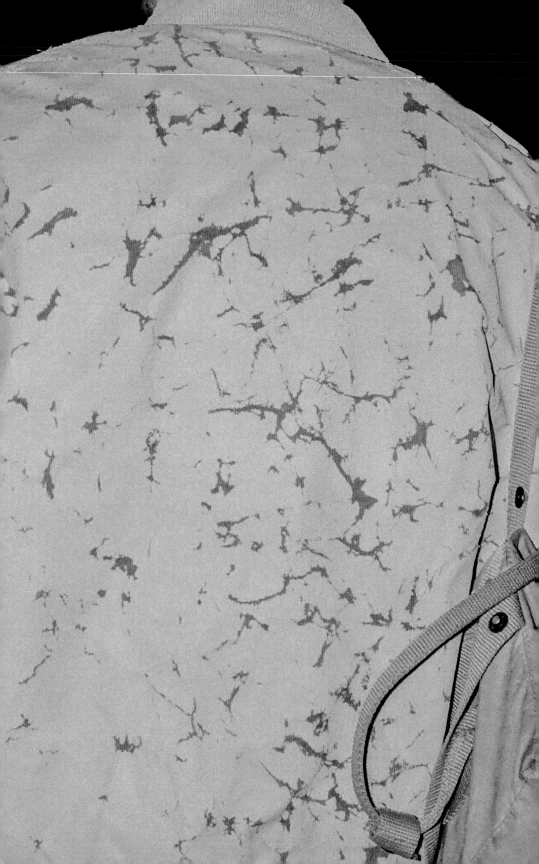

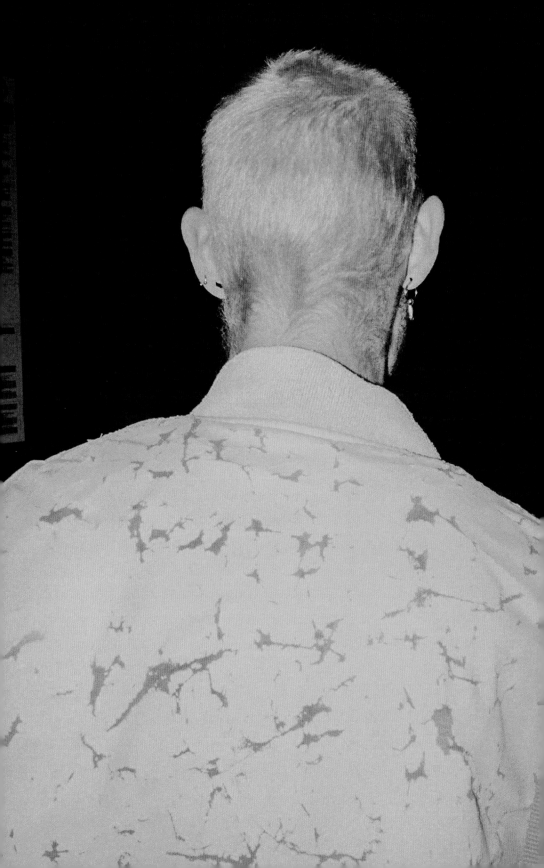

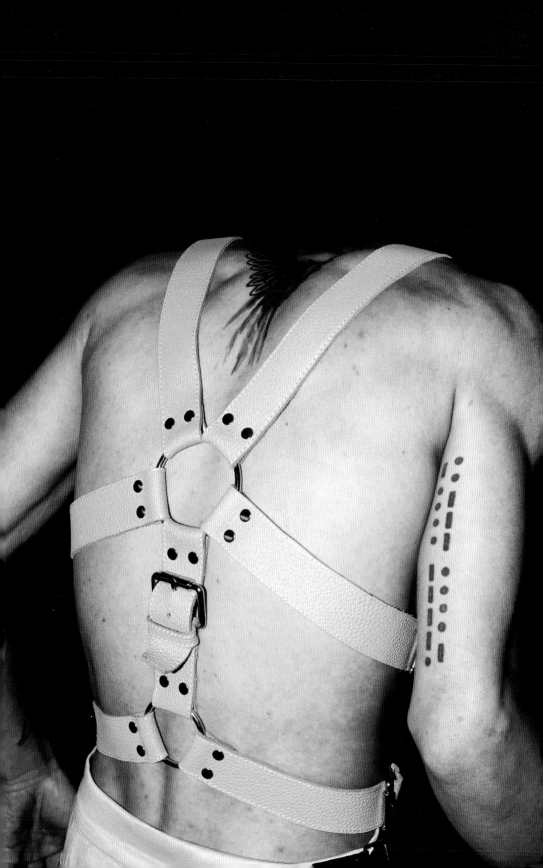

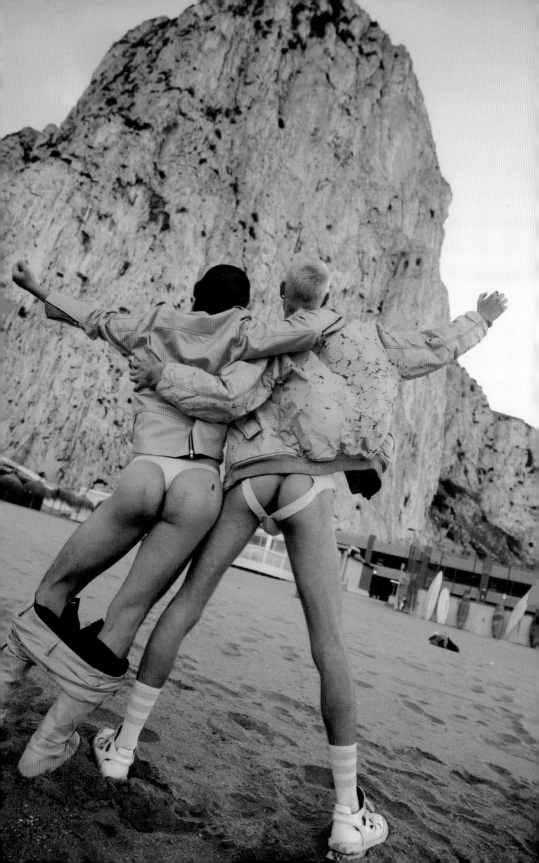

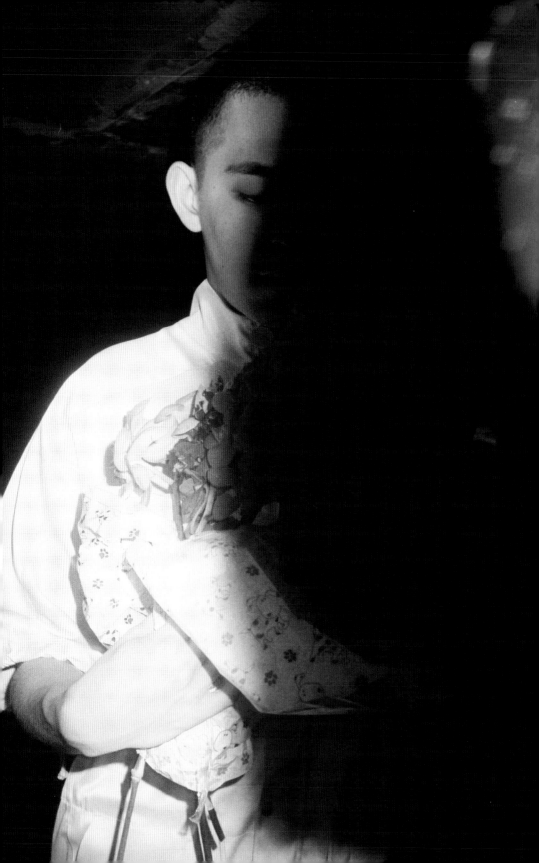

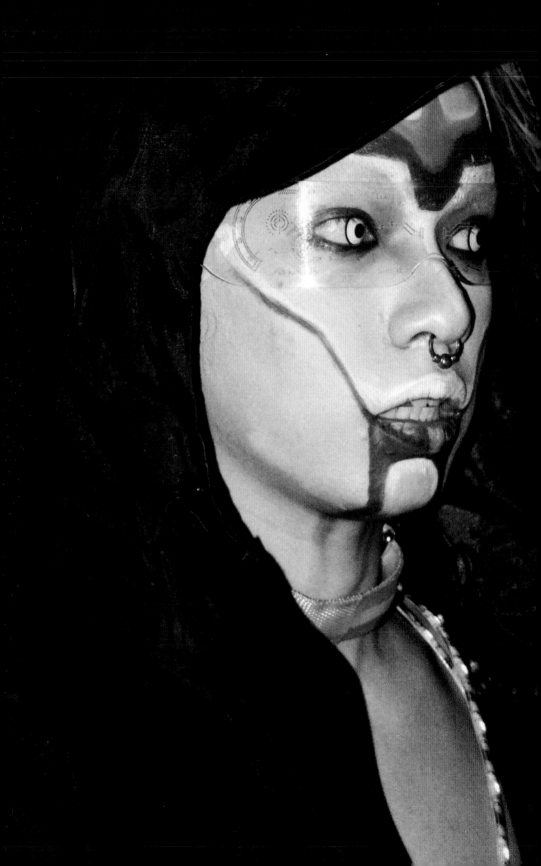

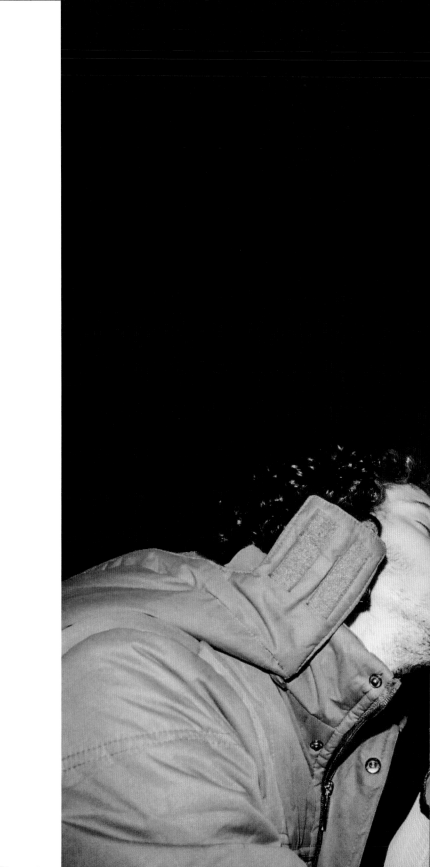

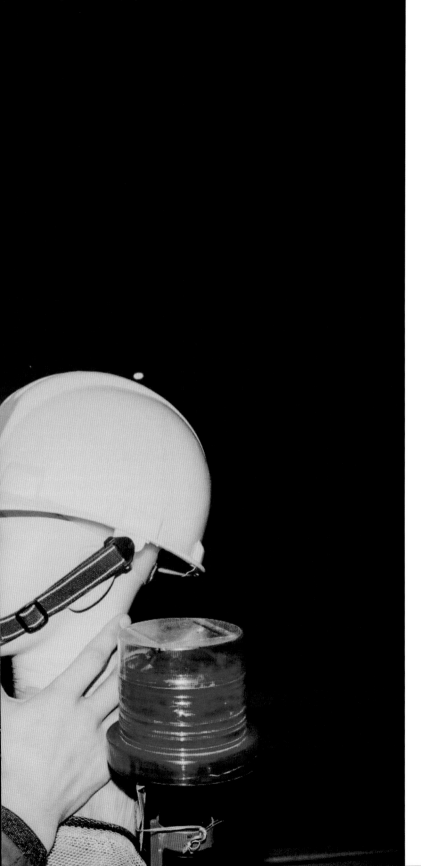

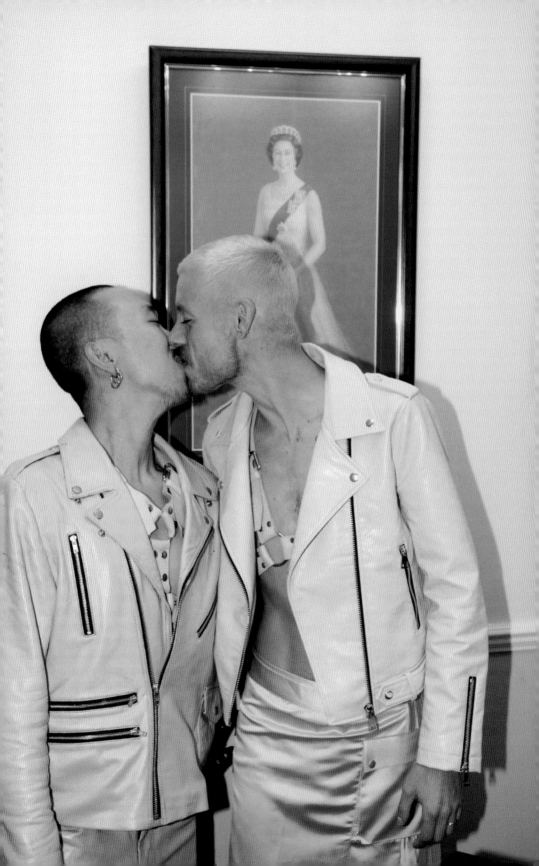

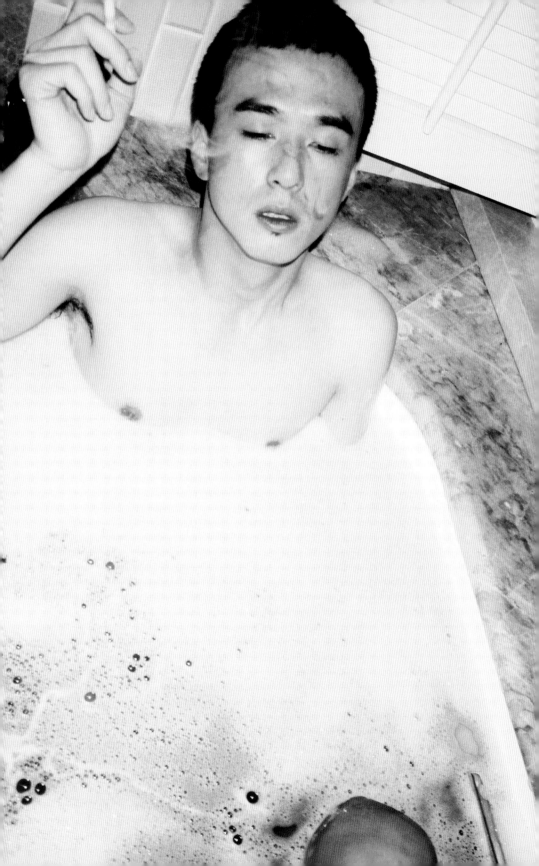

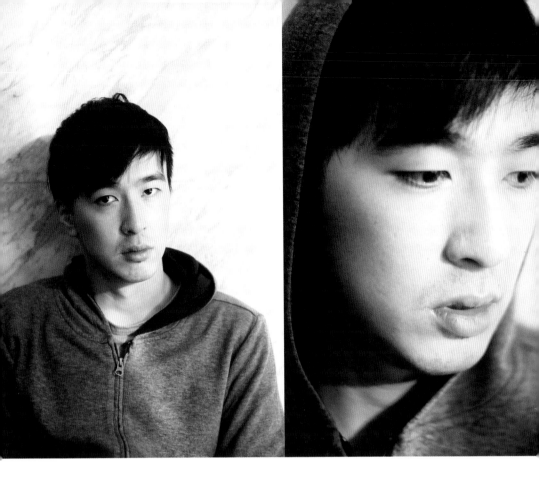

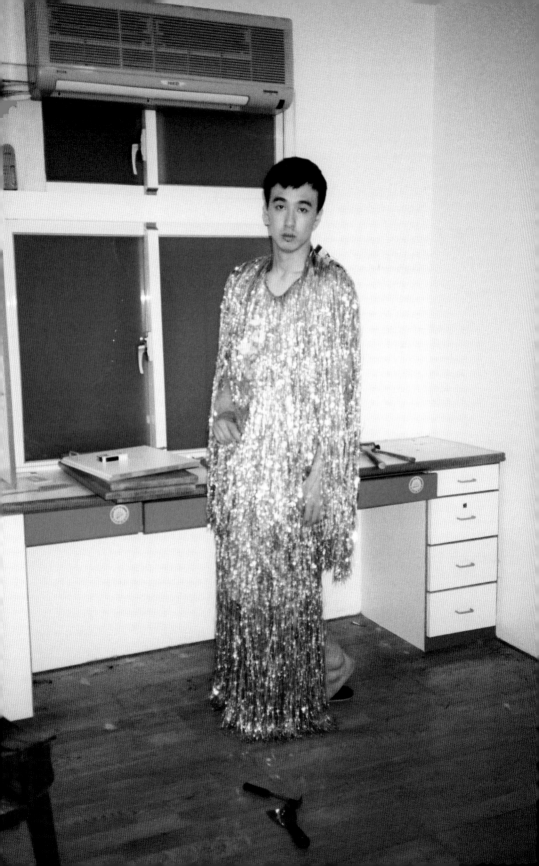

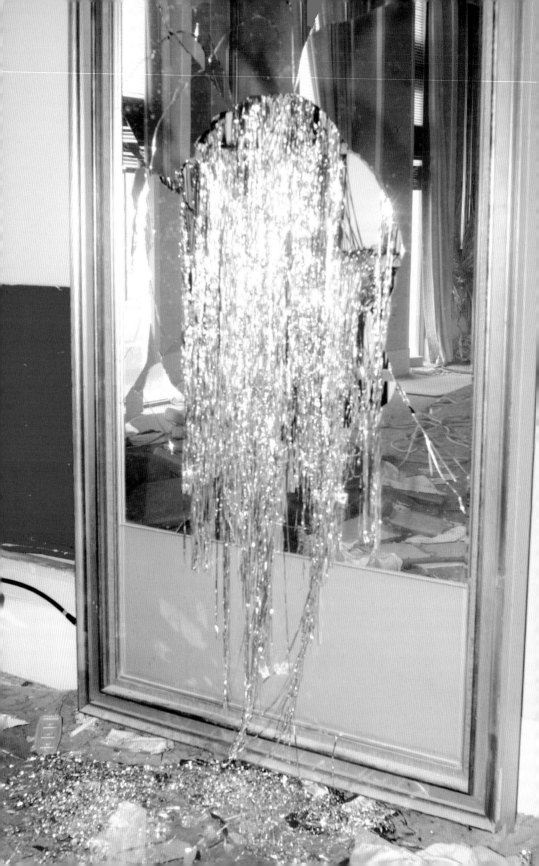

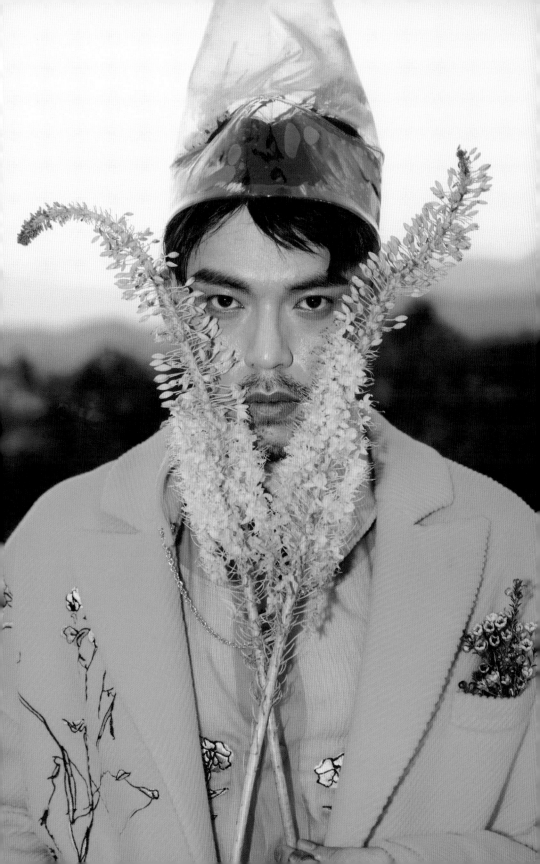

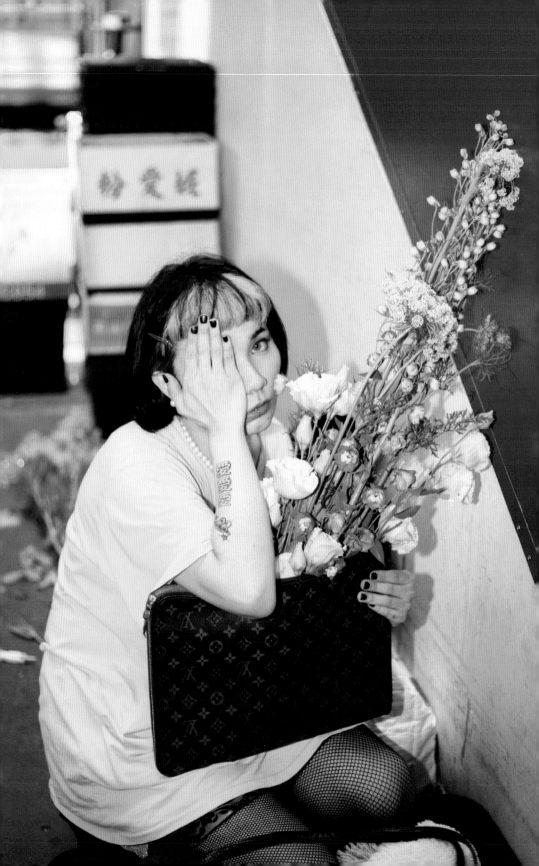

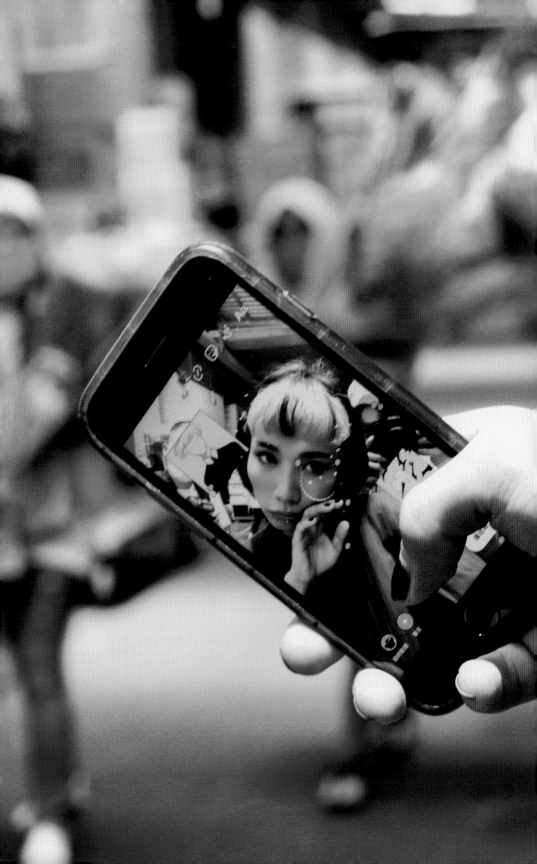

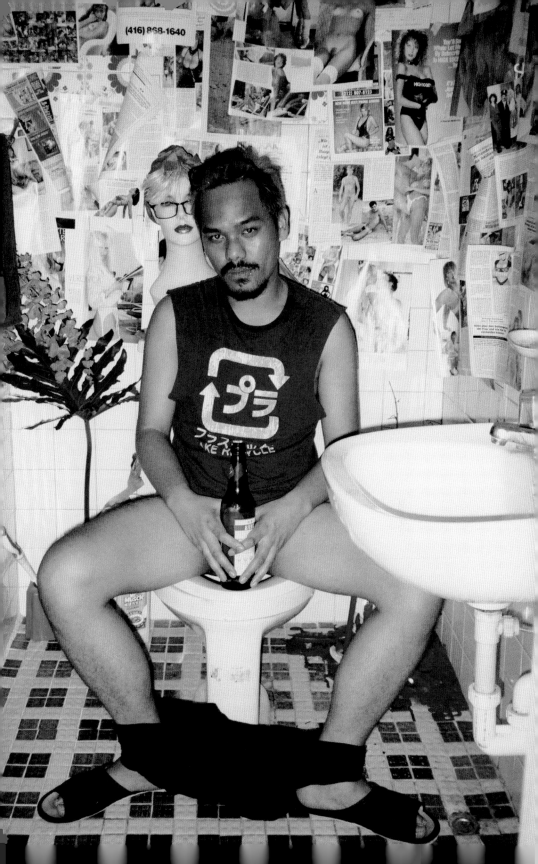

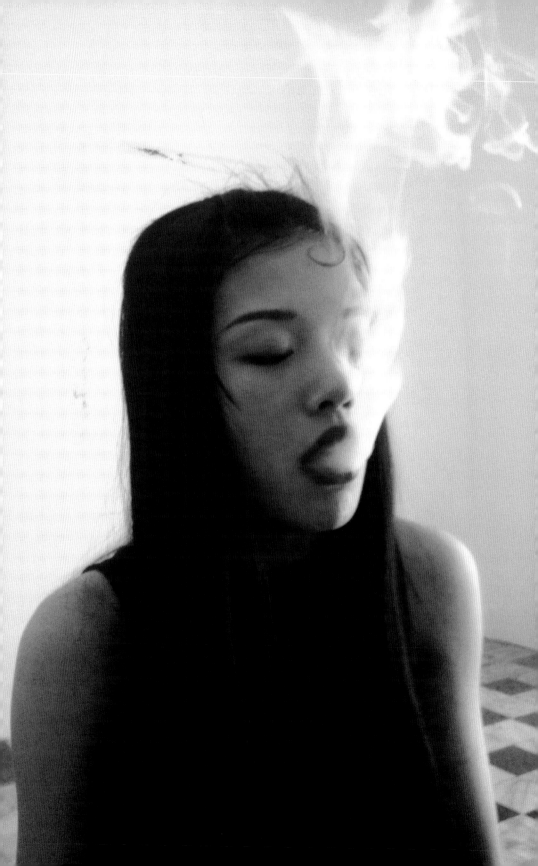

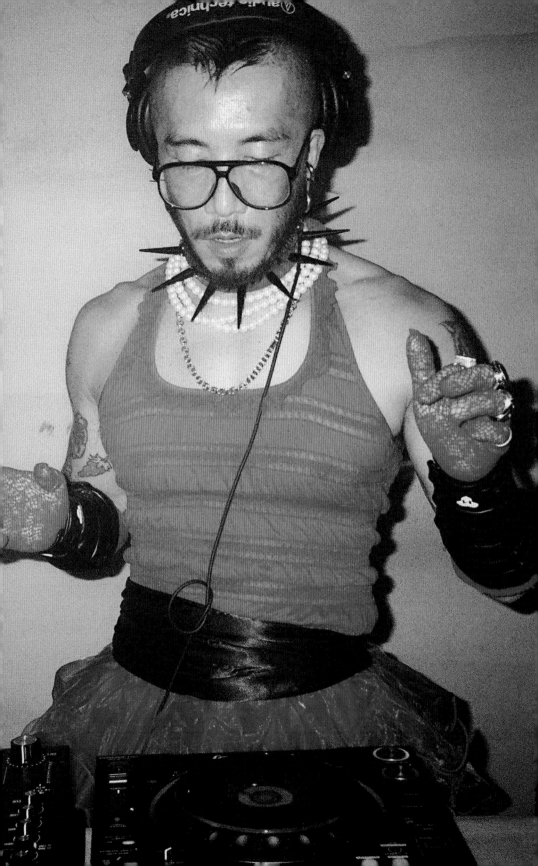

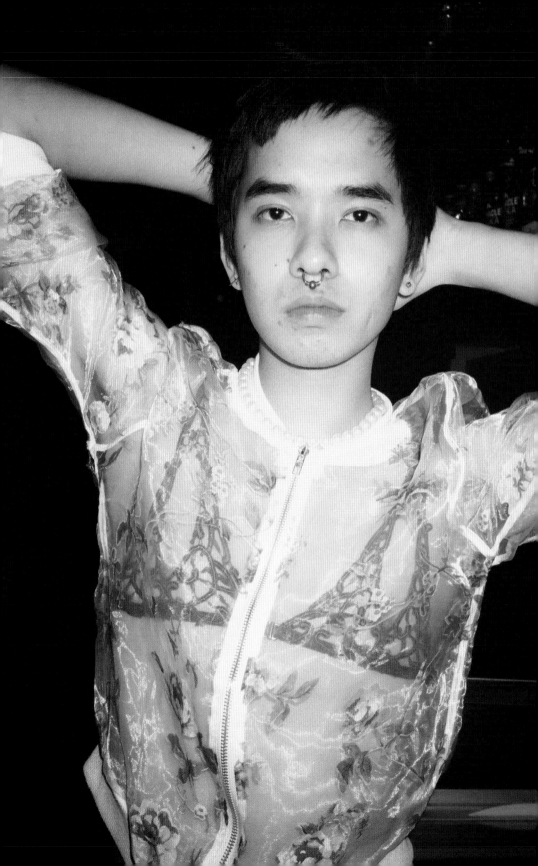

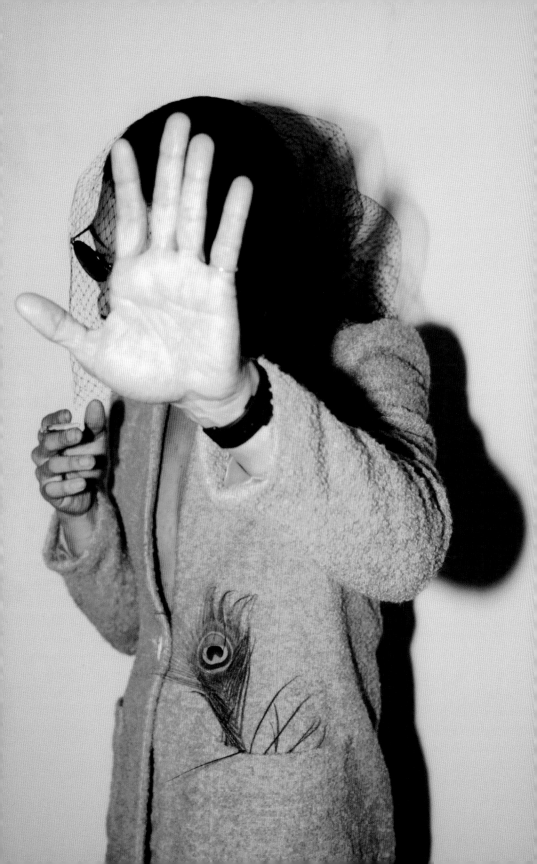

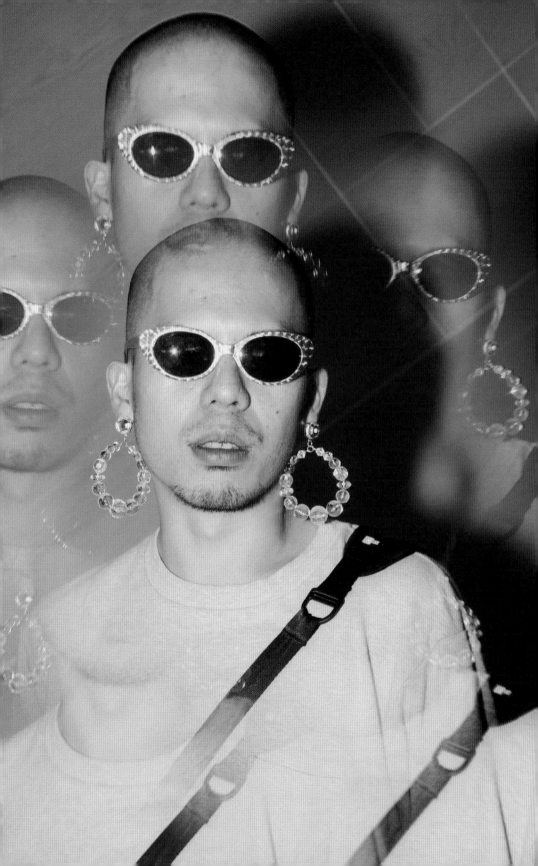

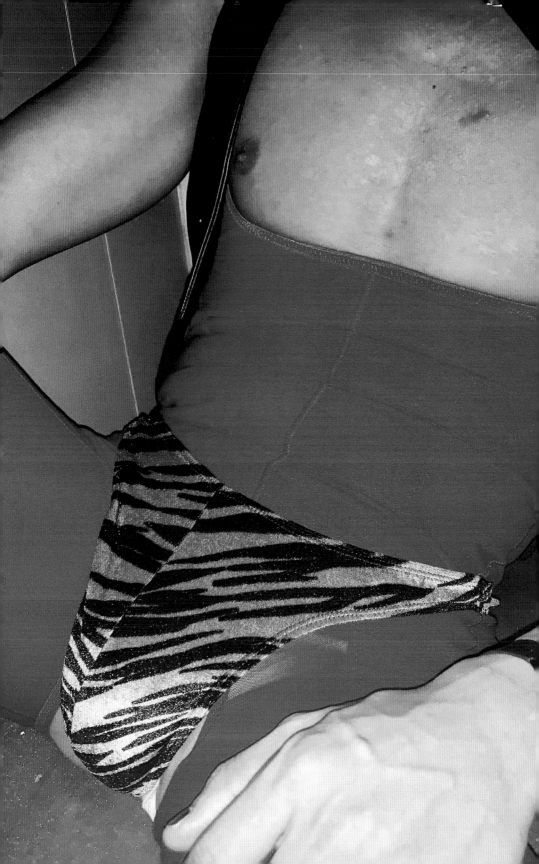

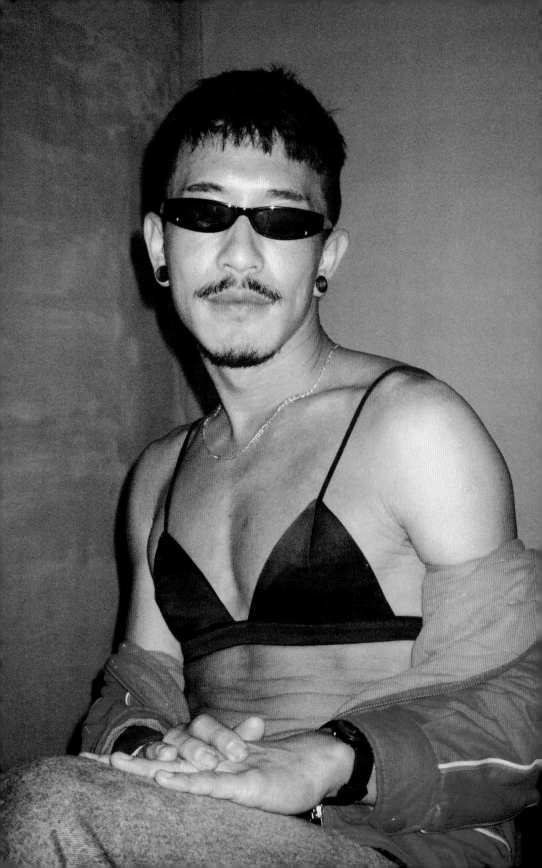

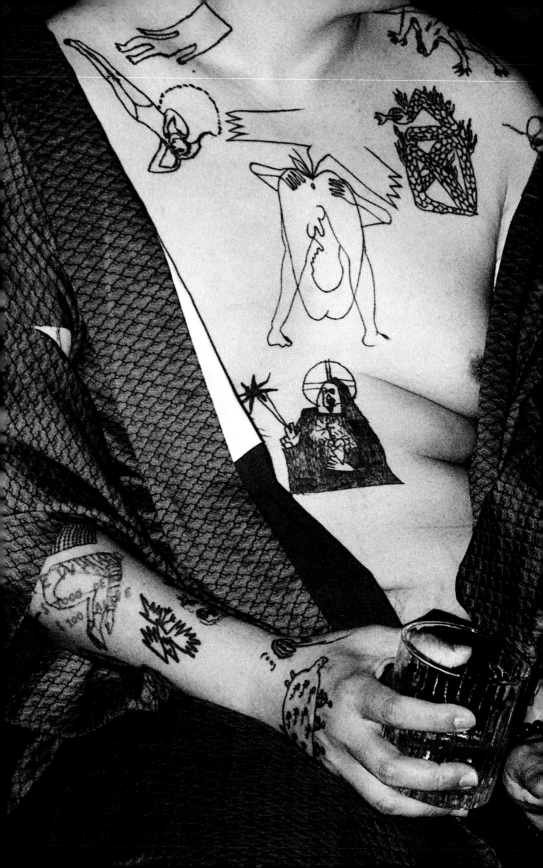

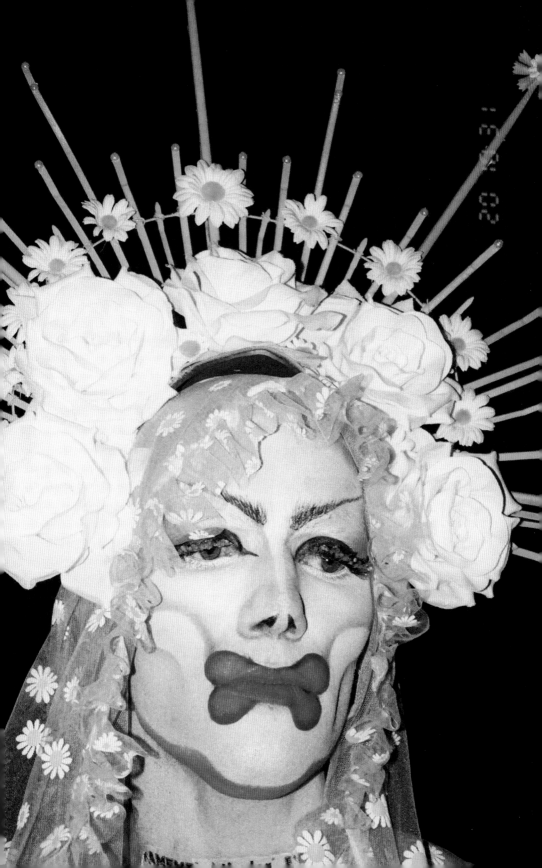

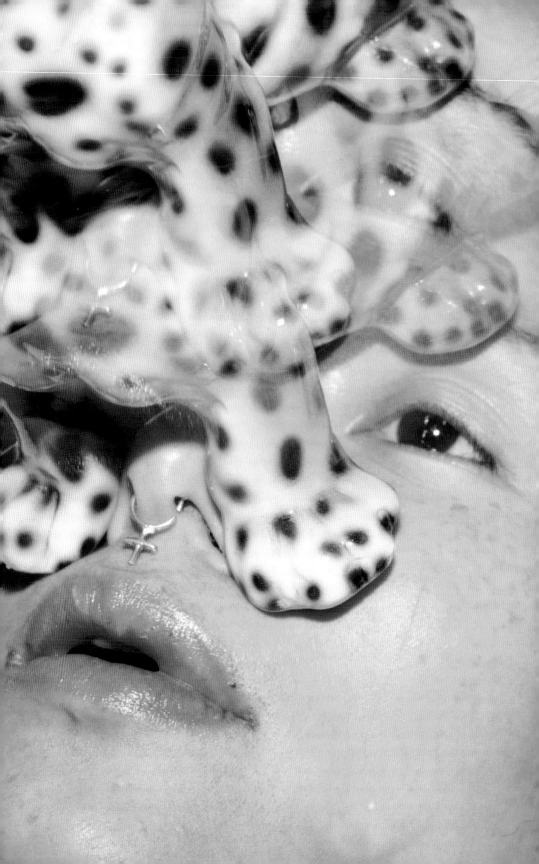

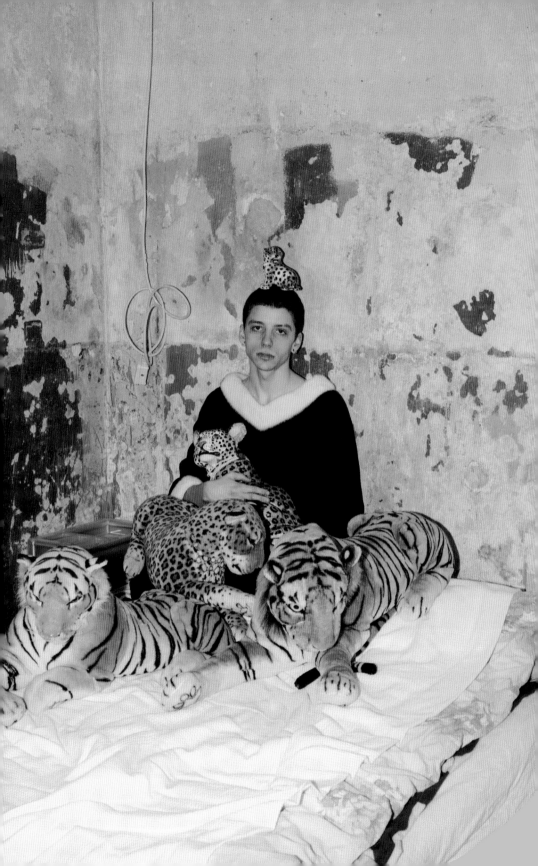

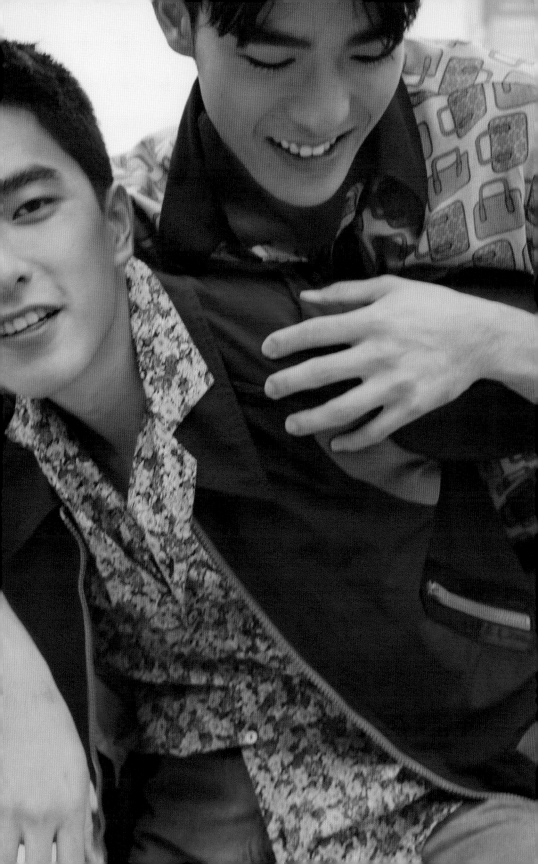

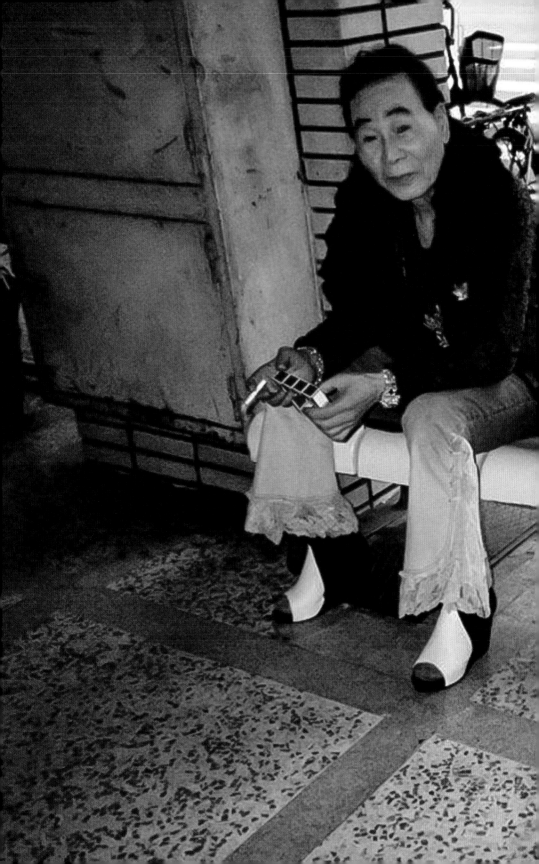

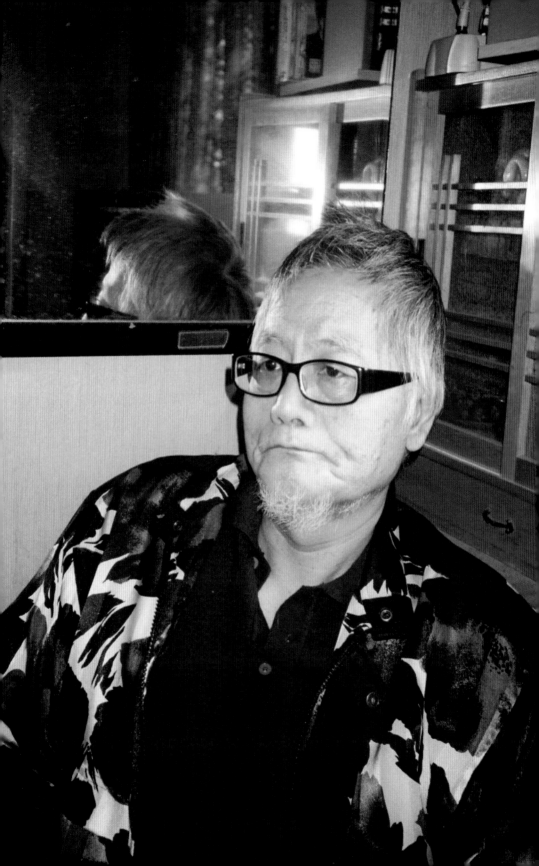

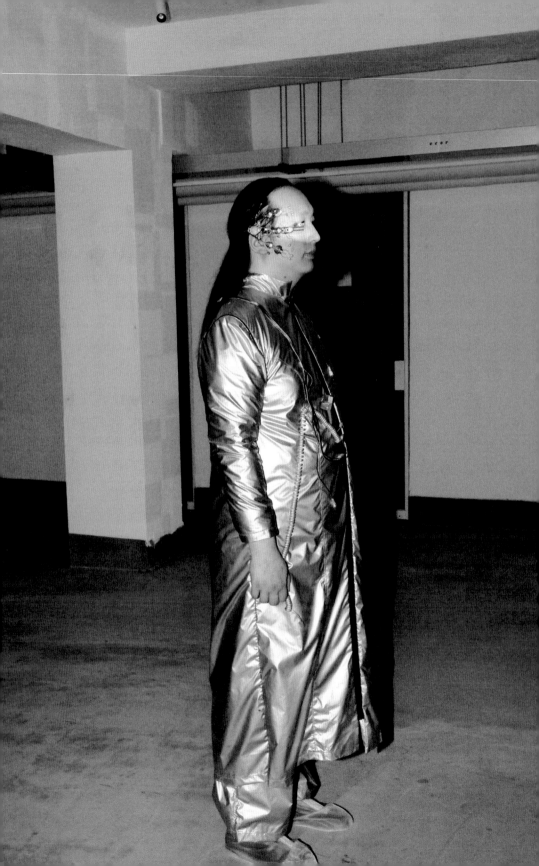

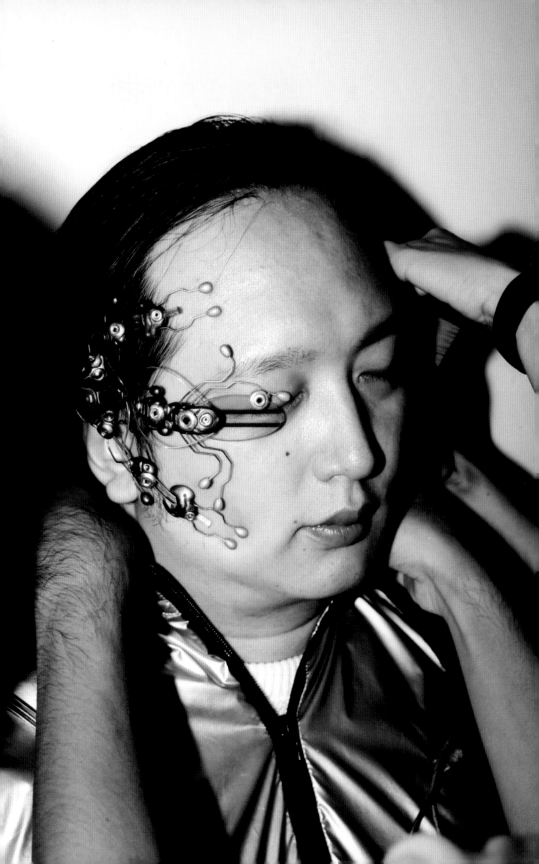

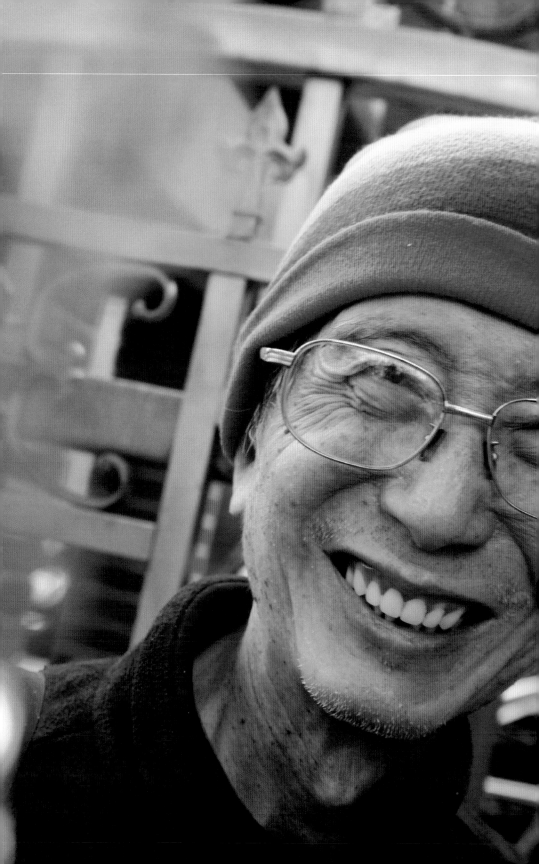

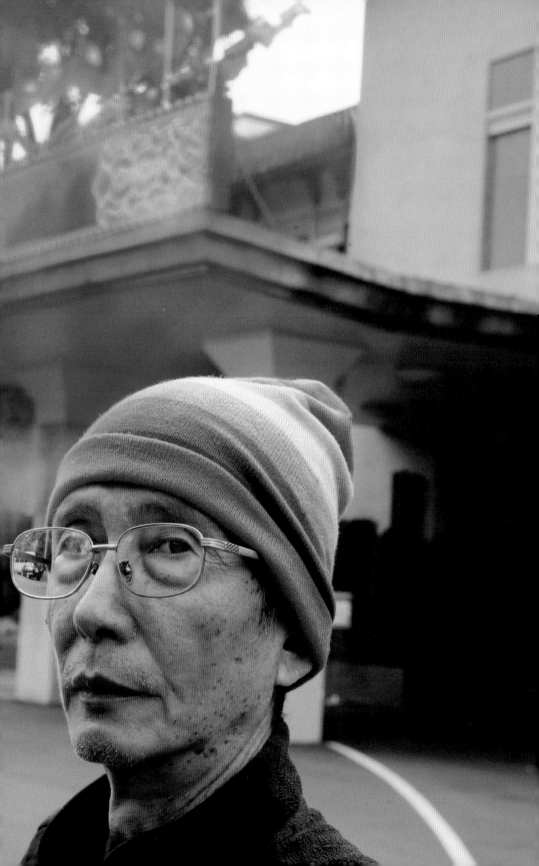

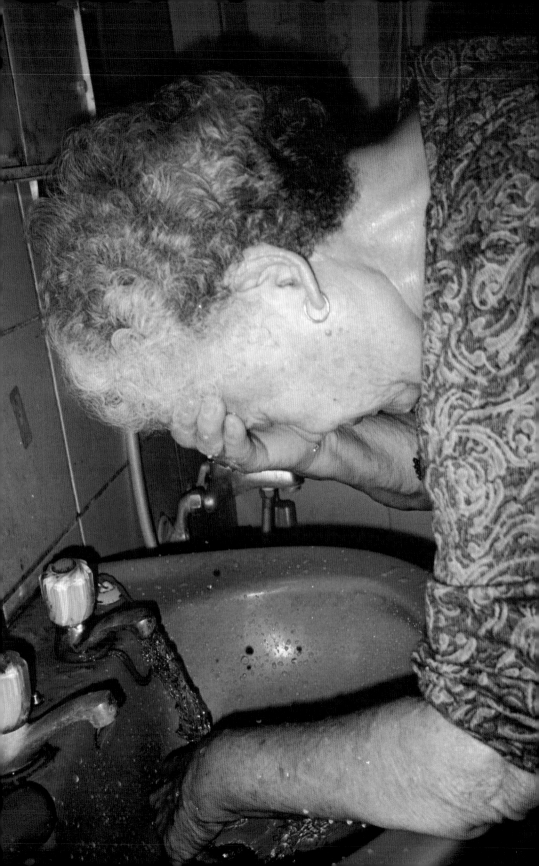

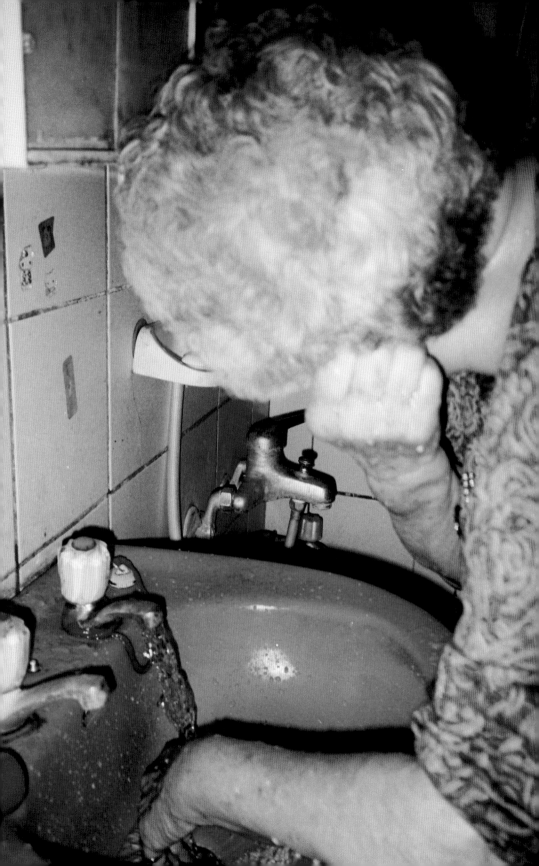

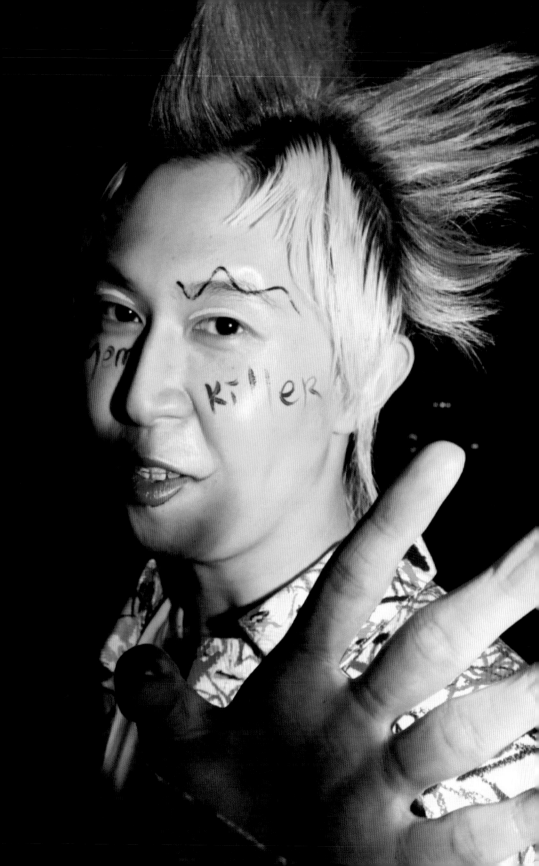

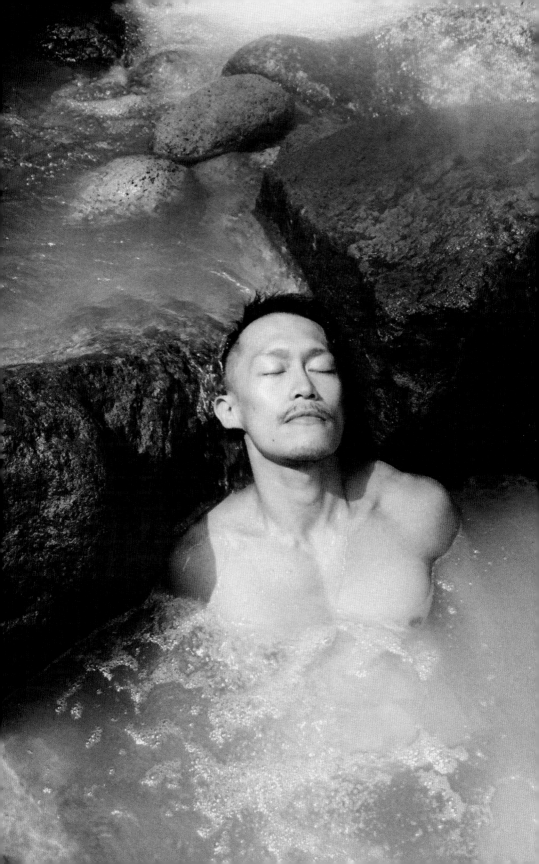

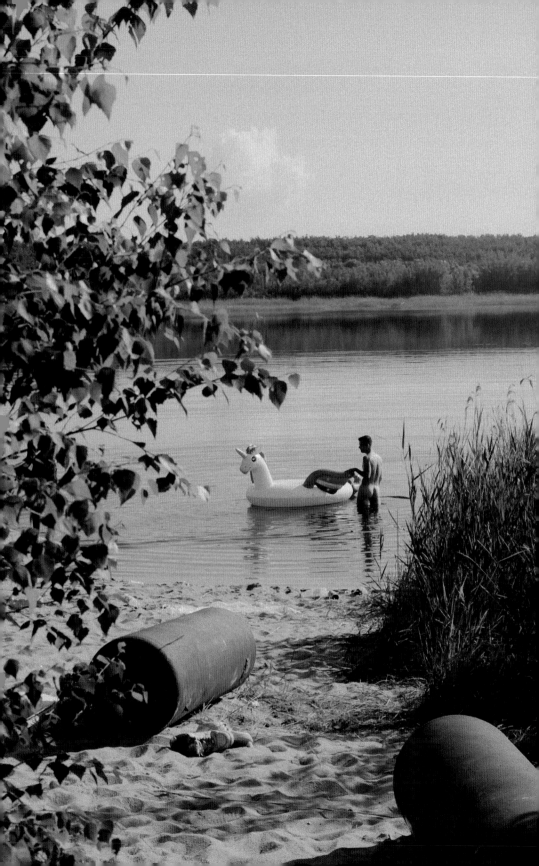

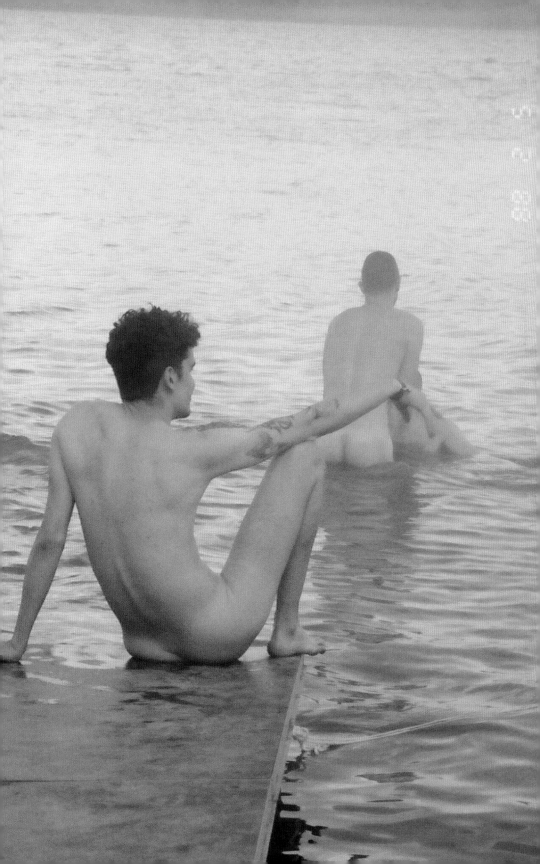

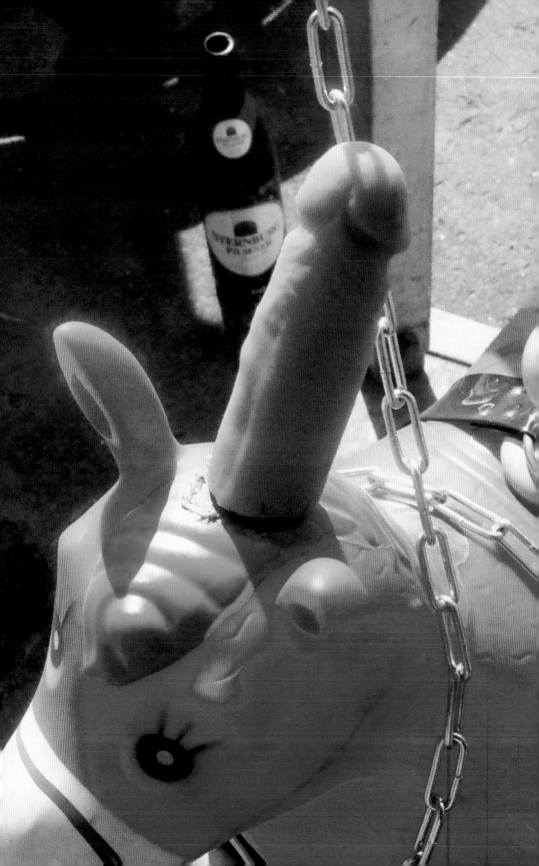

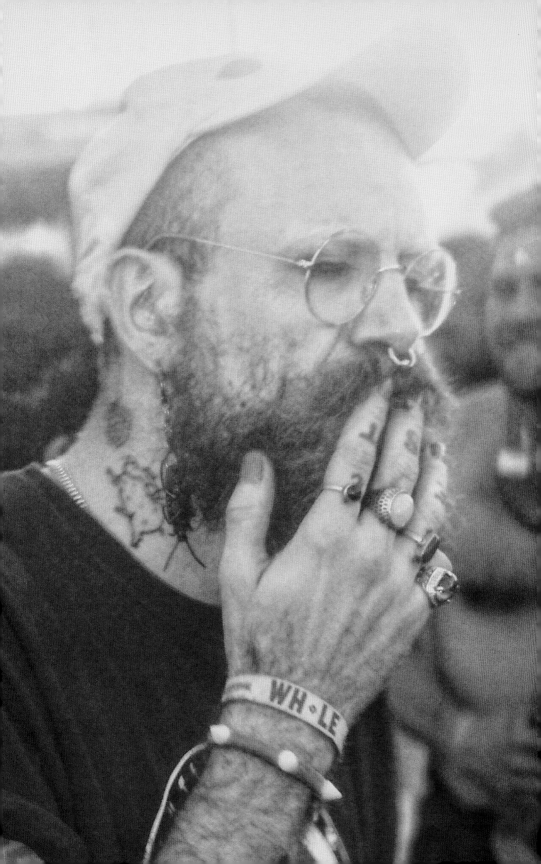

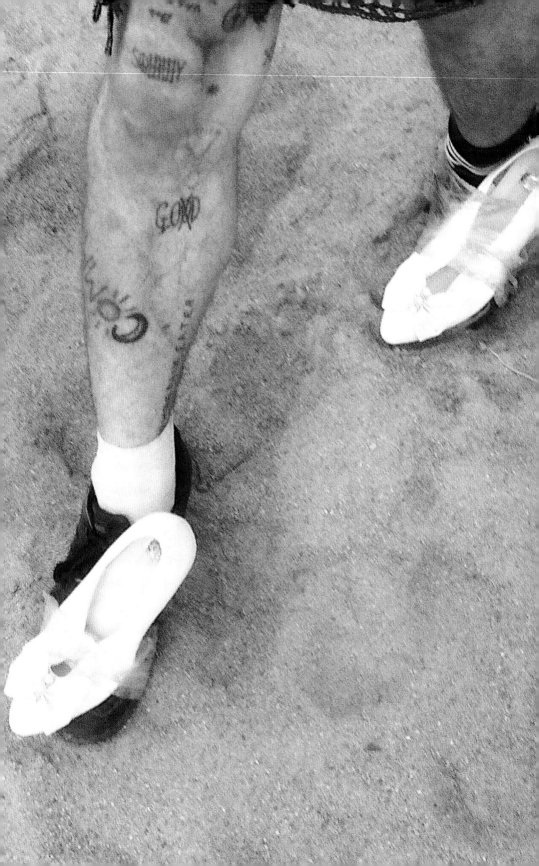

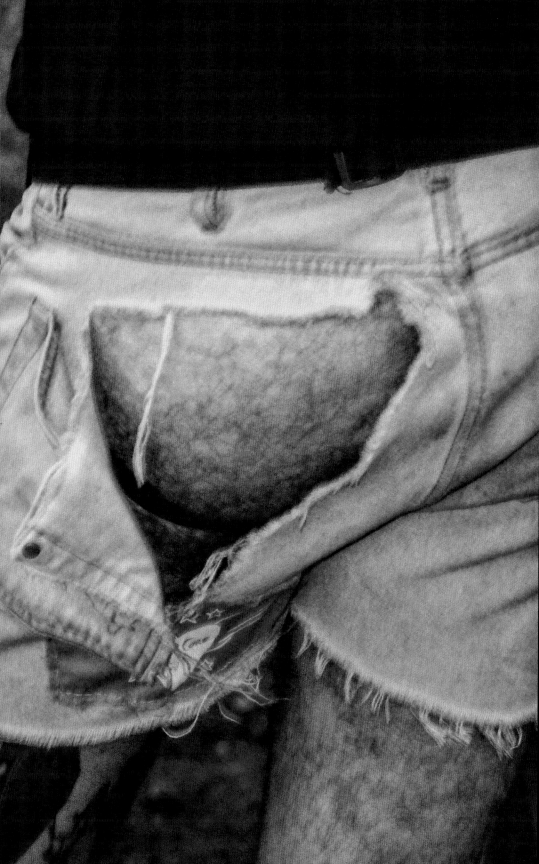

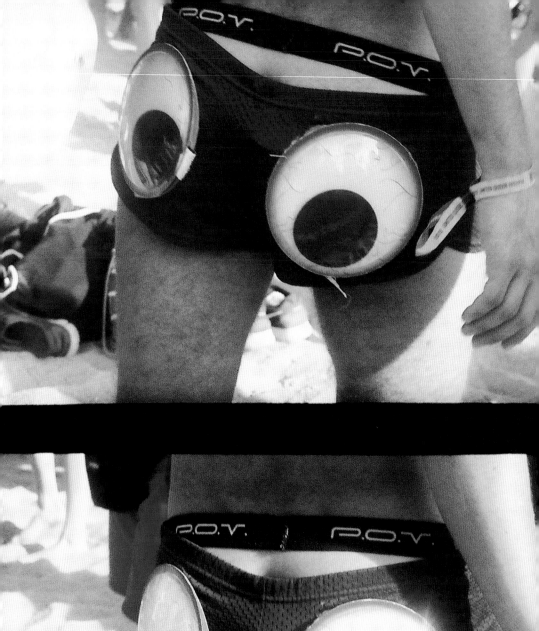
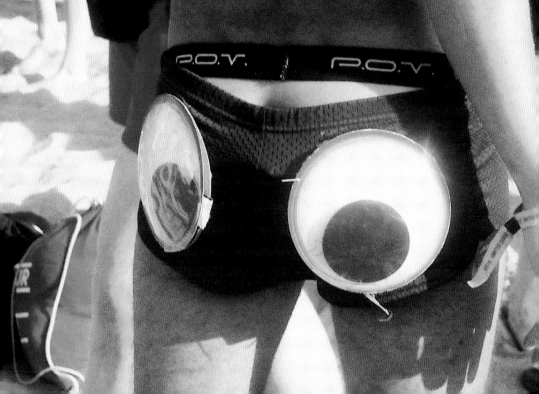

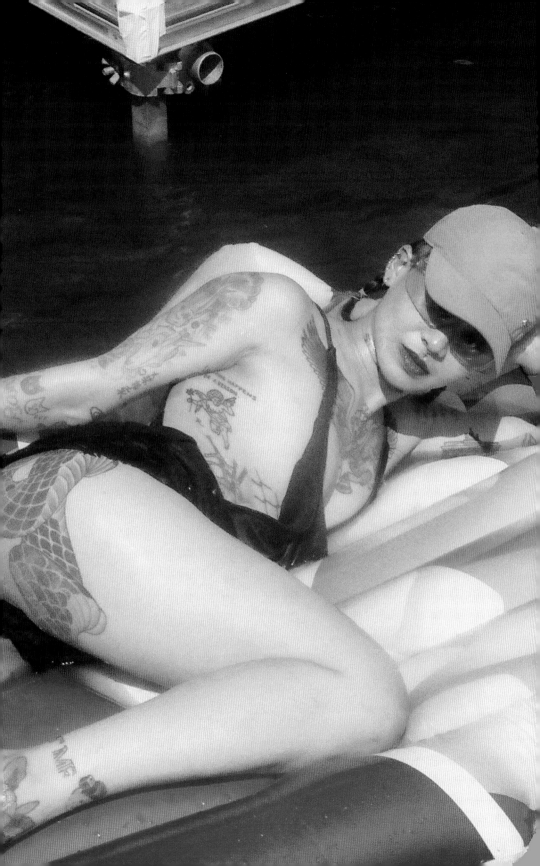

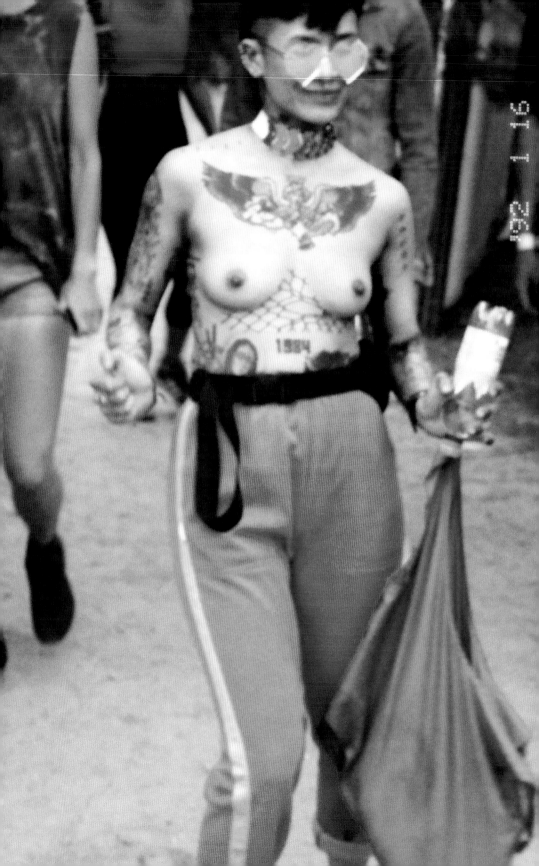

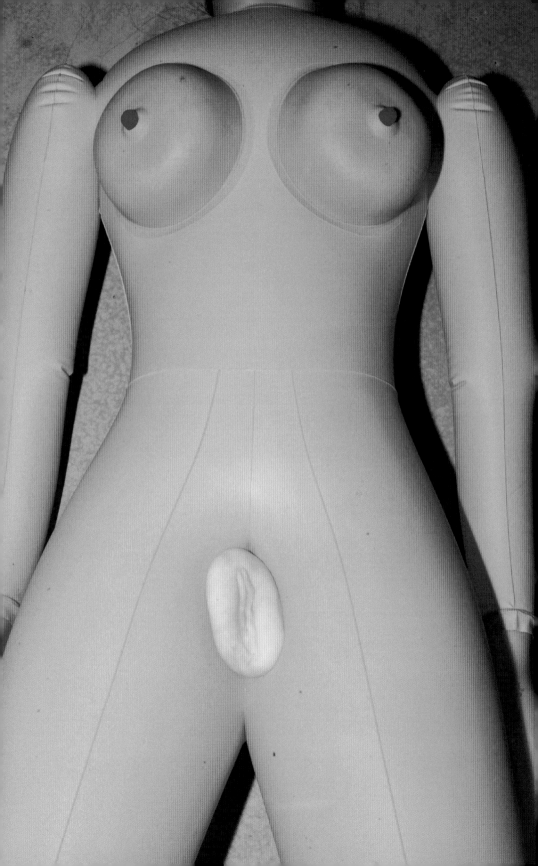

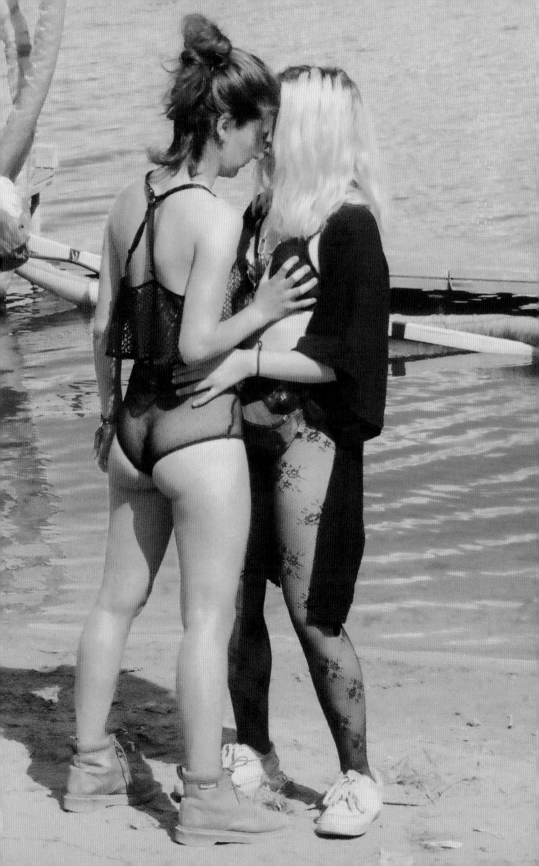

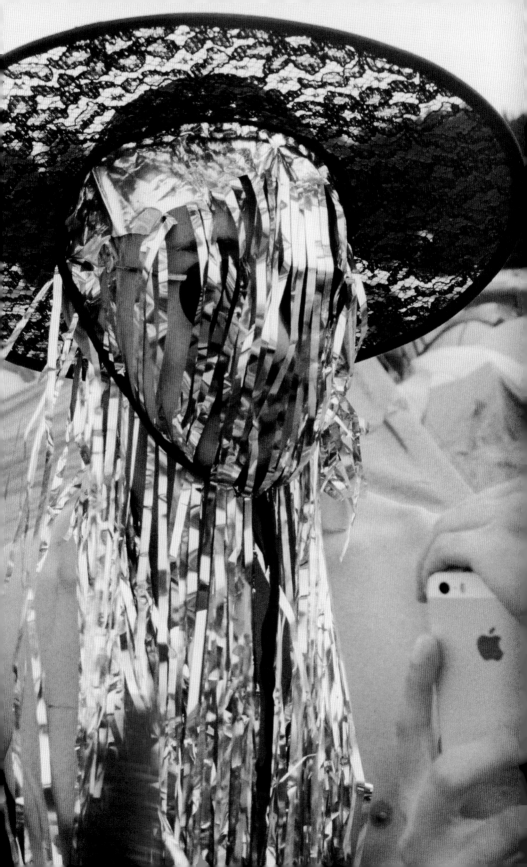

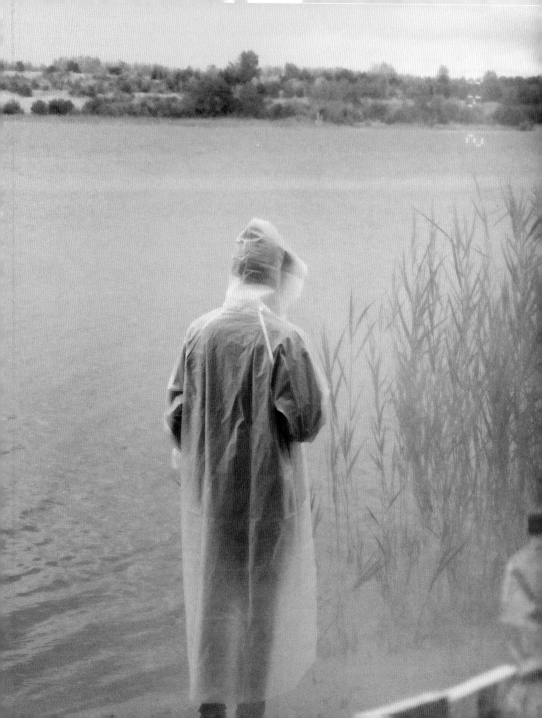

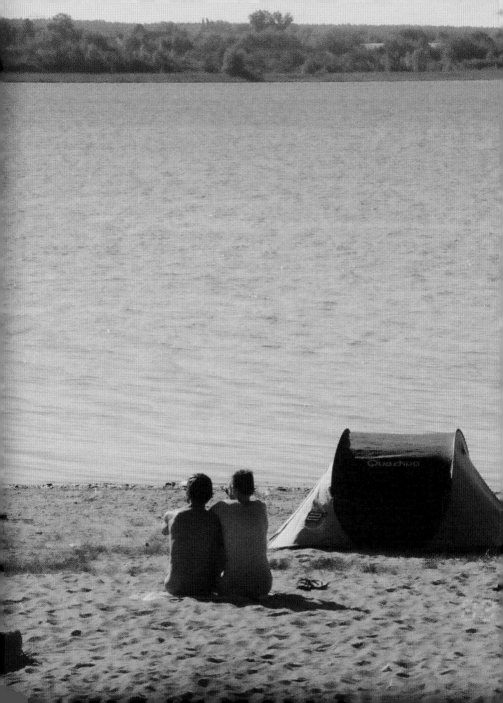

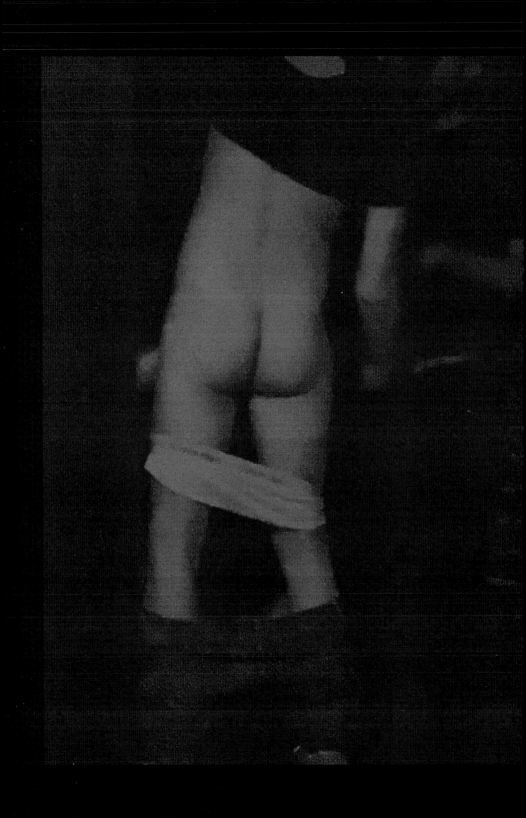

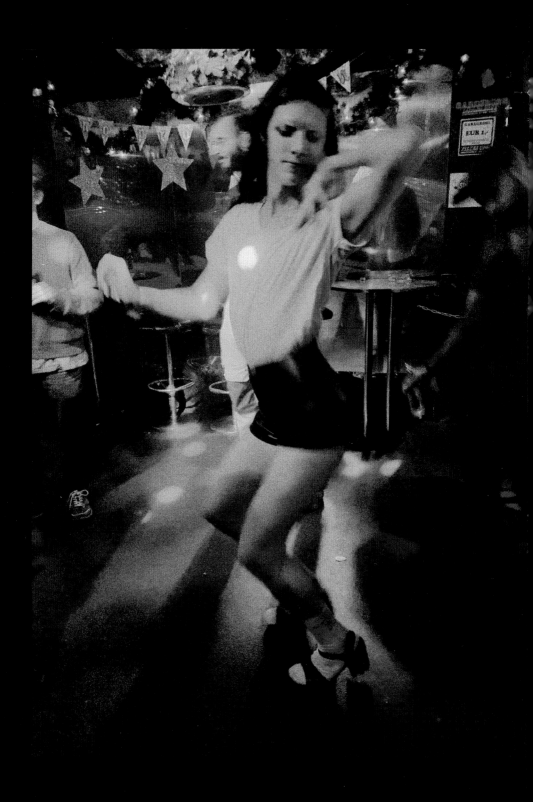

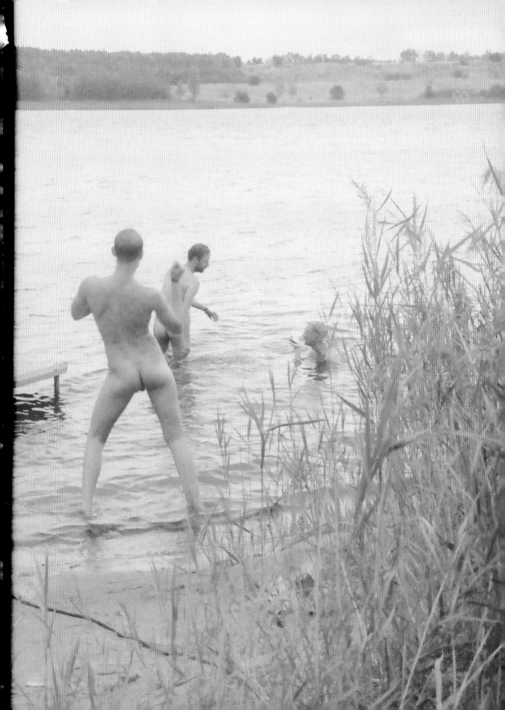

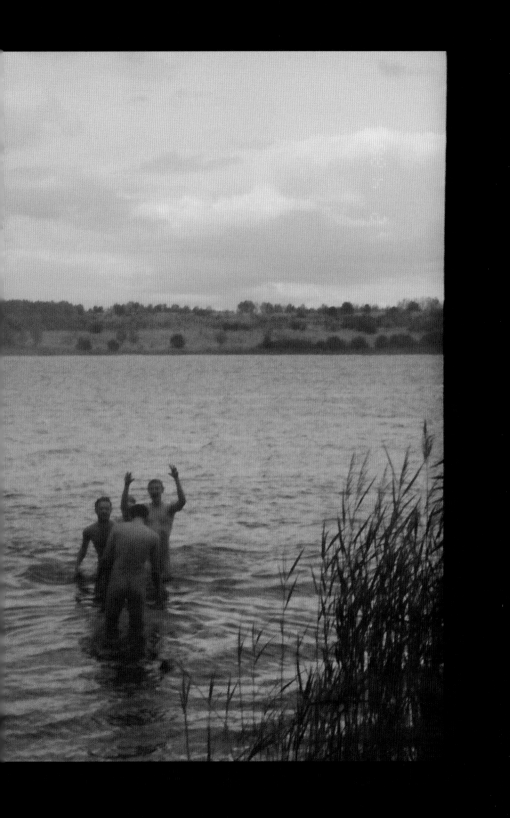

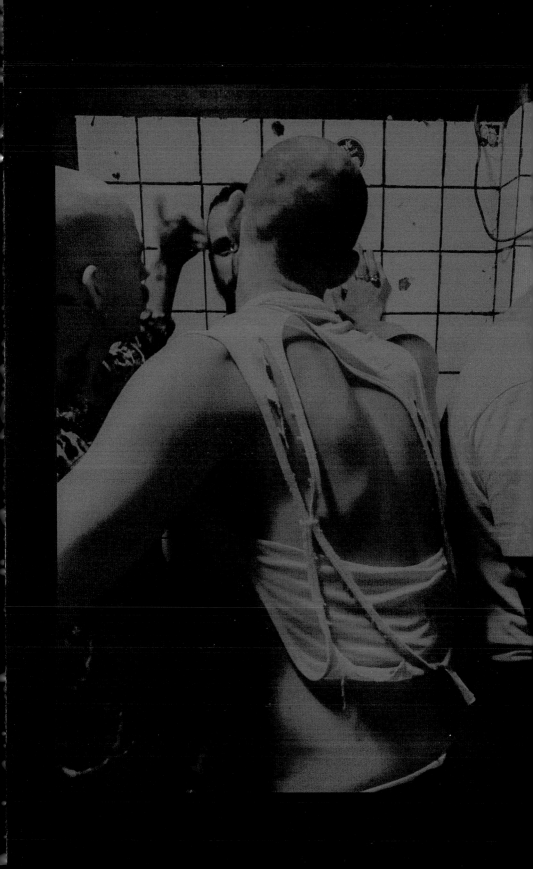

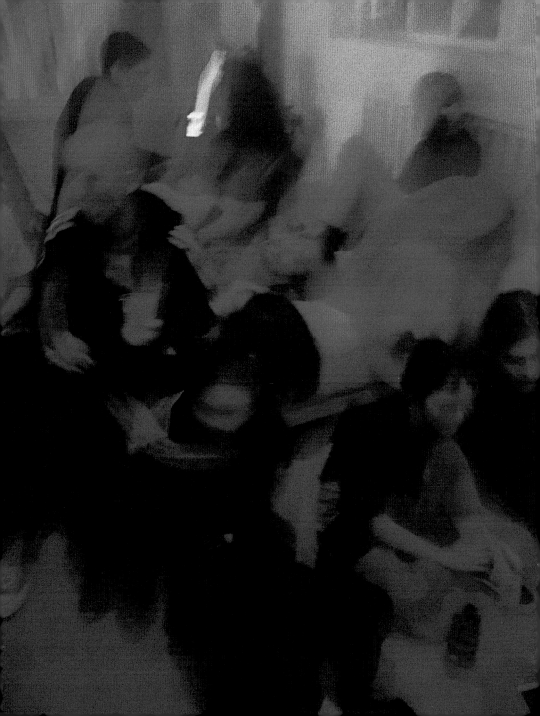

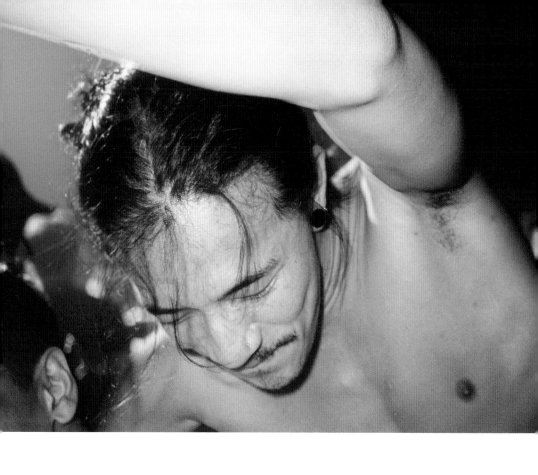

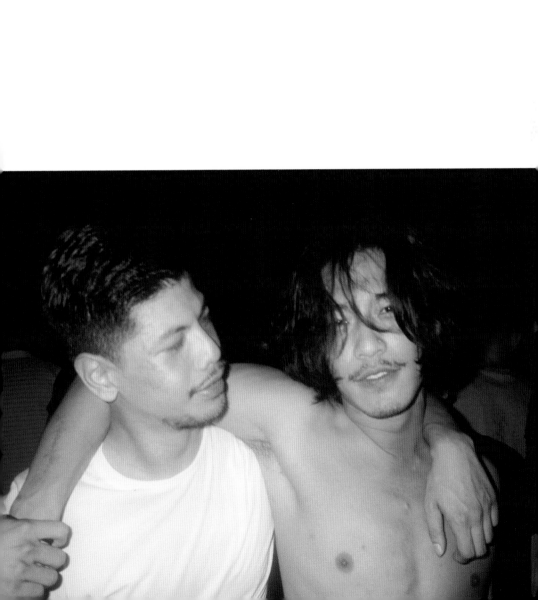

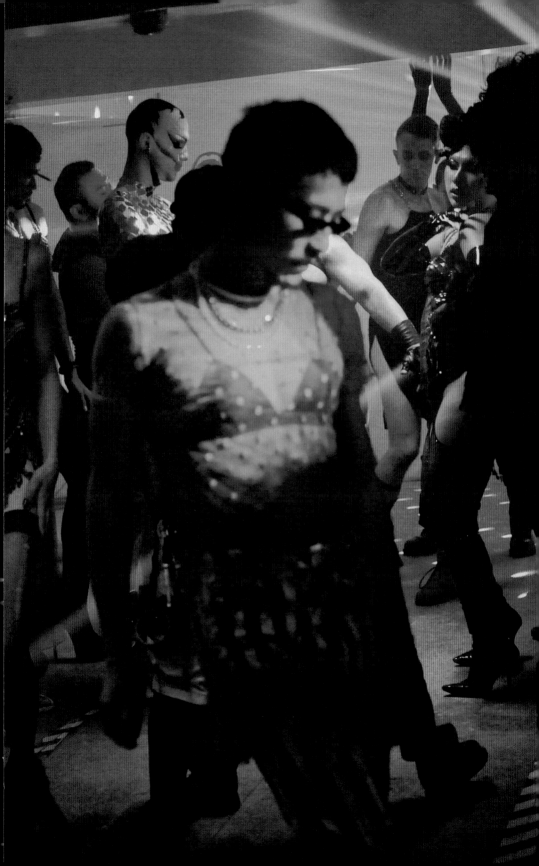

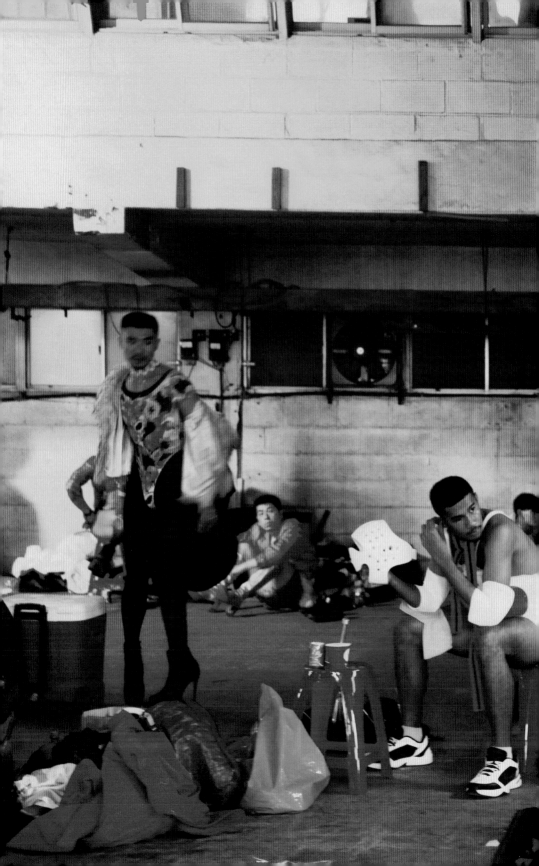

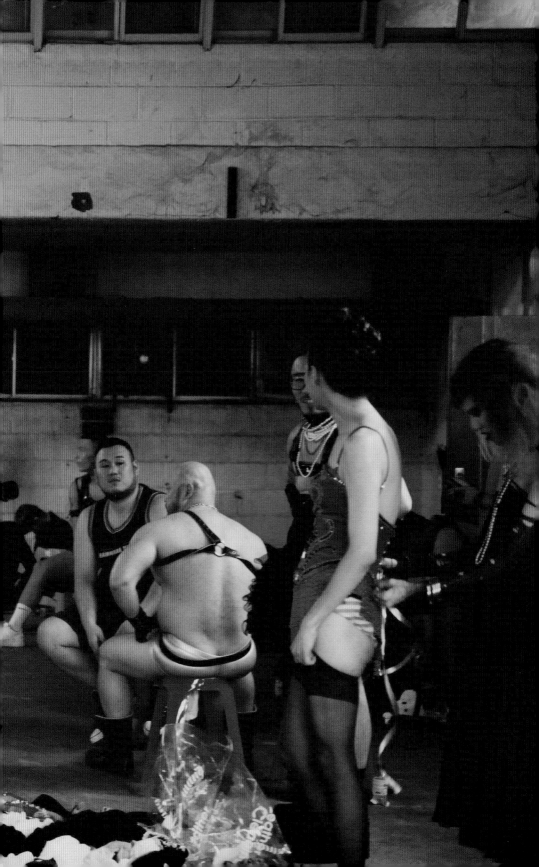

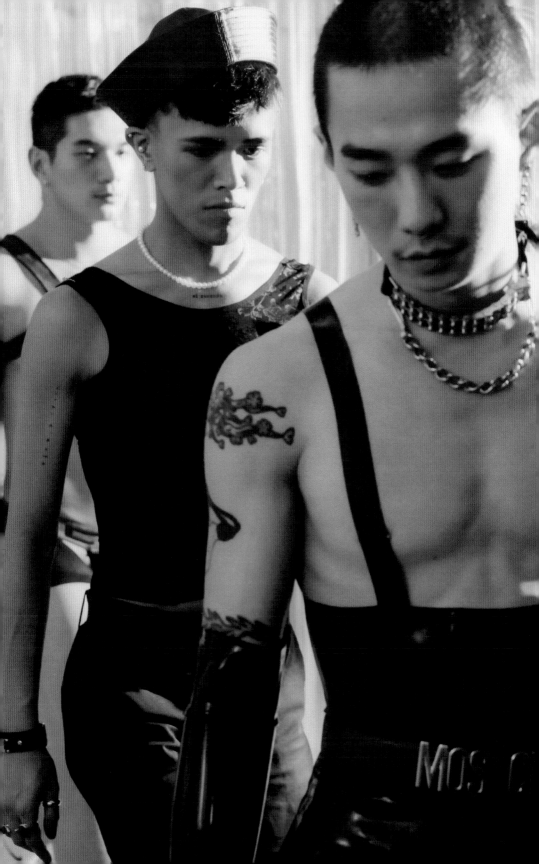

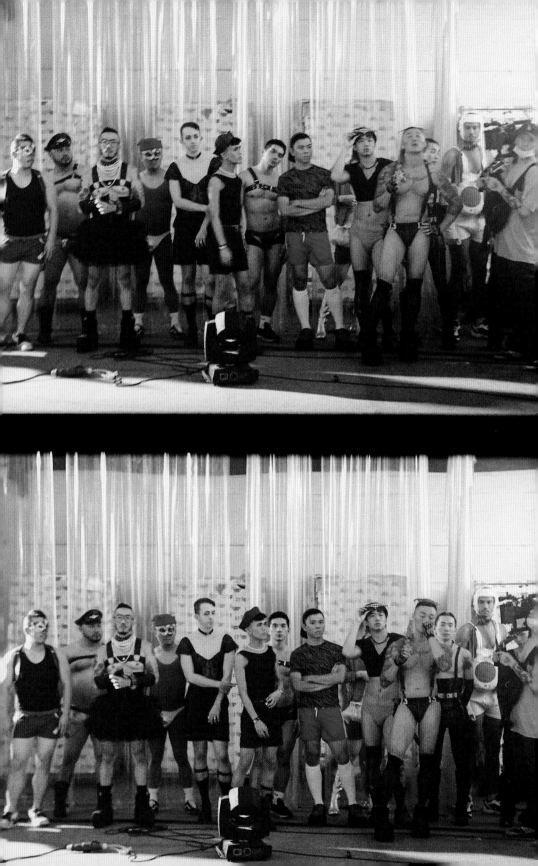

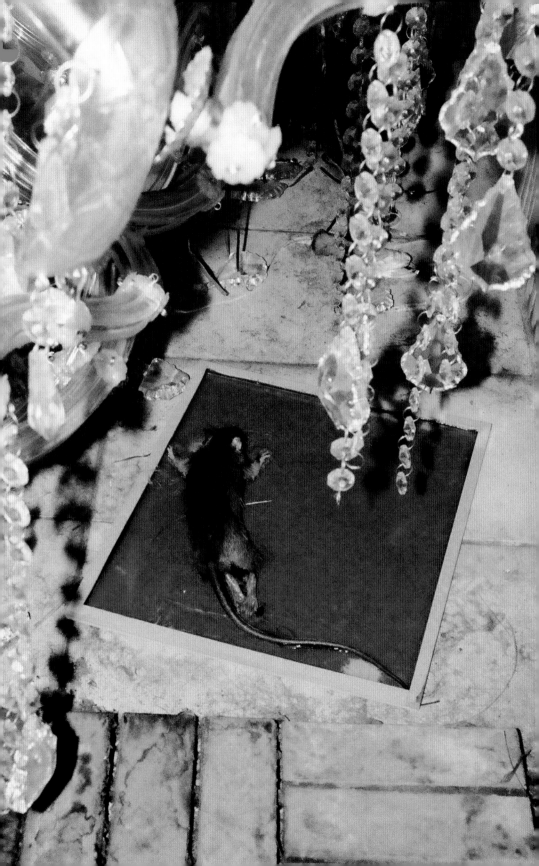

妹
学生好
114 15
1716816834

学生妹
170578 2588 9

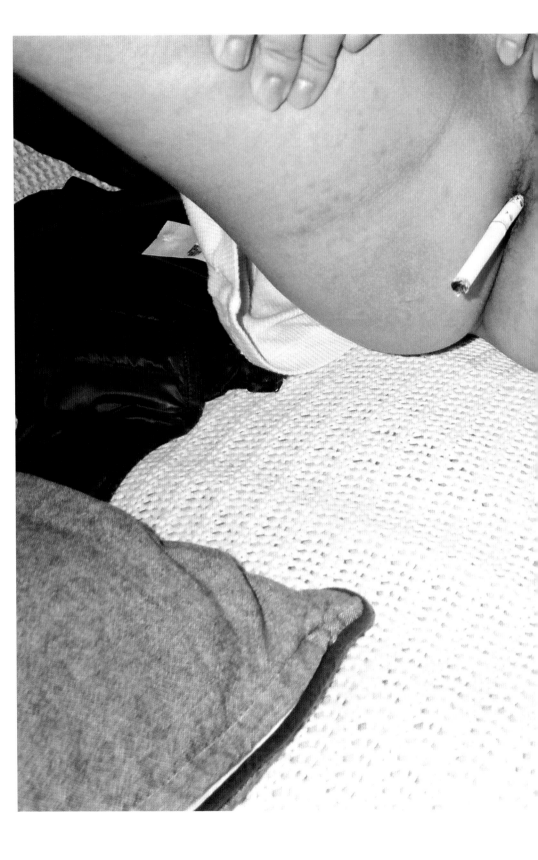

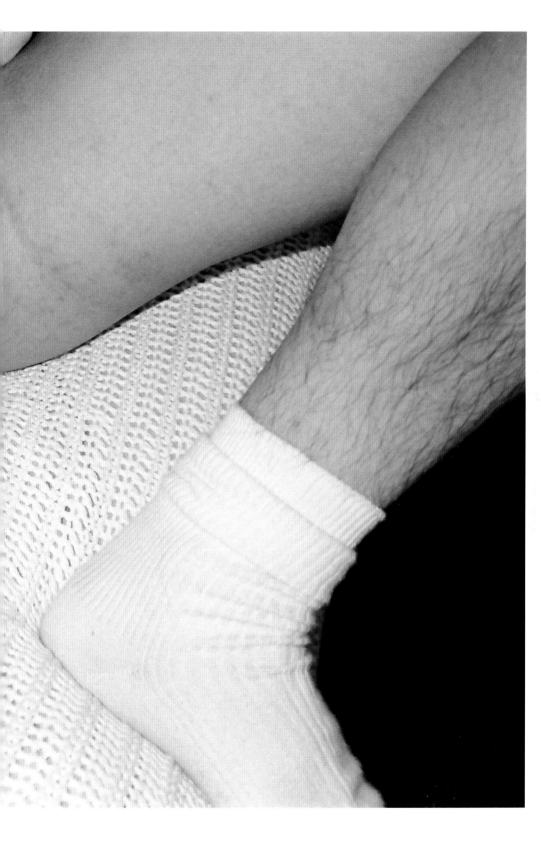

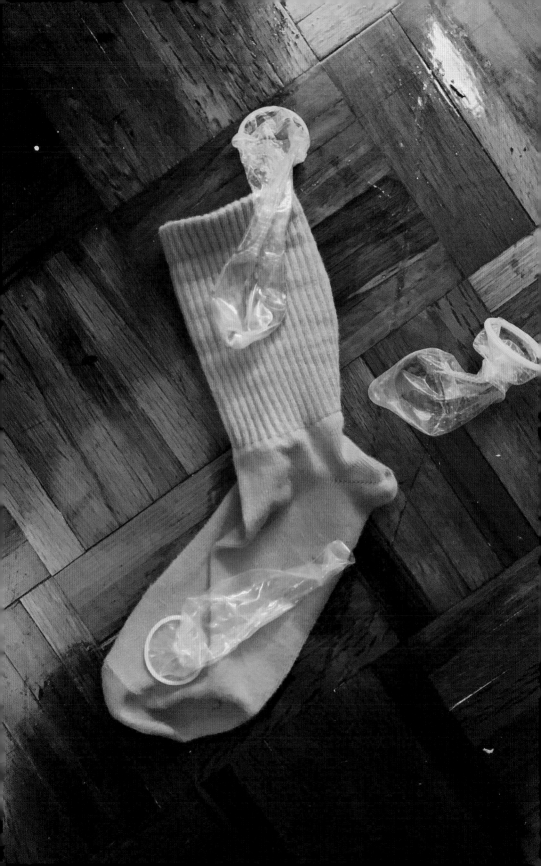

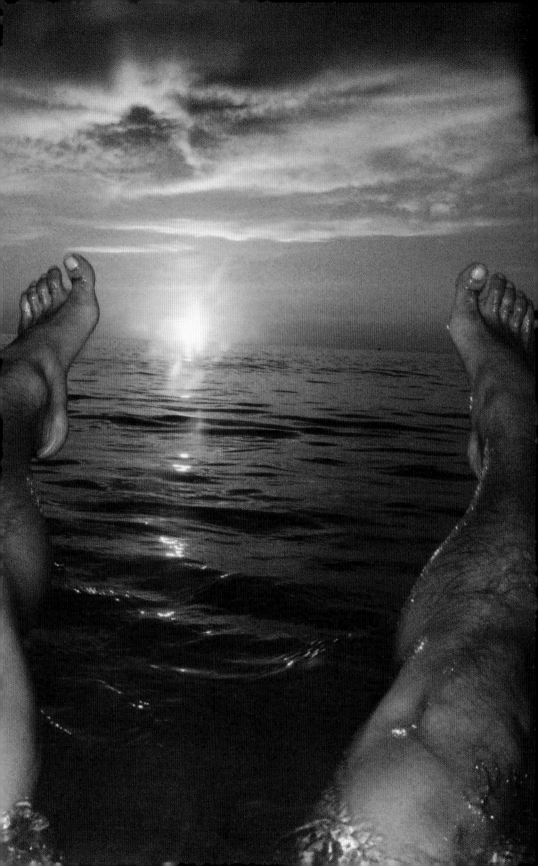

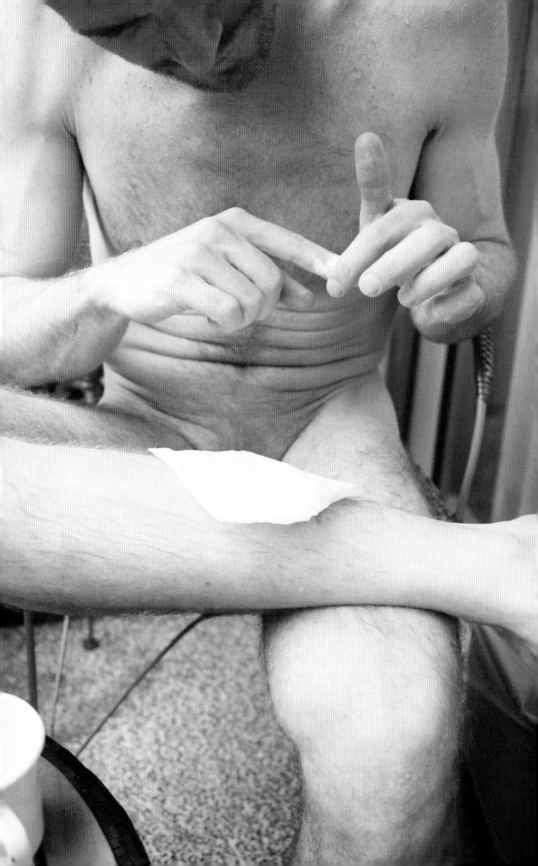

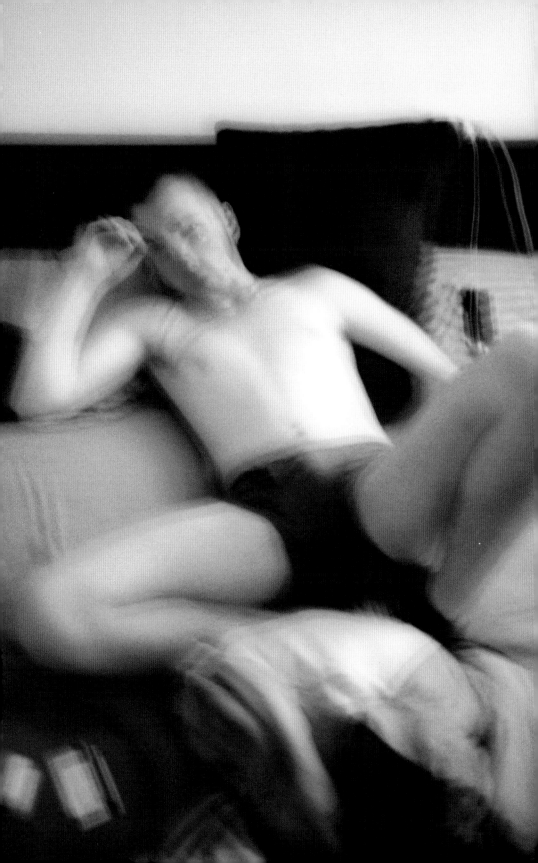

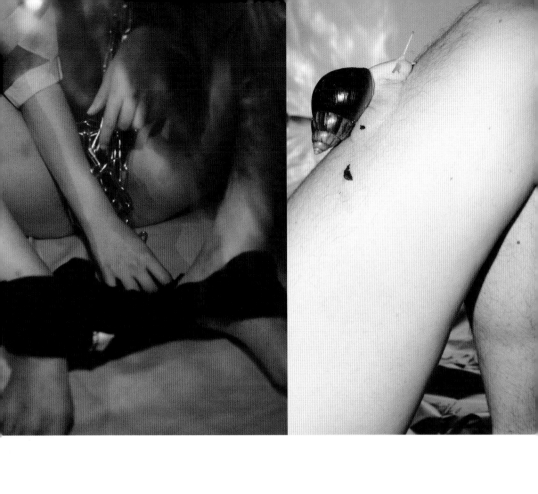

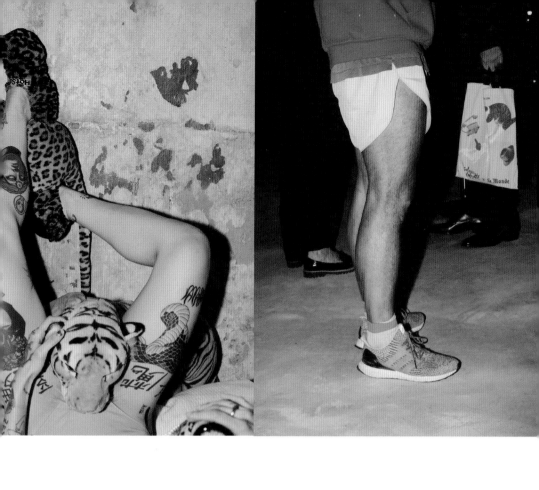

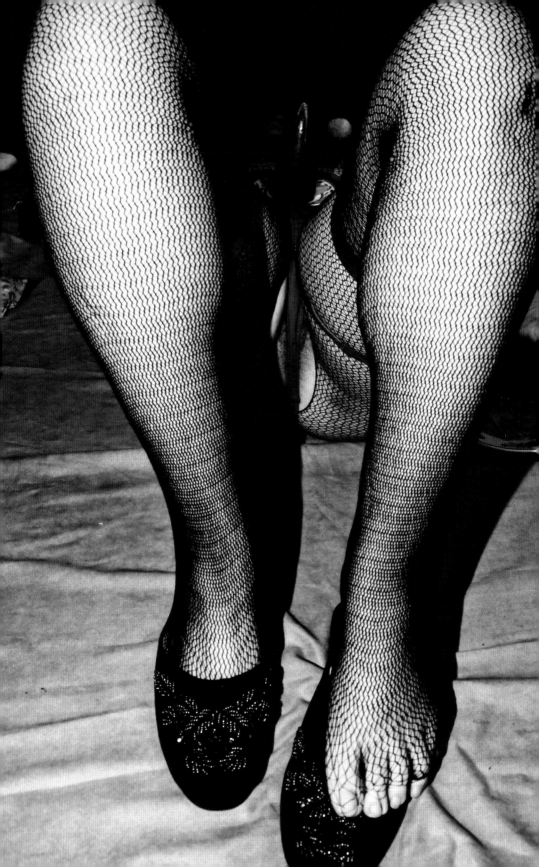

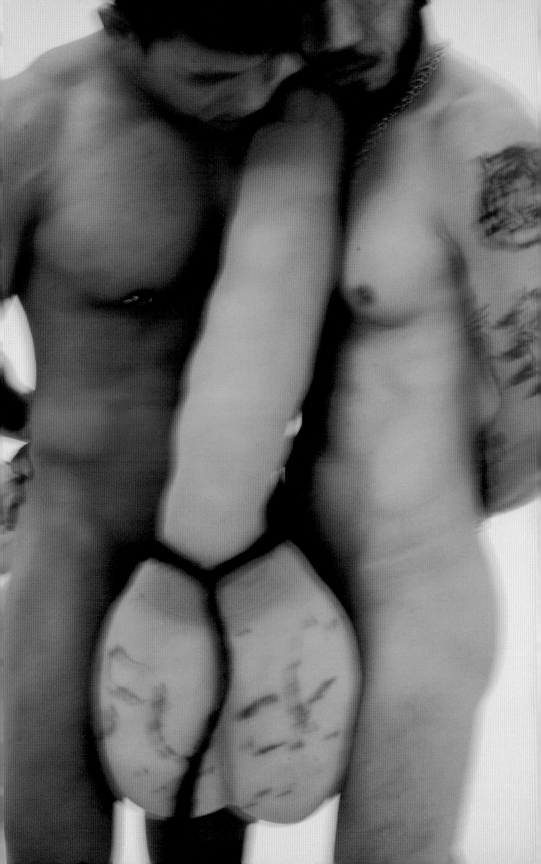

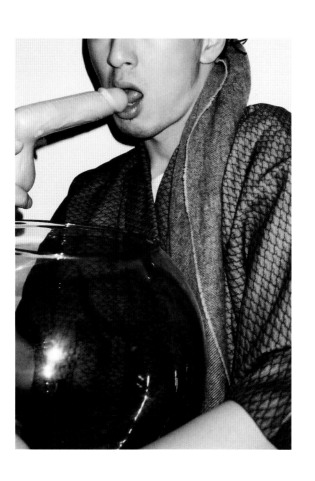

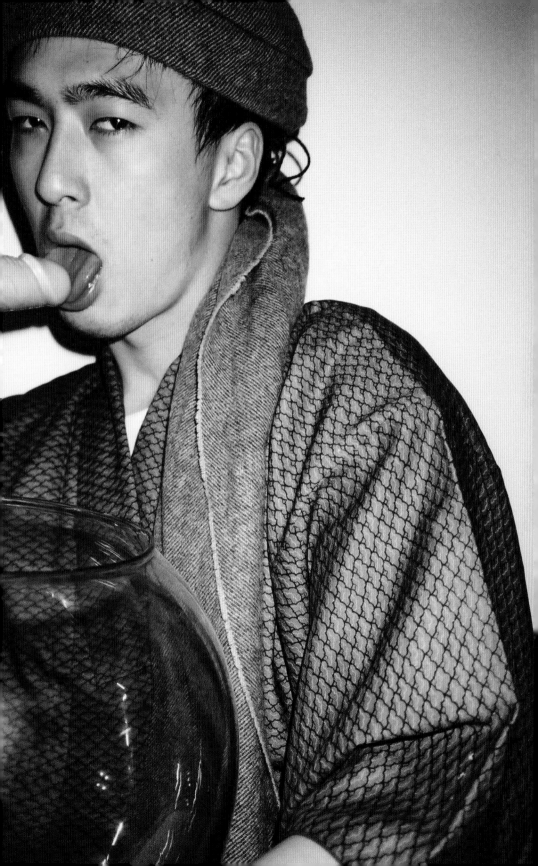

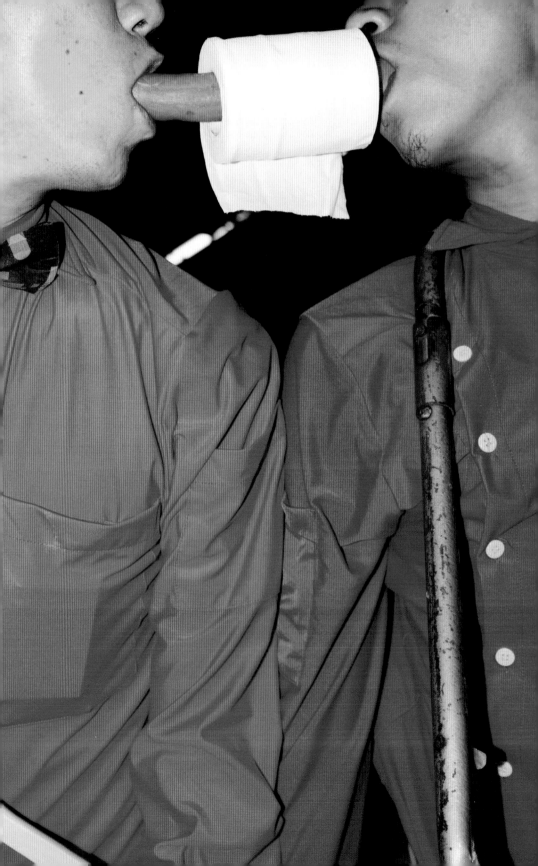

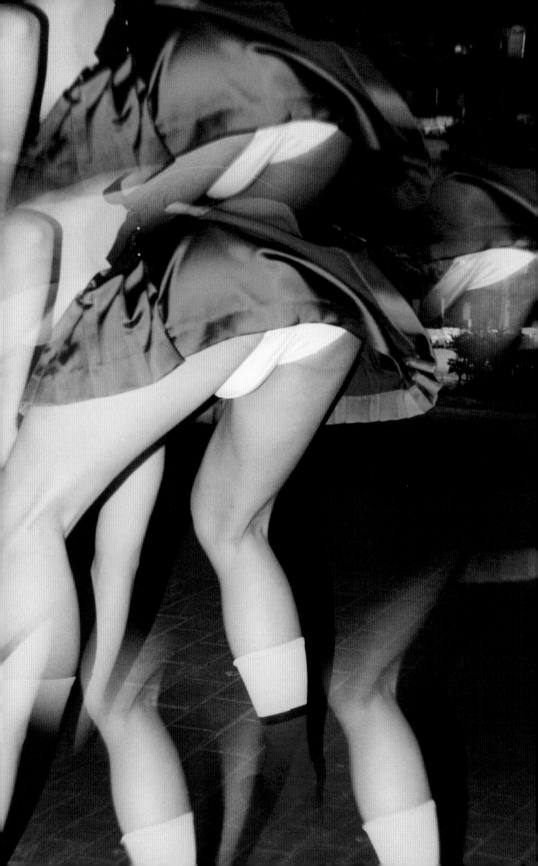

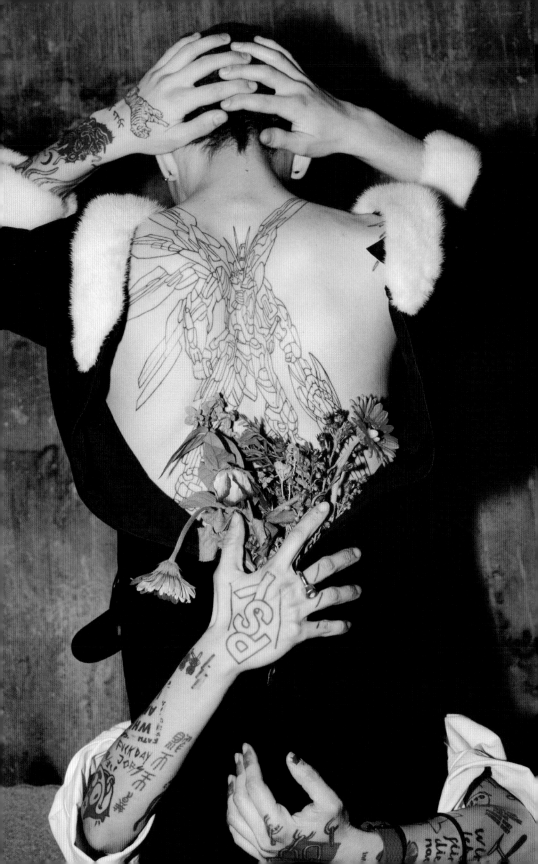

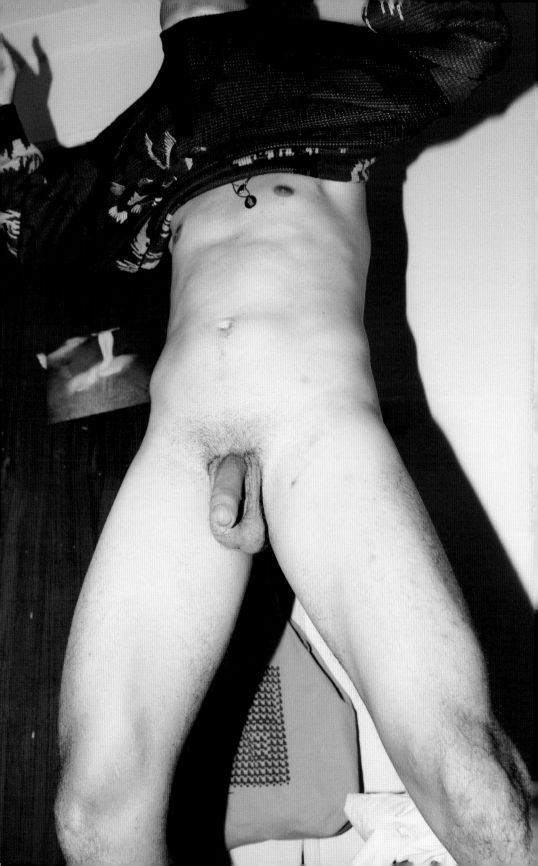

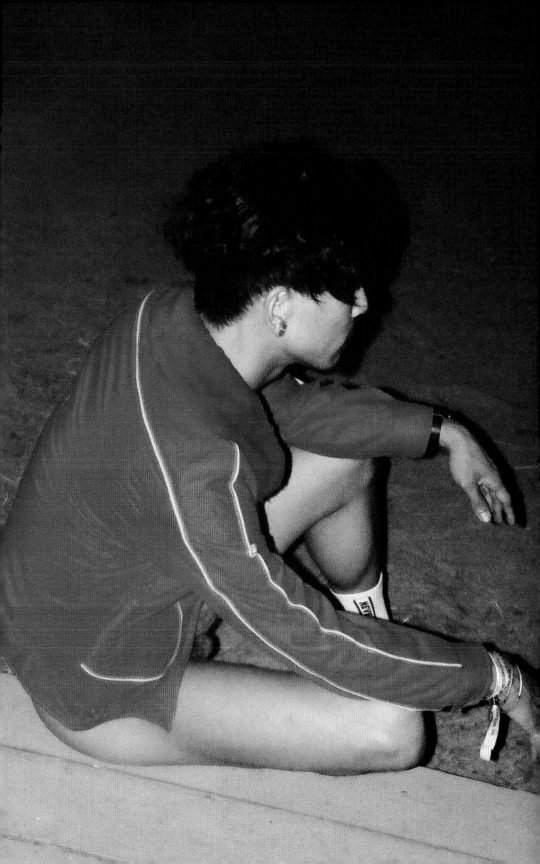

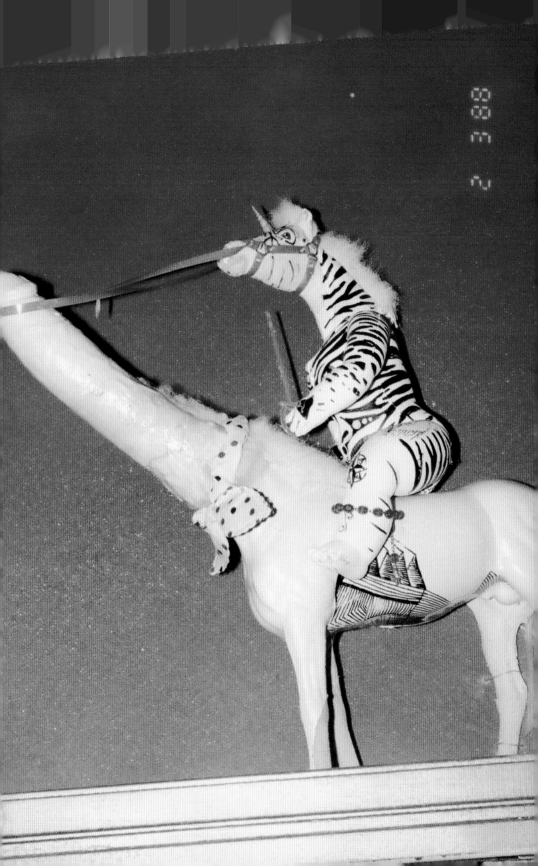

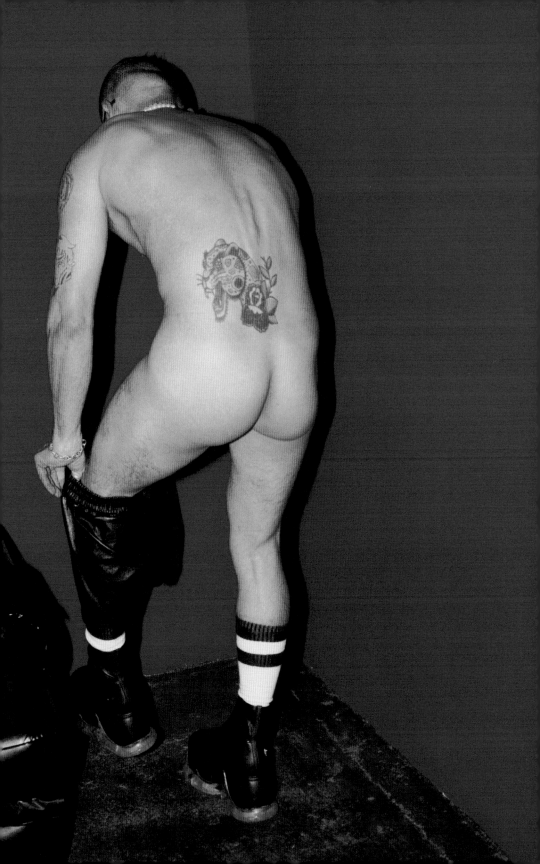

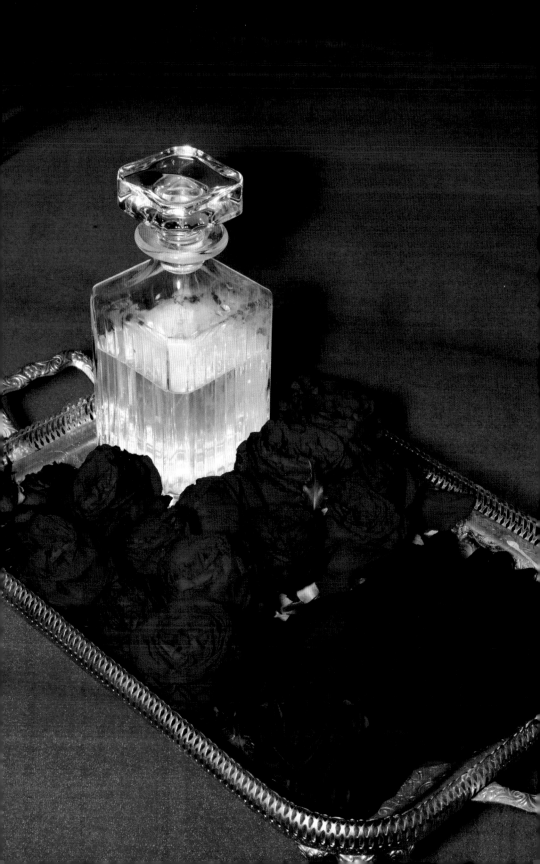

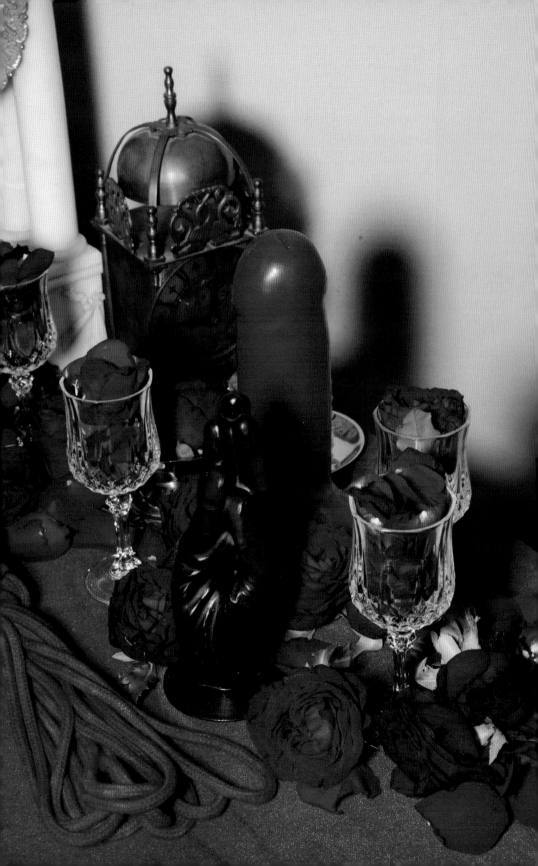

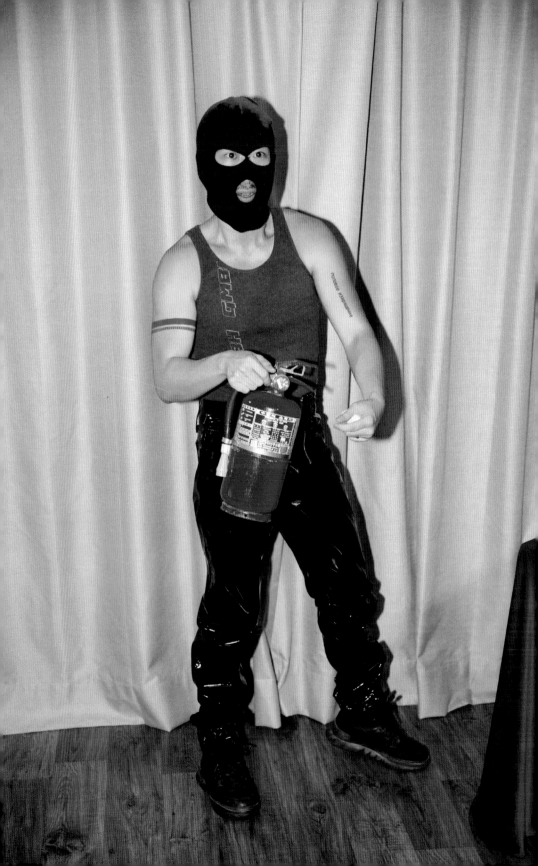

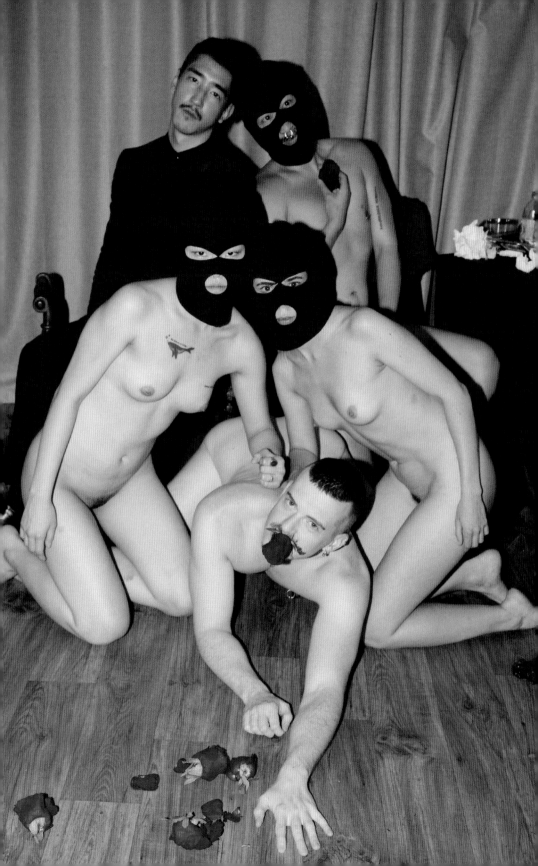

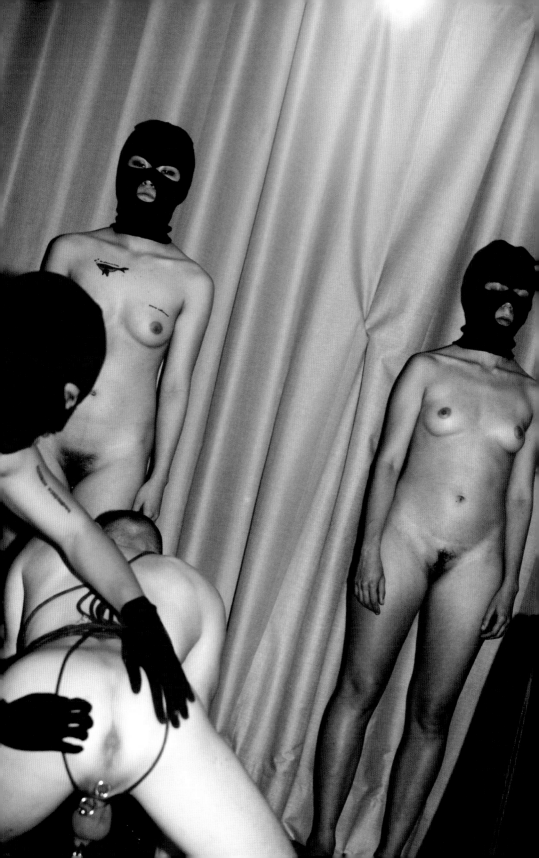

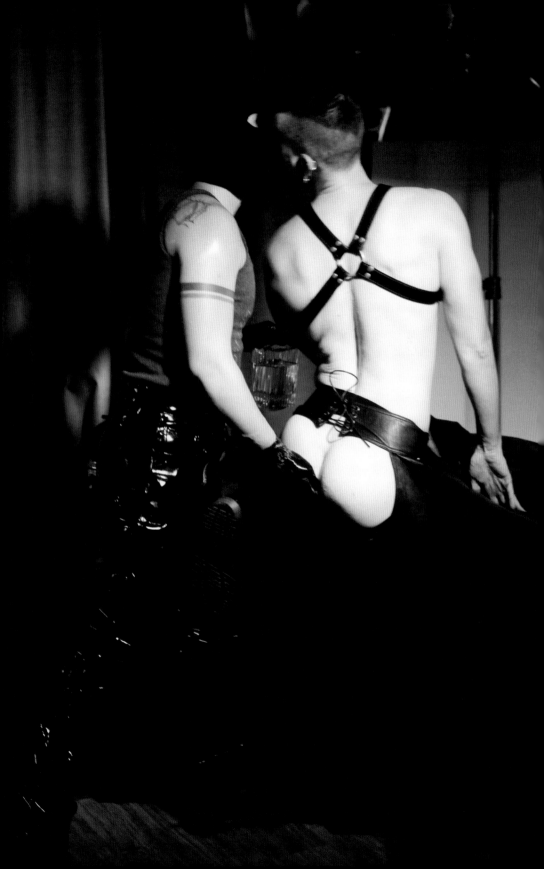

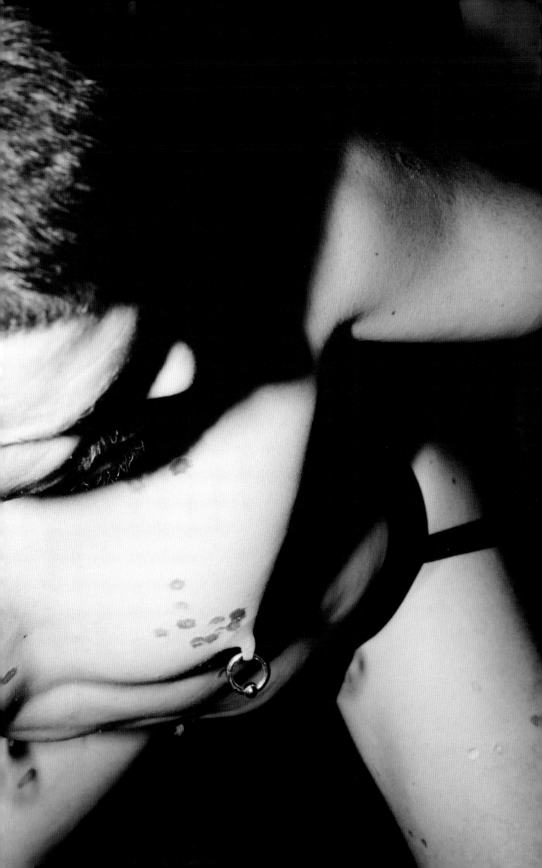

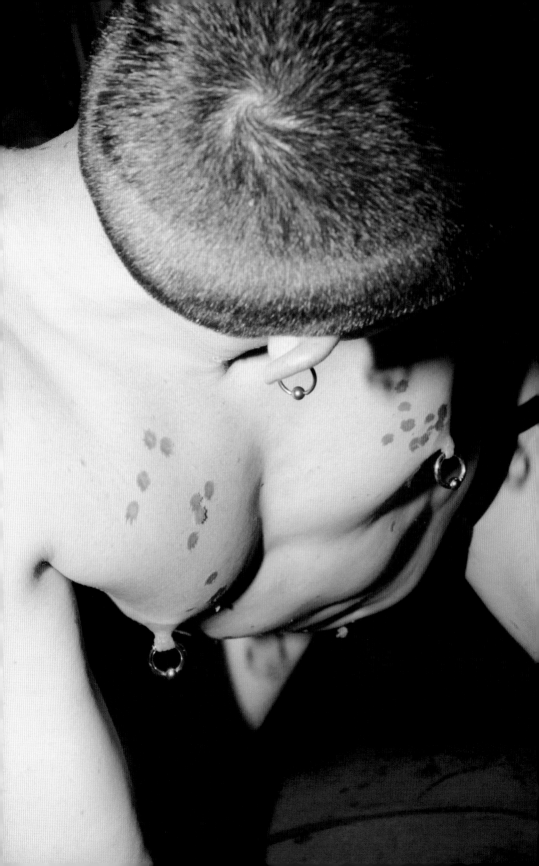

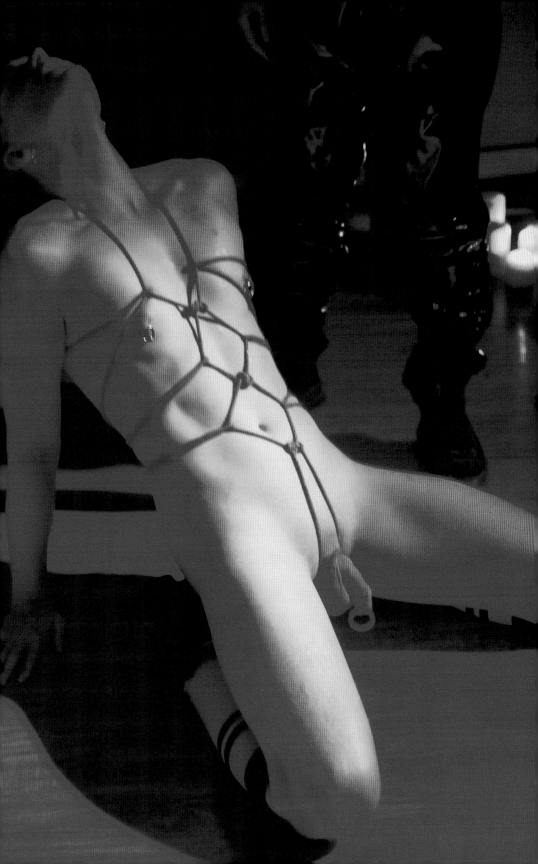

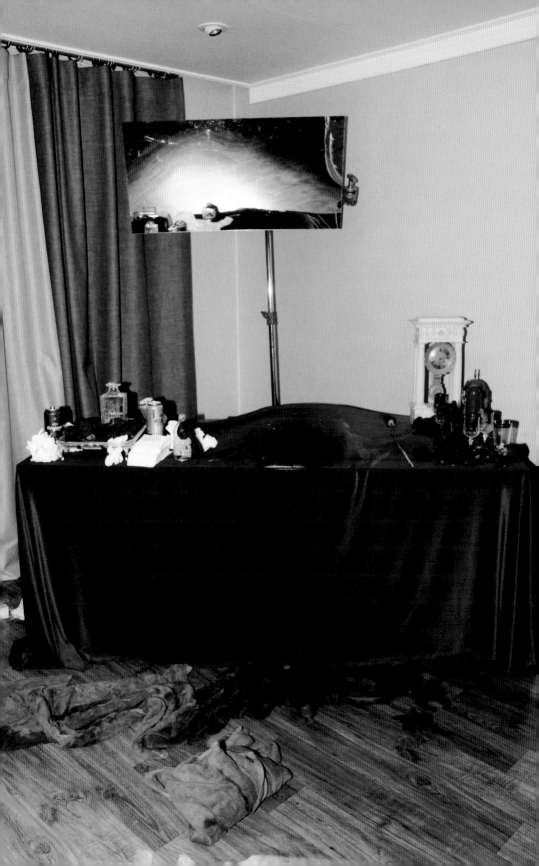

"My hole is my curse. We must destroy it so I can find serenity."—Axel Ab

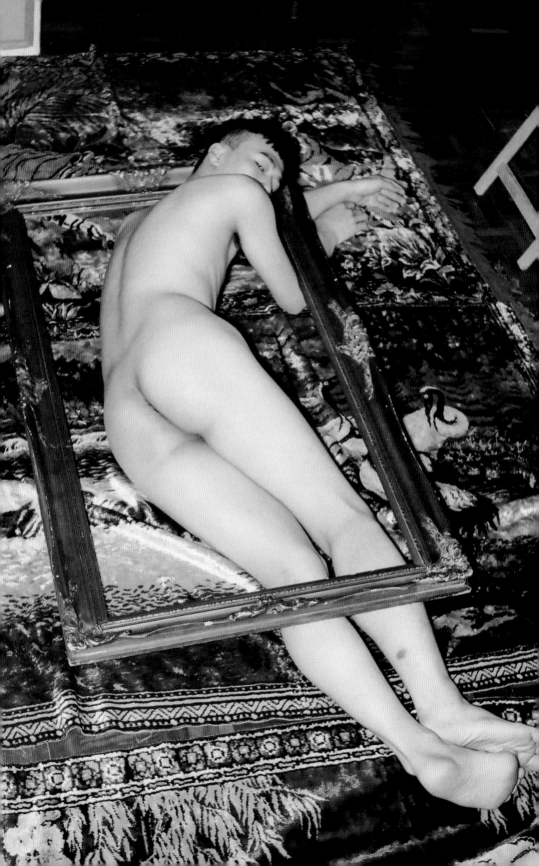

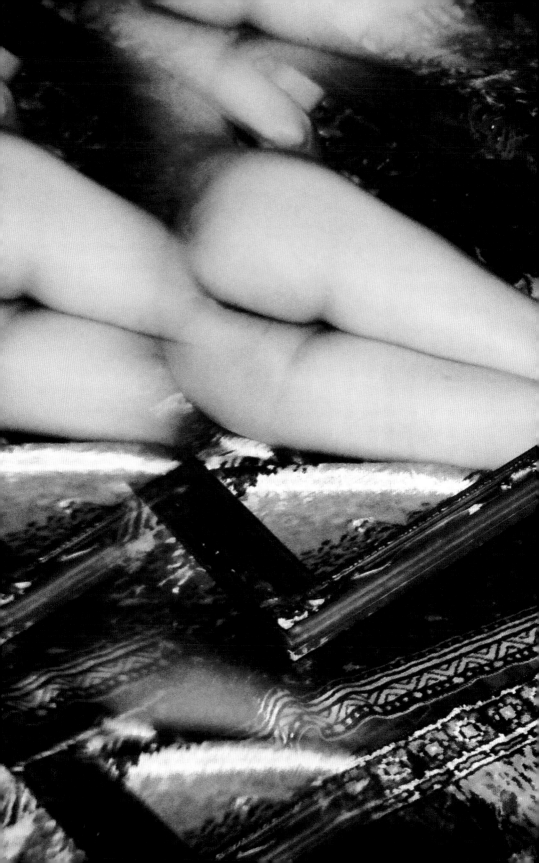

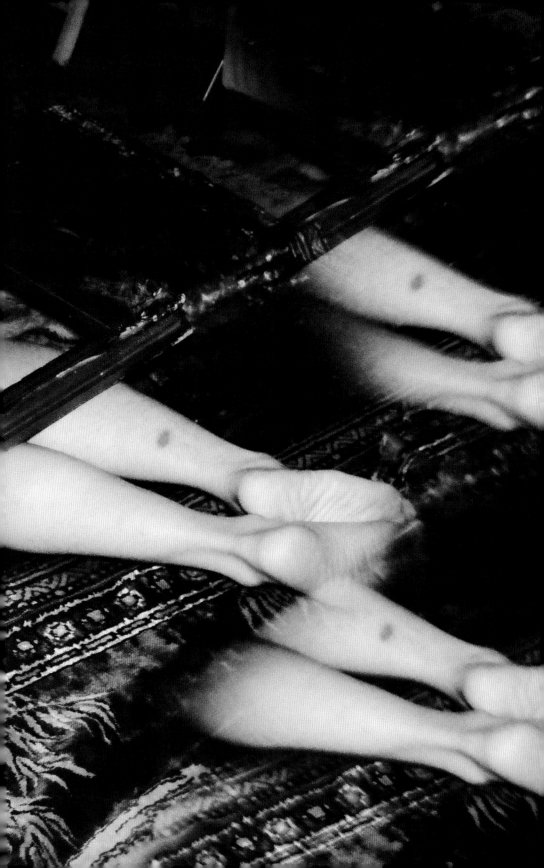

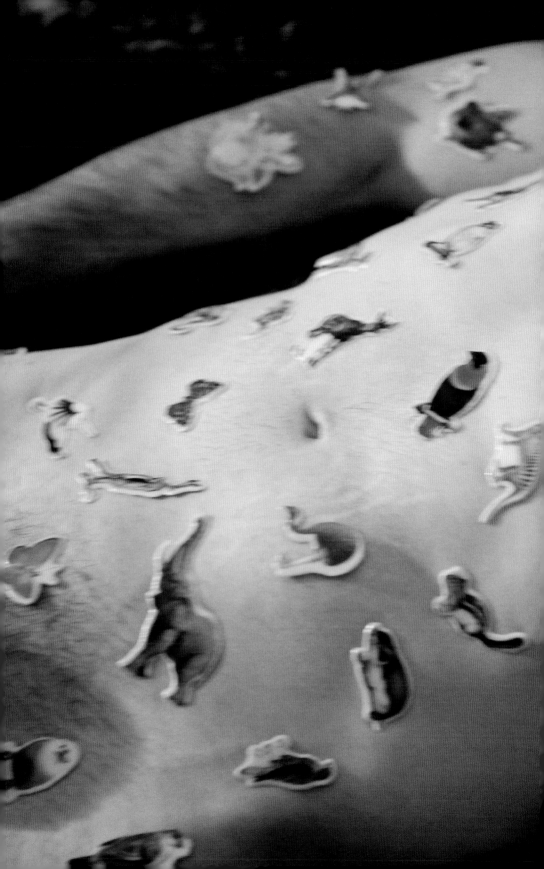

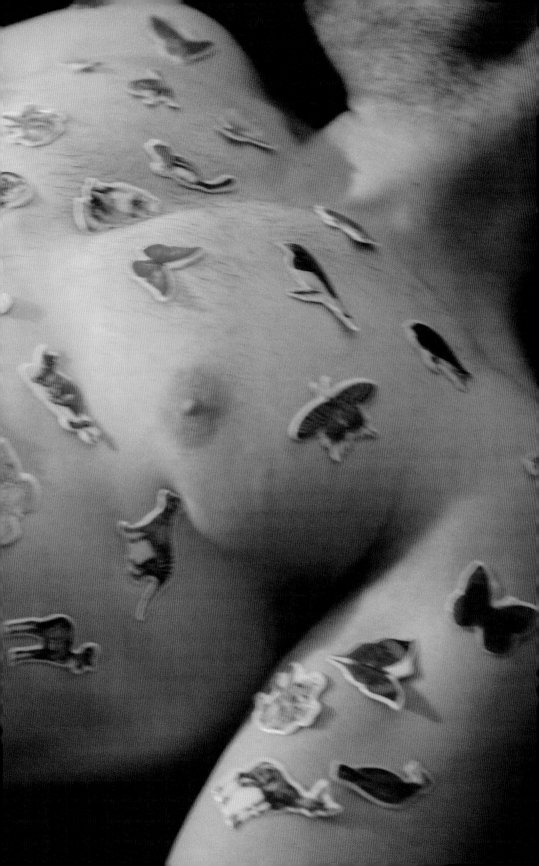

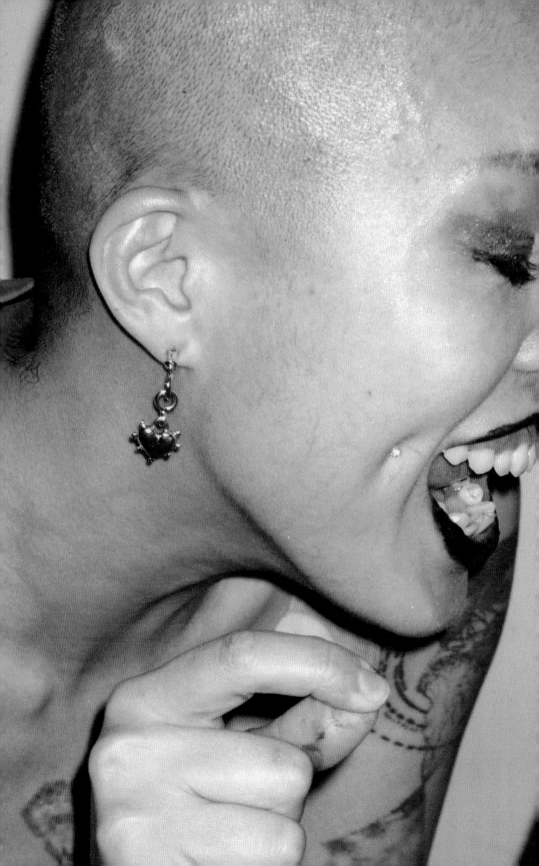

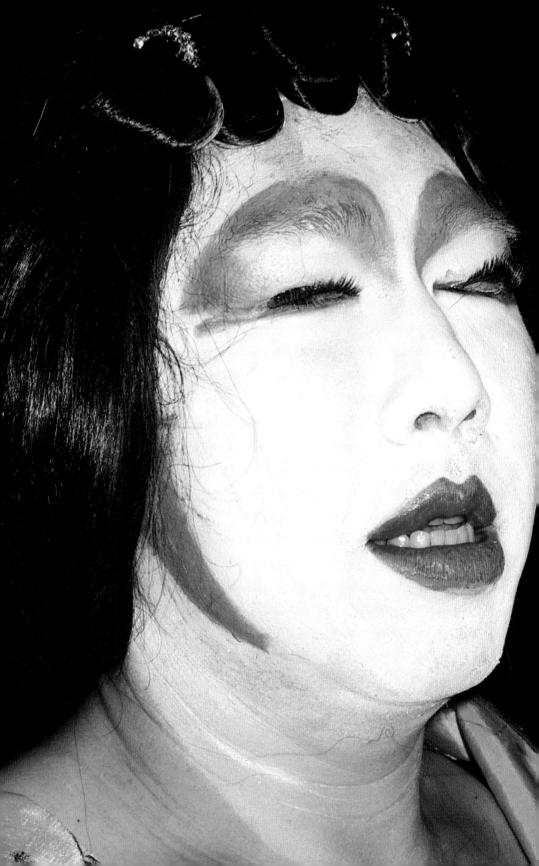

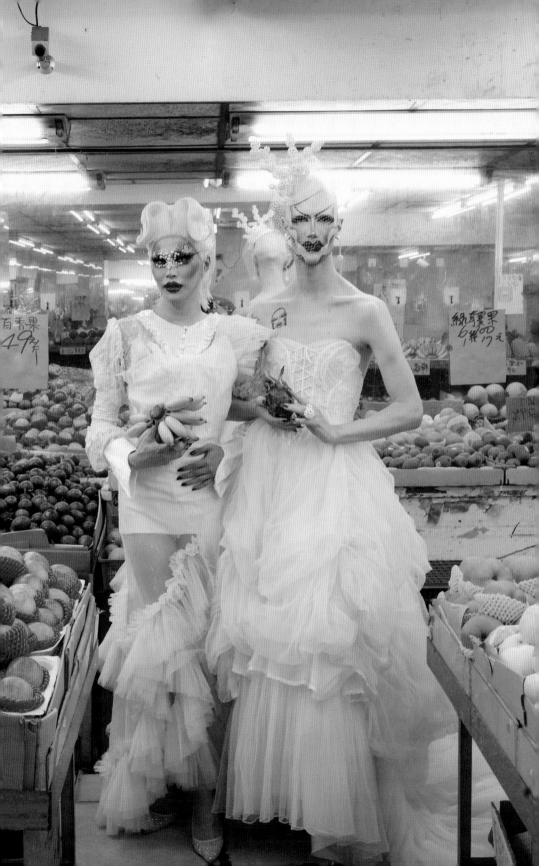

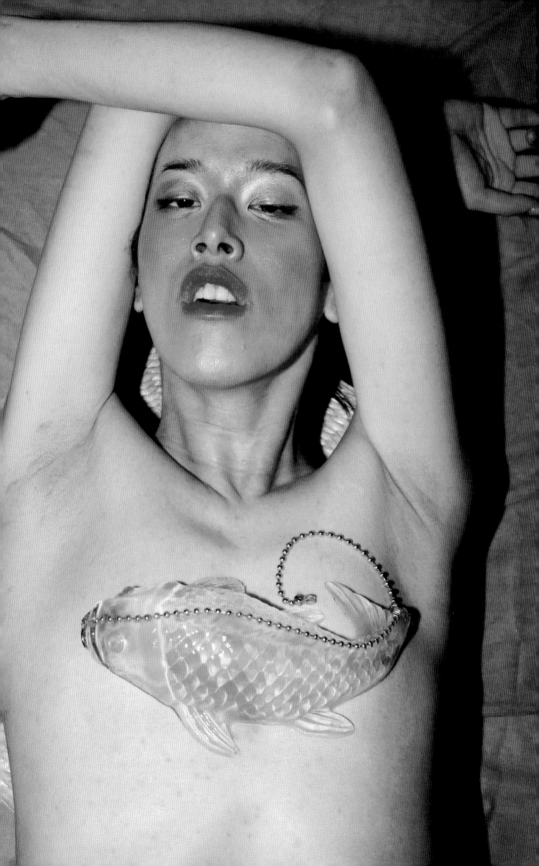

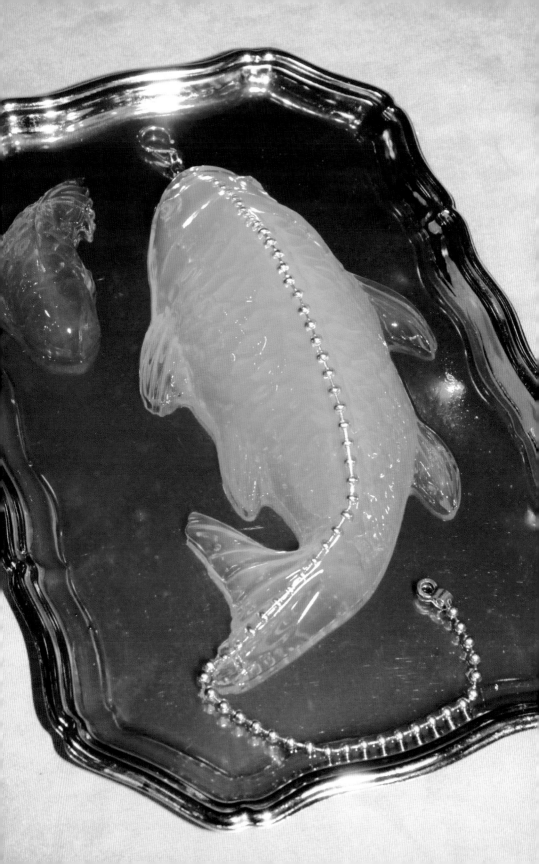

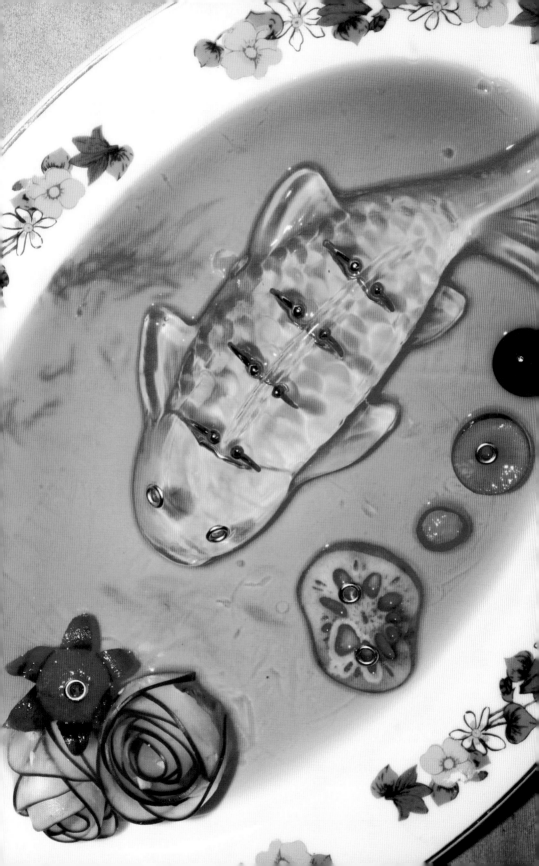

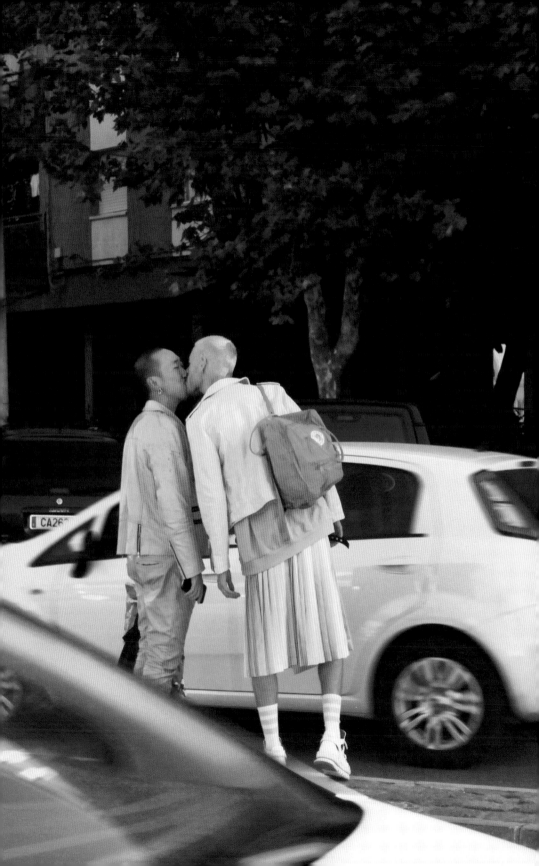

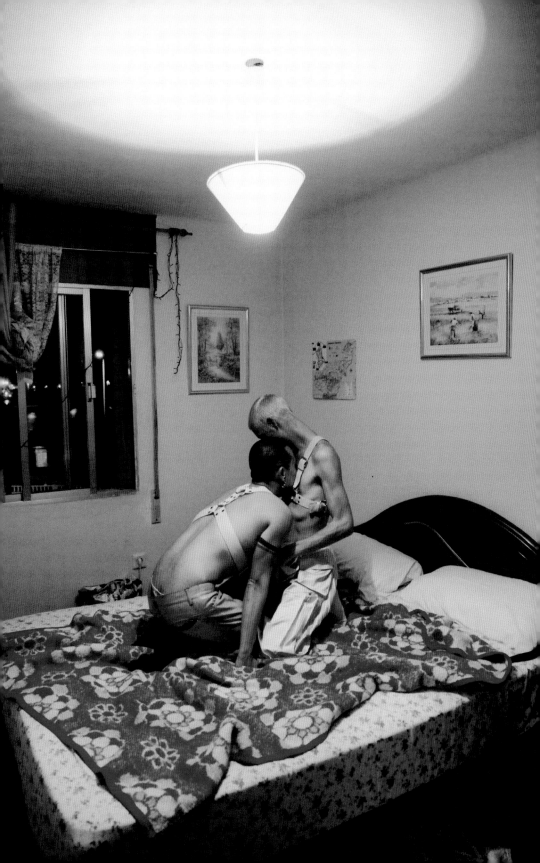

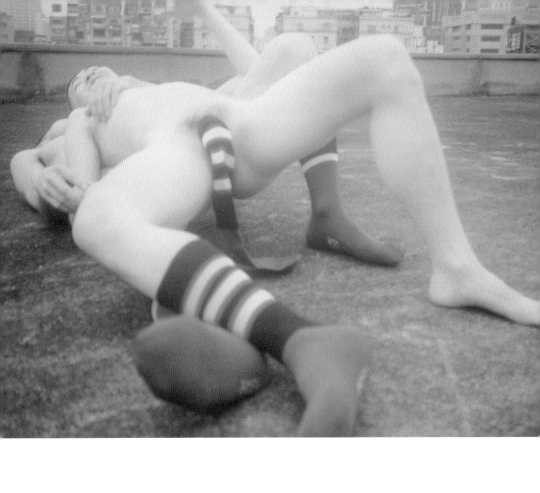

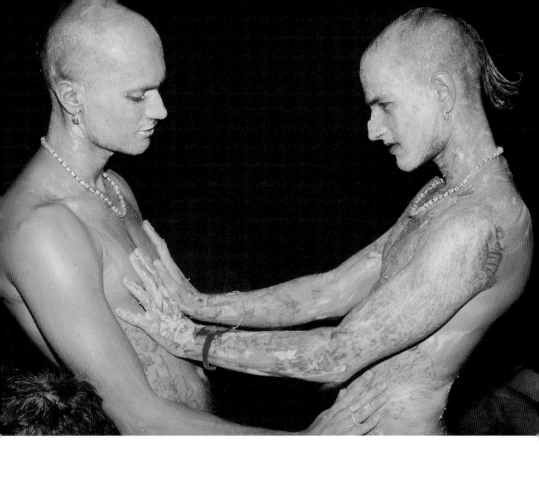

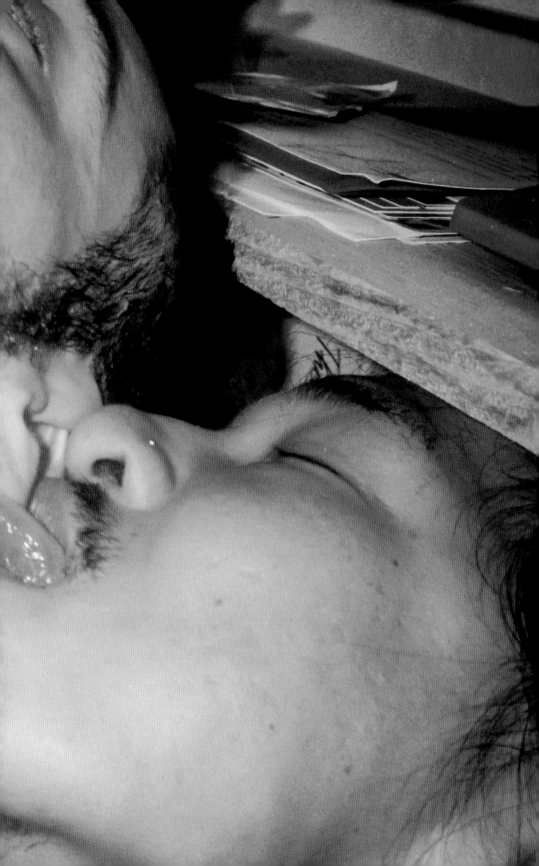

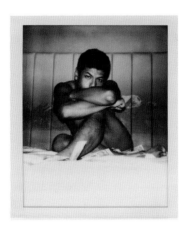

ばんばんぞい　はんばんぞい

おともの犬や　さる　きじは

勇んで車を　えんやらや

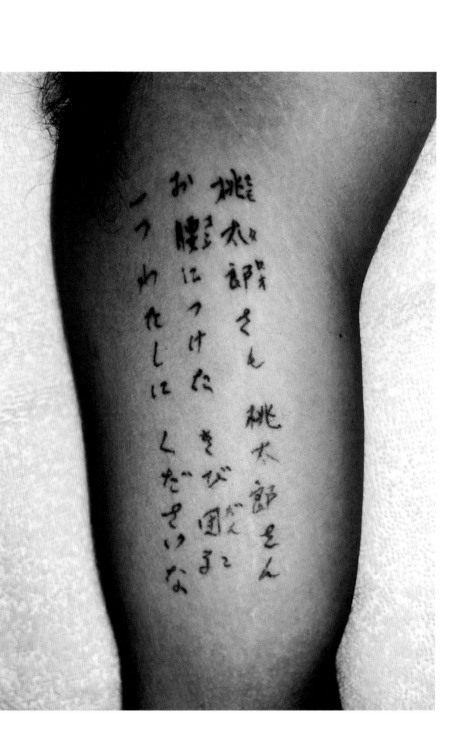

桃太郎さん　桃太郎さん
お腰につけた　きび団子
一つわたしに　くだされな

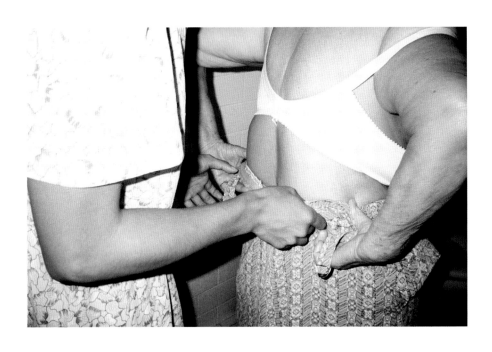

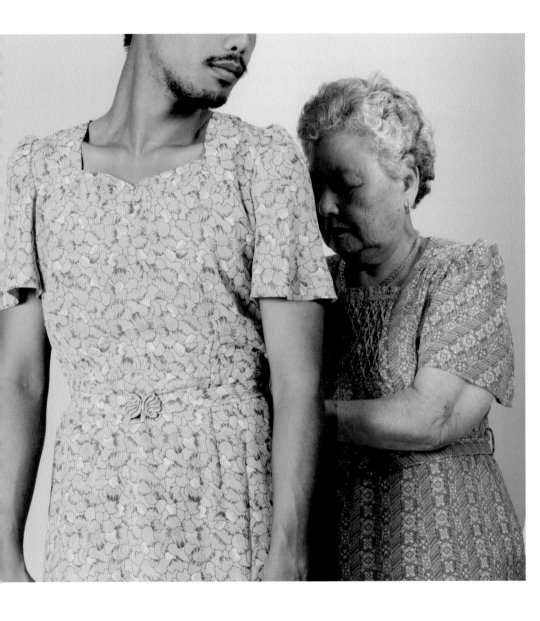

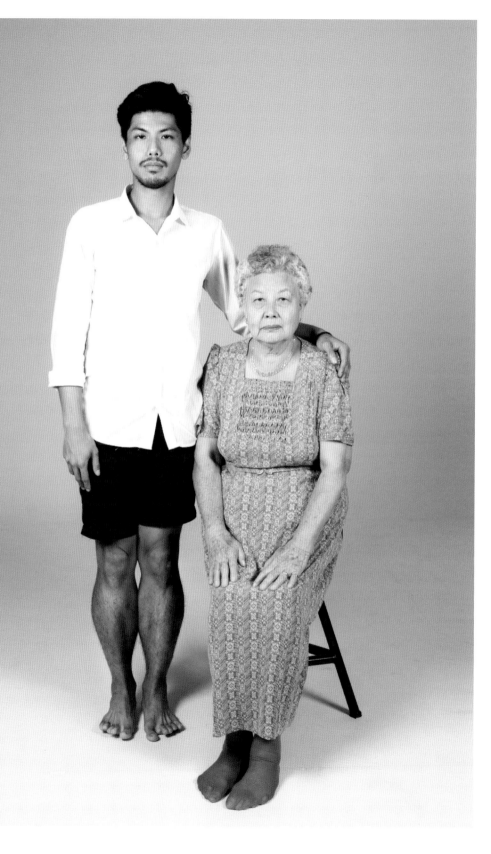

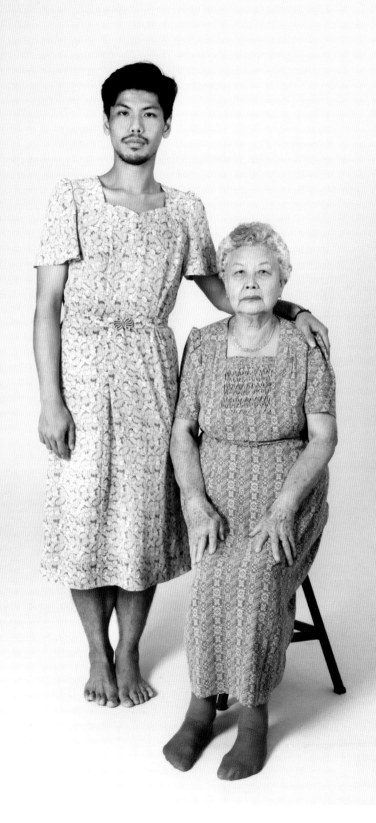

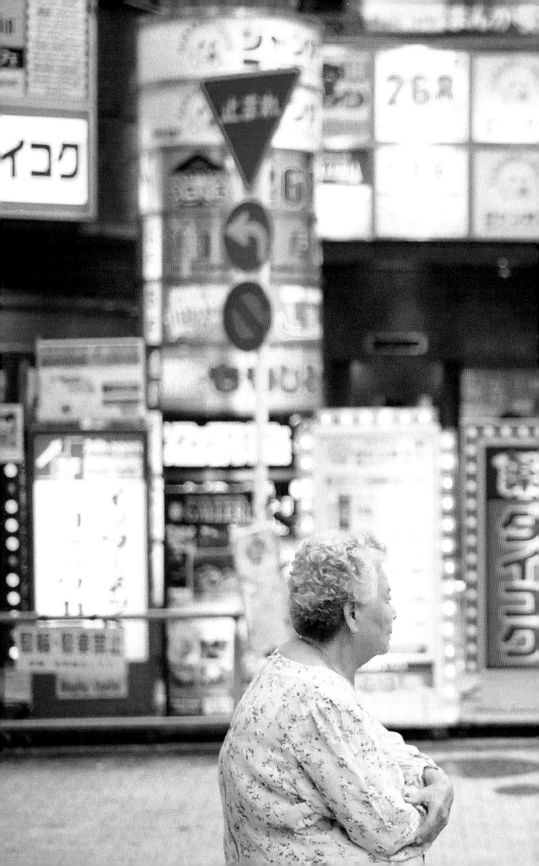

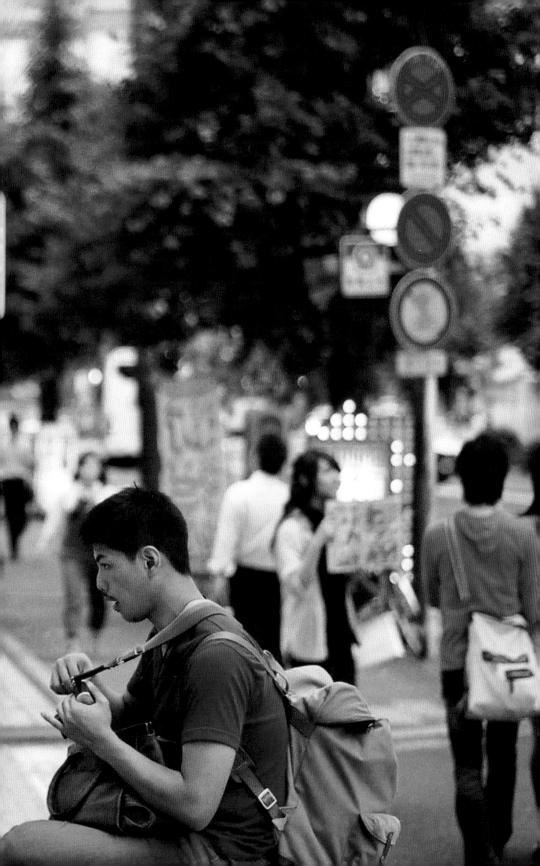

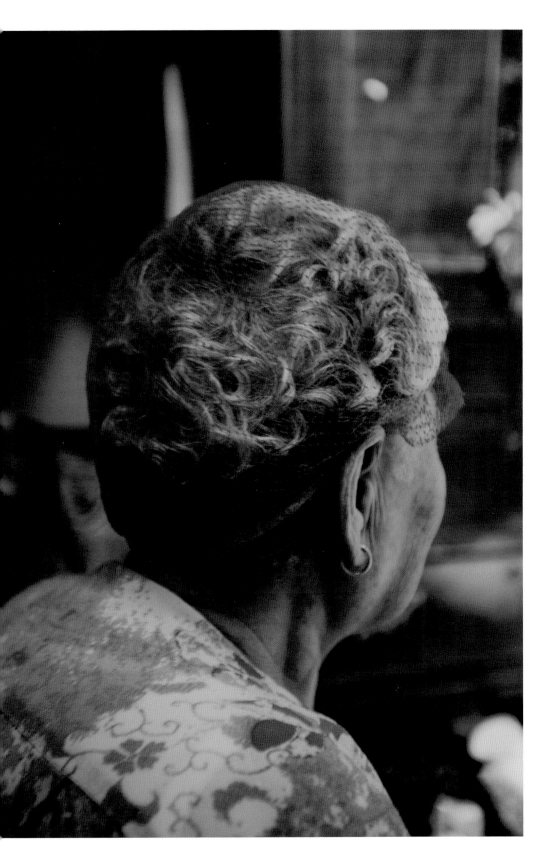

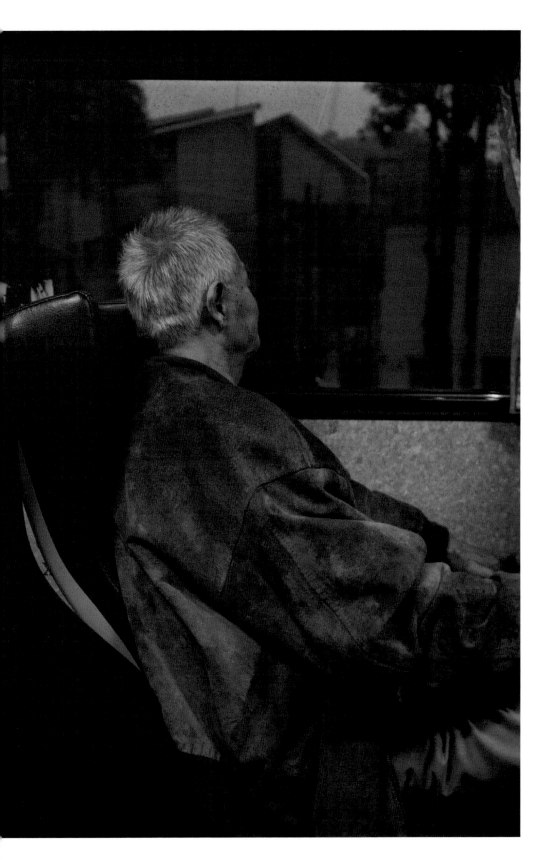

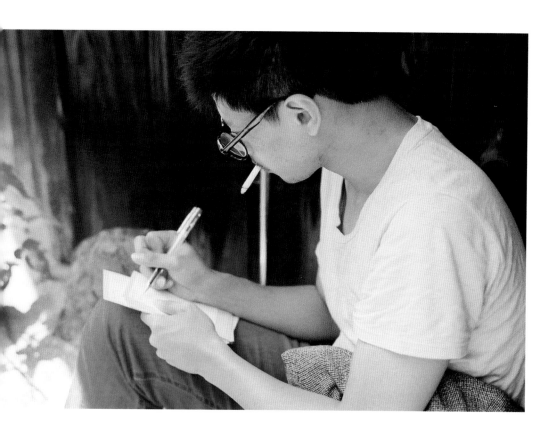

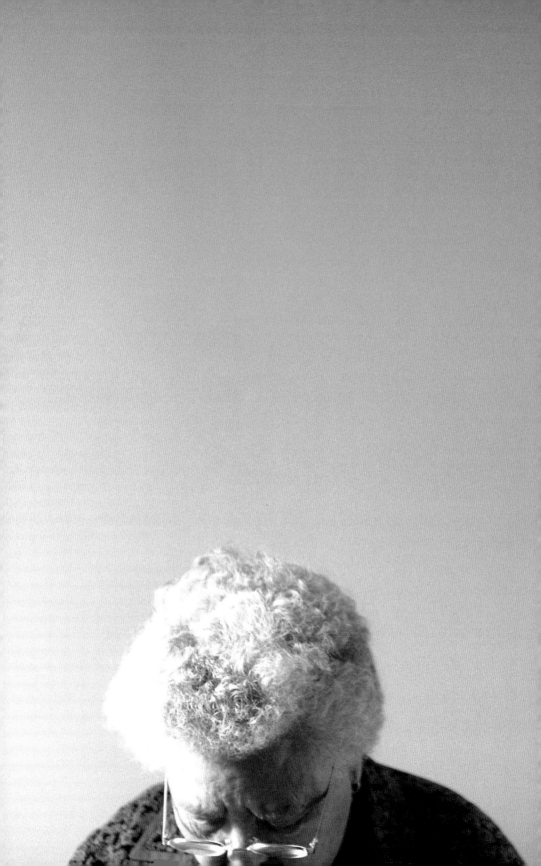

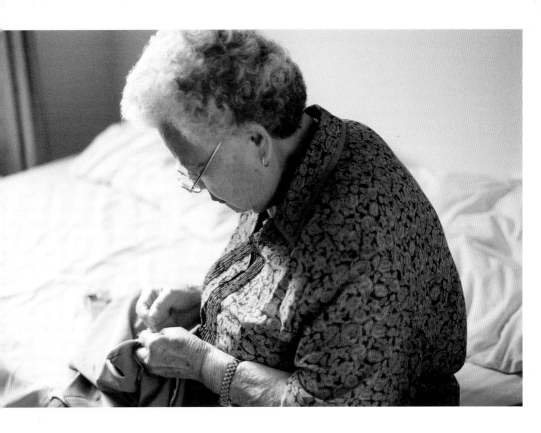

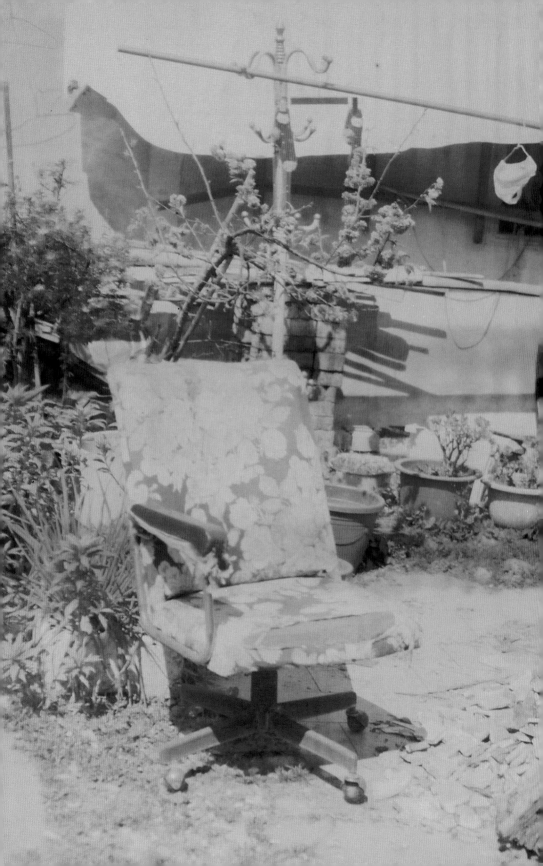

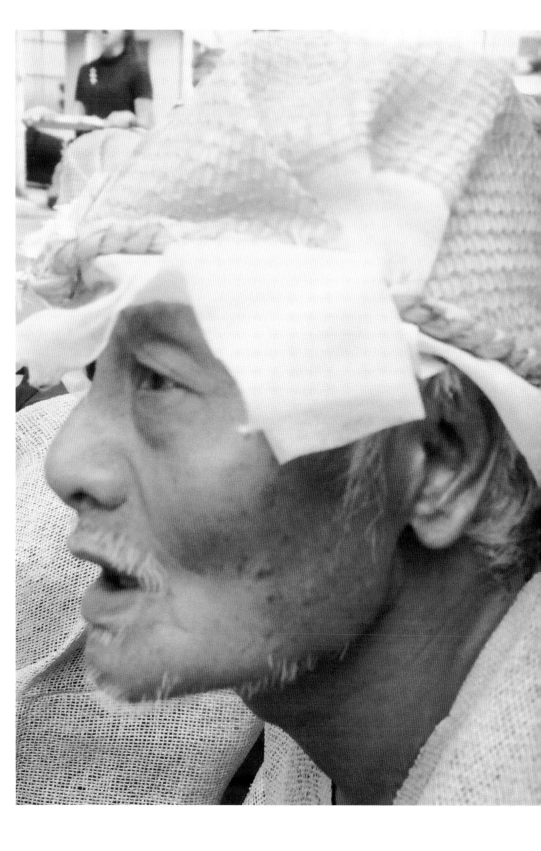

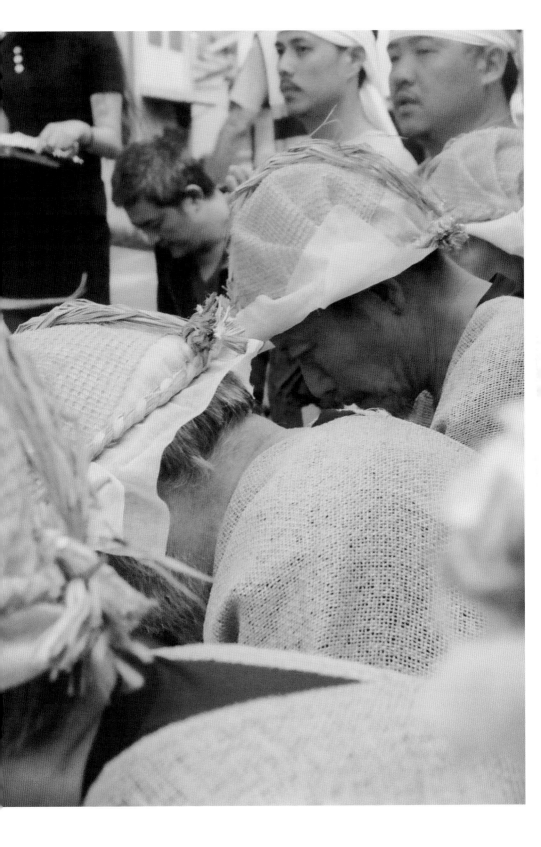

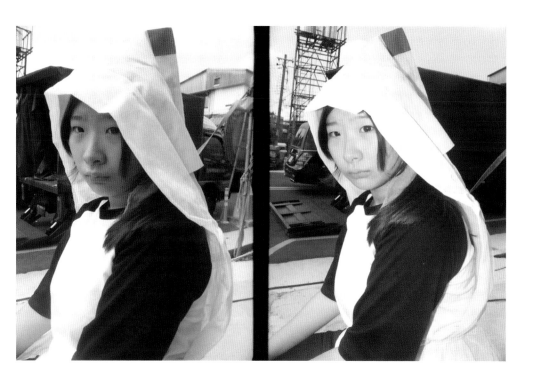

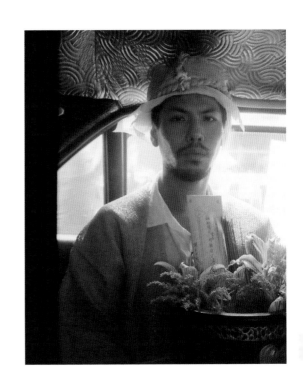

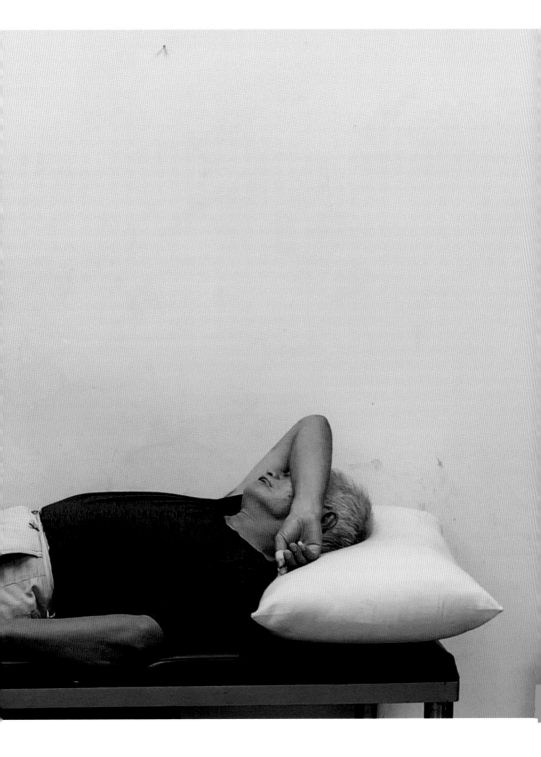

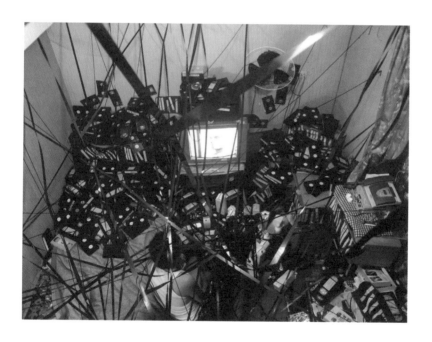

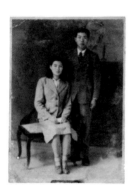

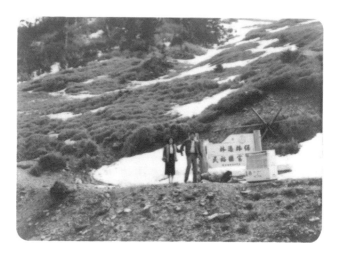

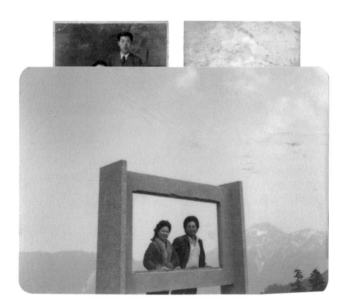

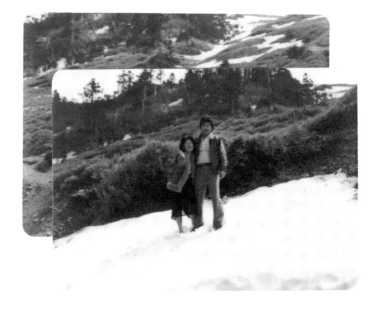

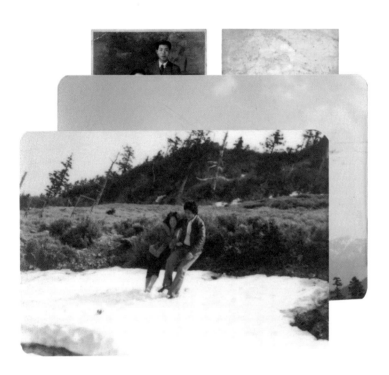

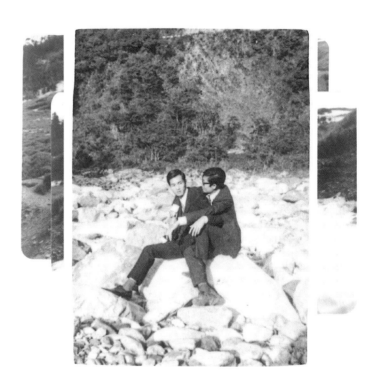

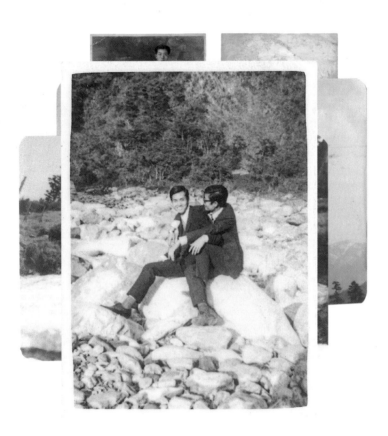

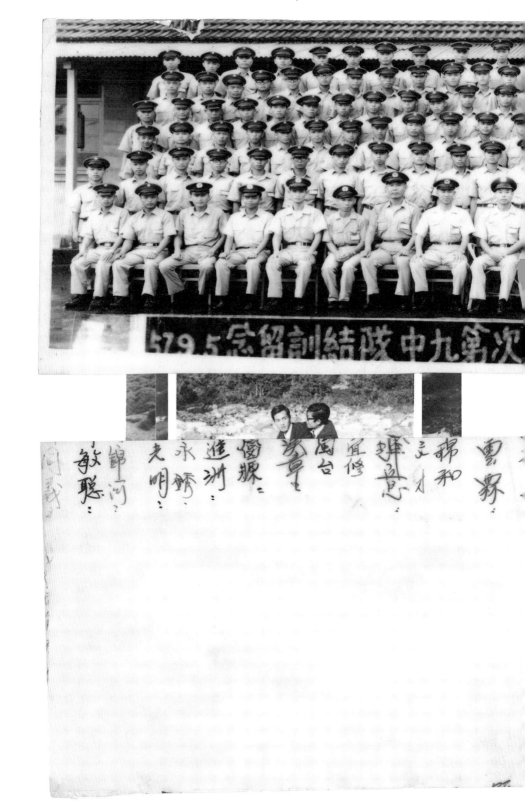

次第九中政結訓留念 79.5

敏聰：
錦河：
克明：
永鑄：
進洲：
傻猴：
漢章：
國台：
宜修：
輝立惠：
文才
錦和：
雲珠：

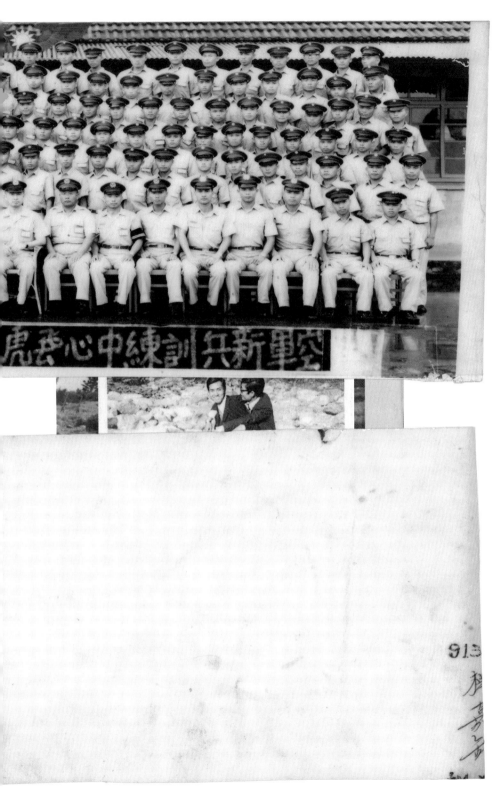

陸軍新兵訓練中心忠義

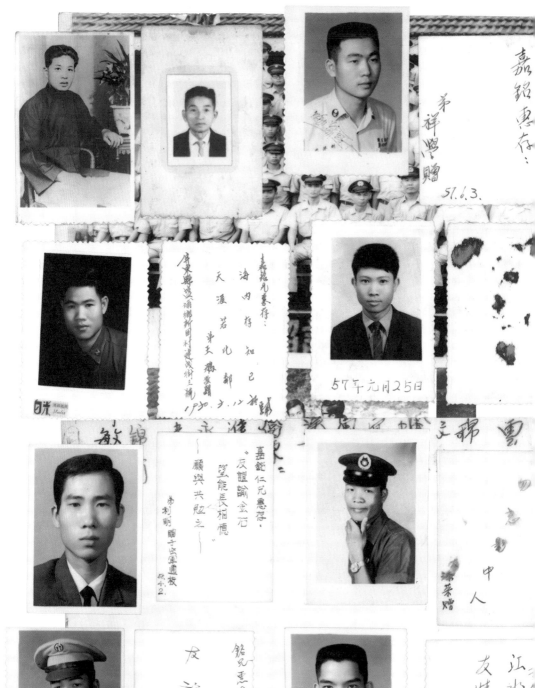

嘉銘惠存:

弟祥學贈

51.6.3.

嘉銘兄惠存:
海內存知己
天涯若比鄰
弟天樂敬贈
屏東縣恆春鎮新興村建成街主楊
伊加 5.12

57年元月25日

嘉銘仁兄惠存:
友誼諭金石
望能長相憶
——願與共勉之——
弟利明贈于空軍官校
嘉56.2.

敏錦

佳 衛

文錦 雲

恵 中 人
沐荣赠

銘兄惠存:
友誼永在

學存 57.5.7

江水常流
友情永存
友情敬贈
1968.5.22

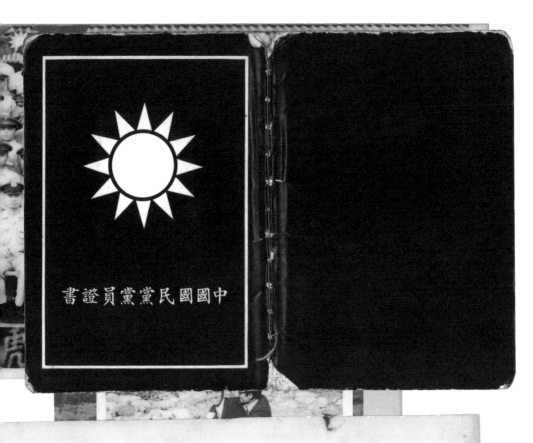

中國國民黨黨員證書

總裁肖像

知廉恥
辨生死
負責任
重氣節
蔣中正題

總理遺像

革命尚未成功
同志仍須努力

總理遺囑

余致力國民革命，凡四十年，其目的在求中國之自由平等。積四十年之經驗，深知欲達到此目的，必須喚起民眾，及聯合世界上以平等待我之民族，共同奮鬥。現在革命尚未成功，凡我同志，務須依照余所著建國方略、建國大綱、三民主義及第一次全國代表大會宣言，繼續努力，以求貫徹。最近主張開國民會議，及廢除不平等條約，尤須於最短期間，促其實現。是所至囑。

孫文

中華民國十四年二月二十四日

1:4500000

中华人民共和国地图

ZHONGHUA RENMIN GONGHEGUO DITU

Chia min - yong.

中 国 地 图 出 版 社
ZHONGGUO DITU CHUBANSHE

1968.5.22

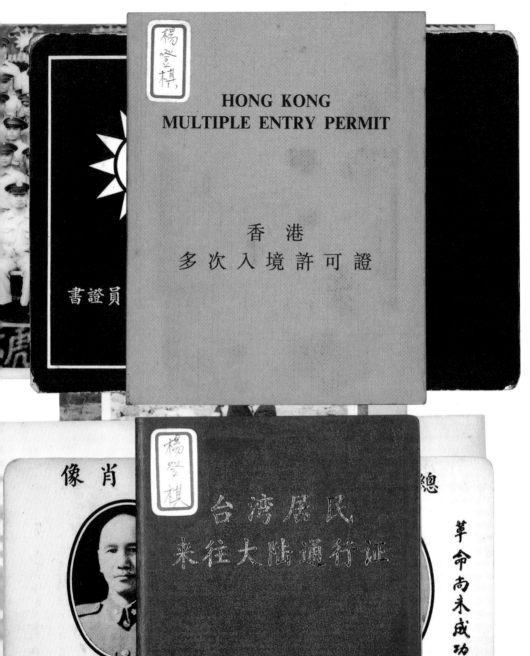

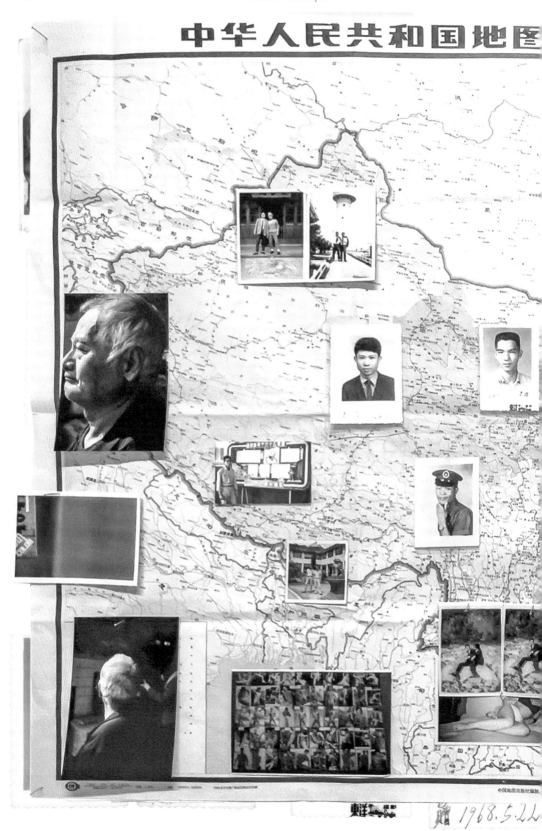

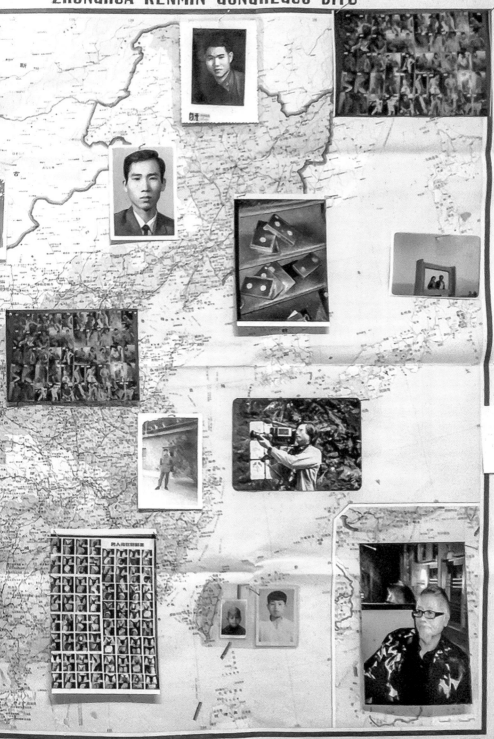

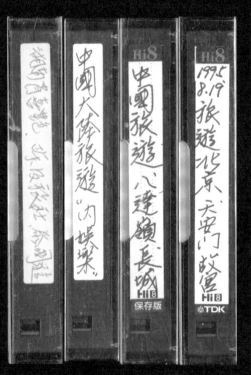

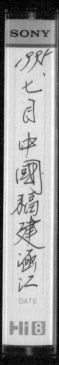

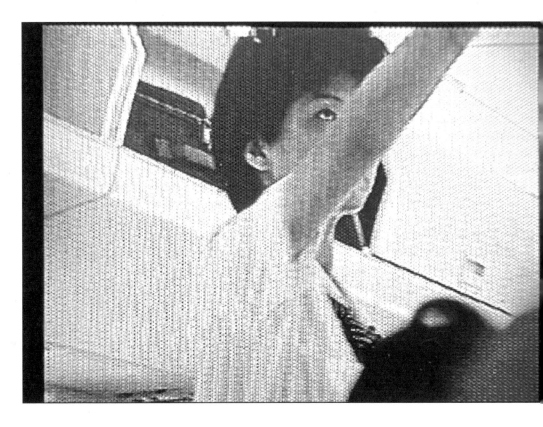

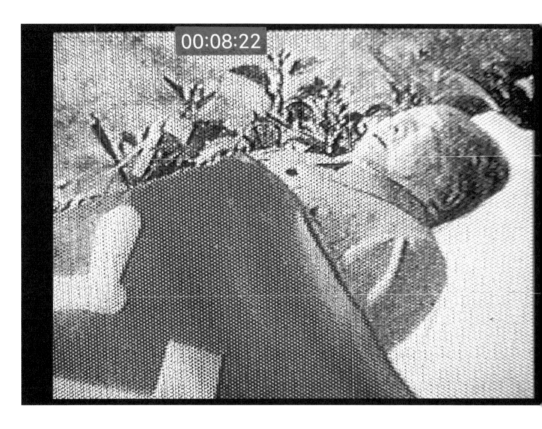

受刑的人

(一)
一念之差，一顆偏激的心
岸，不能夠洗清我罪行，哎
少恨，我悔恨，我悔恨，我

(二)
一串眼淚，一顆破碎的心，然
像春夢一樣的難尋，回憶也
神，我悔恨，我悔恨，我悔恨

(三)
無限希望，像回無限悲又傷
數着無限的晨昏希望又時
我悔恨，我悔恨，我悔恨應接

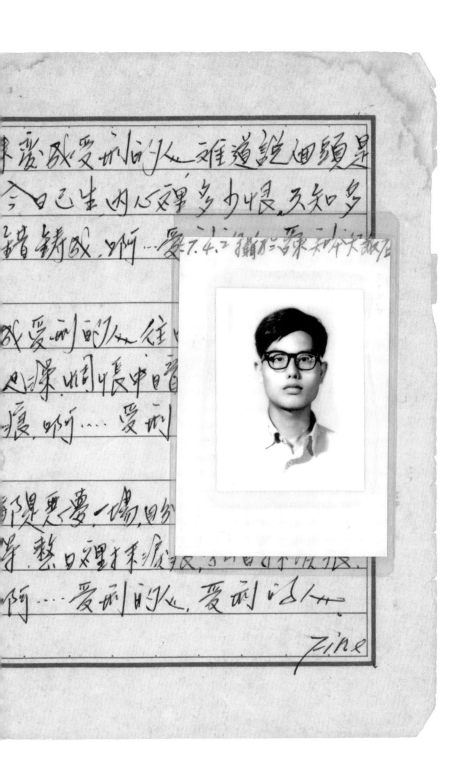

親愛的積、

爸爸臨時有事.和朋友到大陸
去.我不在家時.希望你多聽祖母
的話.好好用功讀書.多聽叔叔
和母等的話.現是要事事都關
以後等我回來.如你成績有
進步.你有什麼要求.我定會
儘量滿足你.希望你不會使
我失望.往後.將會也也爱、
你.知道嗎、?

爸/楊喜銘
12:30.

爸，你最近好無？

佢毋知你還使得寫信分佢無，
毋過佢還係想寫一封信分你，
佢毋知使得看還係看無。
你還記得你伴佢嘛分佢該錄影帶無？
佢問當多問題。毋過你嘛恁覺當支事情
嘛無恁重要，自佢細漢時，佢看到若錄影帶
佢恁覺介時到這下已經改變佢人生。
嘛改變佢這對事情該看法。
可能毋係你故意愛改變佢
佢恁謝你分享你作品錄影帶。
恁謝若靈魂做你自家。

 兒 登棋
 2022.11.15.

登曼波　本名楊登棋，出生於臺中東勢的客家大家庭。在封閉的小鎮中成長，卻因父親的特立獨行，擁有了相對自由的環境，隔代教養亦促使其自年少時便開始獨立自主、構建自我。如此的成長背景，自然地成為他創作時聚焦回盼的對象，並呼應當下外界的變化。慾望驅使他創作，不斷地由內而外探索自己與所存在的環境，向當代提出對話。找尋身體的自我認同之餘，也希望靈魂與身體能更自在地並存。酷兒身分亦令其打破框架、拭去二元，持續以推進整個亞洲在性向／性別議題的對話為旨。

作品目前橫跨影像與裝置，藉由攝影給予記憶一個重新檢視、觀看的機會，2019 年以「父親的錄影帶」獲當年臺北美術獎首獎。2021 年呈現酷兒群體縮影的「父親的錄影帶＿碧兒不談」入圍台新藝術獎。2022 年再以重新觀照家鄉與家族的「複寫：認同＿父親的錄影帶」，參與臺灣與立陶宛對話的「覆寫真實：臺灣當代攝影中的檔案與認同」群展。

Instagram @manbo_key

Yang Teng-Chi, known professionally as Manbo Key, was born into a large Hakka family in the Dongshi district of Taichung. Despite growing up in a small conservative town, his maverick father helped shape a relatively free and liberal environment, one where his intergenerational upbringing enabled him to develop a sense of individual agency at a young age. This background naturally formed Yang's practice and research, with subject explorations that draw parallels to the ever-changing world.

His practice is driven by an examination of desire and a constant investigation of the self. In seeking to expand on understandings of identity and by engaging with contemporary discourse, Yang hopes to create spaces that allow for the coexistence of the body and soul.

As a queer artist, Yang actively challenges the boundaries of social dichotomies and contributes to the evolving discussions around sex and gender in Asia. His current works span images and installations, using the medium of photography to re-evaluate and reconsider memories. In 2019, Yang's work *Father's Videotapes* won the Grand Prize at the Taipei Art Awards. An extension of that series, *Father's Videotapes__Avoid A Void* was shortlisted for the Taishin Arts Award in 2021. The third iteration, *Diverse Identities__Father's Videotapes*, this most recent series was produced in 2022 with a refocus on his hometown and showcased in the Taiwanese-Lithuanian cultural exchange group exhibition *Covered Reality: Archival Orientation And Identity In Taiwanese Contemporary Photography*.

Instagram @manbo_key

展覽

2022　「複寫：認同 ＿＿ 父親的錄影帶」／「覆寫真實：臺灣當代攝影中的檔案與認同」
　　　　群展／國立臺灣美術館／臺中，臺灣
2021　「父親的錄影帶 ＿＿ 碧兒不談」／國立臺灣政治大學藝文中心／臺北，臺灣
2020　「Paripasso Project」／ Regensburg，德國
2019　「父親的錄影帶」臺北美術獎首獎／臺北市立美術館／臺灣
2016　「Too Shy To Kiss」影像個展／唐豐藝術中心／臺北，臺灣
2015　「The Acid of City」城市精神影像聯展／大內藝術節／臺北，臺灣
2014　「im/permanence 無常」影像個展／上海老碼頭藝廊／上海，中國
2011　「Sleep Lesson」登曼波攝影個展／耳房藝文空間／臺北，臺灣

獎項

2022　「父親的錄影帶 ＿＿ 碧兒不談」／台新藝術獎入圍／臺北，臺灣
2021　「父親的錄影帶」／臺北美術獎首獎／臺北市立美術館／臺灣
2014　「父子」／臺北詩歌節入選／臺北，臺灣
2012　「Hiding Animal」／上海 50/100 設計師新銳展入選／上海，中國
2012　「築夢計畫」／客家委員會補助計畫錄取／臺北，臺灣／京都，日本
2008　「無憂」／第十屆臺北電影節學生金獅特別獎／臺北，臺灣
2008　「母親」／貳零貳零學生影展／最佳實驗影片／臺北，臺灣

EXHIBITIONS

2022 *Diverse Identities__Father's Videotapes, Covered Reality: Archival Orientation*
 And Identity In Taiwanese Contemporary Photography Group Exhibition,
 National Taiwan Museum of Fine Arts, Taichung, Taiwan.

2021 *Father's Videotapes__Avoid A Void*, The NCCU Art & Culture Center. Taipei, Taiwan.

2020 *Paripasso Project*, Regensburg, Germany.

2019 *Father's Videotapes* (the grand prize of "2019 Taipei Art Awards"),
 Taipei Fine Arts Museum, Taiwan.

2016 *Too Shy To Kiss*, Tang Feng Art Gallery, Taipei, Taiwan.

2015 *The Acid of City*, Taipei Art District Festival Photography, Taipei, Taiwan.

2014 *im/permanence*, Old Pier Gallery, Shanghai, China.

2011 *Sleep Lesson*, Ear House Art Gallery, Taipei, Taiwan.

AWARDS

2022 *Father's Videotapes__Avoid A Void*, Taishin Arts Award, Taipei, Taiwan.

2019 *Father's Videotapes*, the grand prize of "2019 Taipei Art Awards",
 Taipei Fine Arts Museum, Taiwan.

2014 *Father's Videotapes*, Taipei Poetry Festival, Short film nominated, Taipei, Taiwan.

2012 *Hiding Animal*, 2012SHDC-50/100 YOUNG GUNS, Shanghai, China.

2012 *Dream Project*, Hakka Affairs Council, Taipei, Taiwan/Kyoto, Japan.

2008 *Marrow*, 10th Taipei Film Festival, Golden Lion Award, Taipei, Taiwan.

2008 *Mother's Ring*, Twenty celebration, Best experimental film, Taipei , Taiwan.

English translation by Annette An-Jen Liu

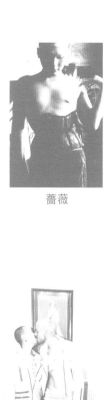

薔薇

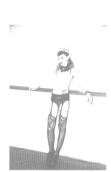

紅尾

Daisy ^{（下二）}
Coco ^{（下一）}

妮菲雅 ^{（左）}
薔薇 ^{（中）}
Popcorn ^{（右）}

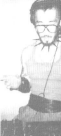

Pondork

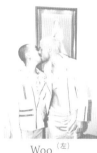

Woo ^{（左）}
Thom ^{（右）}

林耕舞

Alex Haji

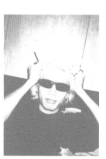

Lucas

An

Summing

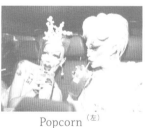

Popcorn ^{（左）}
Manson ^{（右）}

酸六

Andy

Luu

隆兒

Aiko

吉吉 ^{（右一）}

Betty Ap

Yun Pei

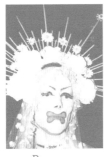

Popcorn

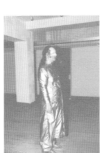

唐鳳

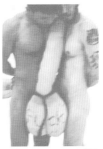

Ting Cheng Ho （左）
Pondorko （右）

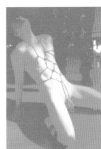

Axel Abysse

Cat

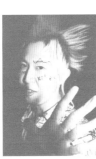

張藝

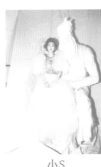

小S

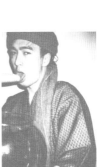

隆兒

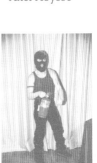

Woo

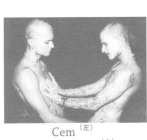

Cem （左）
MCMLXXXV （右）

曾敬驊 （左）
陳昊森 （右）

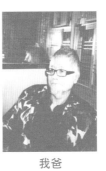

我爸

高小糕

CWL

Hush

Cheng-Ta Yu

阿嬤

Acudus

SPECIAL THANKS

阿嬤、父親、母親、姑姑、欣妤、淑貞、陳順築、台灣同志熱線、漢士三溫暖、漢士阿嬤、薔薇家族、Popcorn、WOO、Liang Zhong、Jing Lekker、紅尾、Homing、修、Bright、Pei、酸六、Ying Fook Lin、SHYN、老大、Seeinnerball、白靈、珊妮公主、安溥、美清、紅豆、大廖、建文、昭昭、Yaode、Nelly 尹宗、Pohan、校長、小宇、愛娃、小玉、隆姐、肥劉、Josh、勇、偉、柏松、Lu、Miranda、Eddie、明月、楷恩、于寧、Shawn、Yoshi、Natus、Tibor、Cat、Tien、Inners、酒井、Ava、任航、三妞、皮特、趙序、王墾、火馬、Ray、Wook、天使 and everyone helped this show。

父親的錄影帶

作者　登曼波
採訪撰文　白樵
拼貼　陳楷恩

責任編輯　林怡君
裝幀設計　Yaode JN
英文翻譯　賴孟宗、劉安蓁

出版
大塊文化出版股份有限公司
105022 台北市南京東路四段 25 號 11 樓
www.locuspublishing.com
Tel: (02) 8712-3898 Fax: (02) 8712-3897
讀者服務專線　0800-006689

台灣地區總經銷
大和書報圖書股份有限公司
248020 新北市新莊區五工五路 2 號
Tel: (02) 8990-2588 Fax: (02) 2290-1658

法律顧問
董安丹律師、顧慕堯律師

初版一刷　2022 年 12 月
定價　新台幣 1600 元

Father's Videotapes

Author: Yang Teng-Chi
Interviewer: Pai Chiao
Collage Artist: Kayn Chen

Editor: MaoPoPo
Designer: Yaode JN
English Translators:
Andrew Lai, Annette An-Jen Liu

ISBN: 978-626-7206-42-3

國家圖書館出版品預行編目（CIP）資料 父親的錄影帶 / 登曼波作 . -- 初版 . -- 臺北市 : 大塊文化出版股份有限公司 , 2022.12
496 面 ; 17x22 公分 . --（tone）ISBN 978-626-7206-42-3（精裝）1.CST: 攝影集 2.CST: 同性戀　957.5　111017884

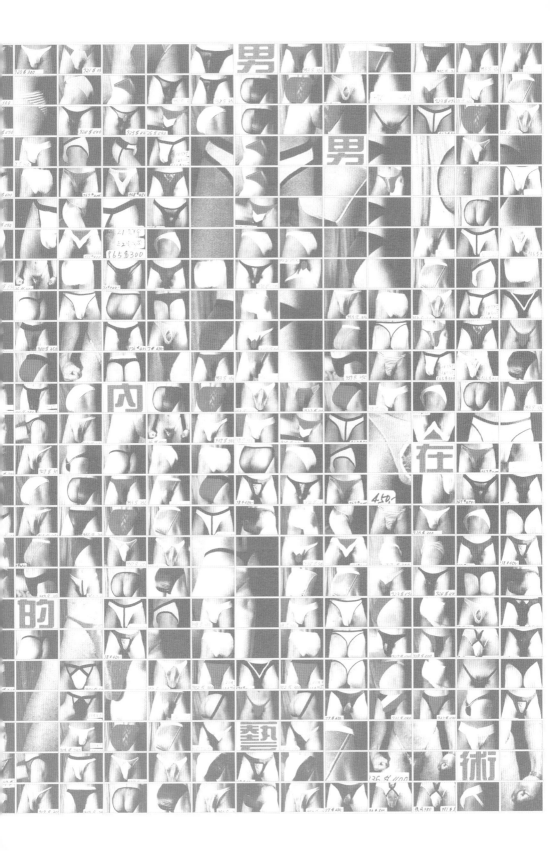

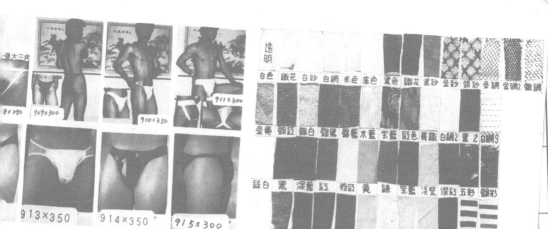

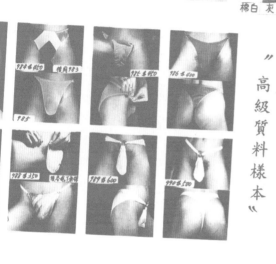